Michelangelo

Six lectures by Johannes Wilde

CLARENDON PRESS · OXFORD
1978

Oxford University Press, Walton Street, Oxford OX2 6DP

OXFORD LONDON GLASGOW NEW YORK TORONTO
MELBOURNE WELLINGTON IBADAN NAIROBI DAR ES SALAAM LUSAKA CAPE TOWN
KUALA LUMPUR SINGAPORE JAKARTA HONG KONG TOKYO
DELHI BOMBAY CALCUTTA MADRAS KARACHI

© *The Courtauld Institute* 1978

British Library Cataloguing in Publication Data
Wilde, Johannes
 Michelangelo. – (Oxford studies in the history of
art and architecture.)
 1. Michelangelo
 I. Shearman, John, b. 1931 II. Hirst, Michael
 III. Series
 709′.2′4 N6923.B9 77–30203

 ISBN 0–19–817316–4
 ISBN 0–19–817346–6 Pbk

*Printed in Great Britain by
Fletcher & Son Ltd, Norwich*

Preface

This book comprises the text of eight lectures of Johannes Wilde on Michelangelo, addressed to students at the Courtauld Institute in the 1950s. The lectures were written out in full and were accompanied by slide lists which have been followed for the choice of illustrations. But Wilde did not repeat the lectures mechanically year after year. More than one version of some survive; and we have exercised our own judgement over which text to follow. The decision to reduce eight lectures to six chapters was dictated by the nature of the material; in some cases, discussion of a single project like the Sistine Ceiling outran a single lecture.

Like all editors of texts originally prepared for the informality of the lecture room, we have been confronted with the problem of how far colloquialisms and personal touches should, or should not, be preserved. Some of Wilde's most personal mannerisms we have reluctantly removed; with equal reluctance we have excluded some of his most engaging asides, such as his injunction to his listeners not to confine themselves to noting his own remarks about Condivi's biography but to sit down and read the book. But we have tried to keep changes to a minimum.

The eight lectures were a part of the Renaissance course of the Courtauld Institute and were not intended to be comprehensive. Readers will not fail to notice that there is little discussion of the architecture. This lacuna should not be construed as evidence of any lack of interest in the architecture on Wilde's part; it simply reflects the pattern of teaching at the Institute at the time. Where architectural problems are turned to, in Chapter 5, the reader familiar with the subject of the Laurentian Library will in fact find an analysis of the building history of the project substantially at odds with the generally accepted account published by Wittkower in 1934.

This book is not, therefore, in any sense the monograph on Michelangelo which Wilde's life-long study of the artist qualified him to write. Nor have we, as editors, made any attempt to bring things up to date. We have tried to limit the number of footnotes but we have attempted, where it seemed appropriate, to indicate the specialized studies concerned with Michelangelo's art published by Wilde in his lifetime.

Publication of this volume has been assisted by generous contributions from Professor Wilde's friends and former pupils.

We should like to thank Dr. Charles Schmitt for help over a reference to Marsilio Ficino, and Jane Shearman and Susan Welsford for help in preparing the manuscript for publication.

M.H.
J.S.

Contents

List of Illustrations

Acknowledgements

A.C.L., Brussels: 28; Archives photographiques: 25, 94, 155; Arts Council: 14; Ashmolean Museum: 60, 61, 85, 176; British Museum: 4, 32, 37, 80, 90, 108, 110, 111, 119, 142, 151, 171, 172, 180, 181; Chomon-Perino: 73; Gabinetto Fotografico, Florence: 2, 5, 12, 18, 36, 91, 92, 109, 118, 128, 129, 137, 156; G.F.N., Rome: 64, 76, 77, 101, 102, 103, 139; Giraudon: 86, 87, 95; Grassi: 30; A. F. Kersting: 89; King's College, Newcastle: 88, 100; Louvre, Paris: 115, 170; Mansell Collection: 1, 10, 11, 15, 19, 20, 21, 22, 23, 24, 33, 34, 39, 40, 42, 43, 44, 45, 46, 47, 48, 49, 52, 57, 58, 59, 62, 63, 65, 66, 69, 70, 71, 74, 75, 79, 96, 97, 99, 113, 117, 120, 121, 122, 123, 124, 125, 126, 133, 134, 135, 136, 140, 141, 144, 168, 174, 175, 179; Mas: 169; National Gallery, London: 173; Oscar Savio: 167; Phaidon Press: 6; Royal Library, Windsor, reproduced by gracious permission of Her Majesty Queen Elizabeth II: 146, 149, 150, 152; Victoria and Albert Museum: 3.

Michelangelo, Vasari, and Condivi

In March 1550, when he was seventy-five years old, Michelangelo received a birthday present the like of which was never given to any other artist. At about that date the first edition of Vasari's great history-book, the *Lives*, was published, a work inspired by, and dedicated to, the genius of Michelangelo. Inspired, too, because the whole conception of the work was based on the experience of following this exemplary artistic career. Michelangelo's life's work was the model on which the leading ideals of Italian art in general, and even the periods of their development, could best be demonstrated.

When Vasari wrote, Michelangelo had already been working for sixty years, and his career was not yet at its end. Surveying this life we find his earliest and his latest work separated by exactly three-quarters of a century—an exceptional case in the whole history of art. He always stood in the centre of the artistic scene and was one of its main forces. His works are numerous and we know much about them—again an exceptional amount. There exists a very large quantity of contemporary records, documents of all kinds relating to his work, and a great part of his correspondence is preserved (500 letters written by him, about 800 addressed to him). We are far from having fully exploited this material.

Our work is greatly helped by two contemporary biographies; this, too, is something quite extraordinary, for biographies written and printed in the lifetime of earlier Renaissance artists do not exist. To these we can add a third, published shortly after Michelangelo's death, which is in effect the earliest and most important monograph on the artist. By this I mean the long chapter on Michelangelo contained in the second edition of Vasari's *Lives*. I call this chapter the earliest monograph on Michelangelo although it was preceded by the two other biographies: the corresponding chapter in the first, the 1550 edition of the *Lives*, and Condivi's *Vita di Michelagnolo Buonarroti* of 1553. But these two are not really monographs. First, they are incomplete; since both were published in Michelangelo's lifetime they do not contain the events that occurred after 1550 and after 1553 respectively. Nor are they comprehensive—the first, because of some big gaps in the author's knowledge of the subject, and the second, because of the selection of facts made by the author to serve the polemical purpose of his book.

The long chapter contained in the 1568 edition of Vasari can also rightly be called the most important of all the existing monographs on Michelangelo. It was written by a contemporary who had made a very careful study of his subject, and who was personally well acquainted with his hero. It contains facts not otherwise recorded or documented, and therefore one must still use it repeatedly as a source for Michelangelo's career. Besides this, Vasari's narrative is clear, and his account of the work, and his picture of the personality of the artist are so suggestive that, in fact, you will find most of the later monographs to be largely dependent on them.

Vasari gave an important place to this chapter in the composition of his book. He further emphasized its importance by making a separate edition of his Michelangelo *Vita* in the form of a small book, which followed the publication of the complete three-volume 1568 edition of the *Lives* within a month. As this little book—a real monograph not only in its contents but also in its form—has become very rare, and as its preface has never been reprinted, I should like to quote a few sentences from it. Vasari begins:

Many of our artists—but other persons too who are lovers of the arts—have asked me, ever since Michelangelo's death, to complete his life-story which I had published in 1550, with an account of the works done by the master between this date and his last day. I was unable to fulfil this demand earlier. But now, at last, I have made his biography completely anew and have given my manuscript—together with those of many other biographies which were lacking in my book—to the printers. Nevertheless, as there are many readers who would like to possess that life of Buonarroti alone, separated from the other lives, it appeared appropriate to me to have a certain number of separate copies printed. They may satisfy those who will not, or cannot, buy the whole work.

The preface is followed by the dedication of this separate edition to the son of Ottaviano de' Medici, one of the earliest and most intelligent of all Vasari's patrons. It ends with these words: 'Accept this gift willingly. By chance, it is not a small thing in spite of being my work—for it speaks of the solemn works of the greatest, the noblest and the most excellent artist who has ever lived.'

As we are told by the author that he has not simply patched up or re-worked his first text but replaced it by an entirely new one, we may rightly ask what reasons induced him, one of the busiest men of his time, to make his task so difficult. To answer this question, we must first compare the two texts. One of the results of the comparison is a qualification of Vasari's statement: the first *Vita di Michelagnolo* was not simply thrown out by him; though modified in places, it is retained in the second. To be precise: it is one of the three main components of the new text. The other components are Condivi's *Vita*, and the body of information collected by Vasari himself during the twenty years that preceded the publication of his second edition.

It is precisely this textual criticism of Vasari's final Michelangelo *Vita*

that is my objective here. It seems to me indispensable if we want to use the chapter as a source. So let us examine the three components one by one, and begin with Vasari's first *Vita*. As I have said, it appeared in print in the two-volume edition of the *Lives*, in March 1550, almost in time for Michelangelo's seventy-fifth birthday. But its manuscript was finished three years earlier, and so it recorded events only up to the beginning of 1547. Vasari completed this last and most important chapter of his book immediately after a long visit to Rome, and he made no additions to it in the following three years. There are even some indications that this text was preceded by a first draft, probably dating from as early as 1543—also following a visit of the author to Rome, and written under the fresh impact of Michelangelo's *Last Judgement*. (I can refer only in passing to this hypothesis of an early version of Vasari's Michelangelo chapter, a version culminating in, and ending with, the description of the *Last Judgement*.)

The most important fact concerning Vasari's first *Vita* is that it was entirely based on information collected by Vasari himself, and on his acquaintance with Michelangelo's works: that is to say, oral tradition and autopsy were its only sources. With a single exception, Vasari did not know any written record concerning his subject, nor was his personal relation to Michelangelo close enough to allow him directly to approach the artist with questions. But he knew a large number of persons, both in Florence and Rome, on whose memories he could draw for information; and Michelangelo's works were exhibited in public places in these two cities. He became acquainted with these works one after another.

It is perhaps worth following this sequence which I think has a bearing on Vasari's work as a whole. We may use as a guide Vasari's autobiography and other related passages in the *Lives*.

By lucky chance, Vasari was taken to Florence as a boy of thirteen, in 1524, and his studies in drawing were continued there somewhat aimlessly, with occasional visits to the workshops of Andrea del Sarto and Bandinelli. His story that he was then apprenticed for a short time to Michelangelo (the story appears only in the second edition of the *Lives*) is a fiction the aim of which is obvious. But doubtless Michelangelo was at that time the almost exclusive centre of interest in Florence for all those who were concerned with the arts. He was known as the greatest living artist. His giant *David* stood, admired by all, in the Piazza. His colossal cartoon of the *Battle of Cascina*, also known as the *Bathers*, had been, for a decisive decade, the academy of all ambitious artists. And the victory he had won with his Sistine Ceiling in Rome, against the strongest competition, set the final seal on his reputation. Nobody dared to challenge it; an attempt in this direction, by Bandinelli, provoked public uproar. Working in Florence again after many years of absence—working behind the carefully closed doors of

the Medici Chapel—new miracles, greater than ever before, were expected of him by his friends. It was only natural that the young Vasari should be one of the curious admirers. A proof of this is the touching story how he and his friend Francesco Salviati, as boys, collected and saved the fragments of the left arm of the marble *David* which, in the revolutionary tumults of April 1527, lay about on the pavement of the Piazza. He recognized the inestimable value of those fragments, because he knew the work well.

He admired the unfinished figure of *Saint Matthew* which was standing in the Office of Works of the Cathedral, alongside San Giovanni. He also admired the copies of single figures or groups from the *Bathers Cartoon* which he saw in every studio he visited. And he went to the church of S. Spirito and to the courtyard of the finest palace in Florence, the Palazzo Strozzi, to see the wooden *Crucifix* and the marble *Hercules* respectively—the first two works done by the young master after he had left school at the age of seventeen. The young Vasari may have meditated on the path which led from these beginnings to the peak reached in the *David* and the *Bathers Cartoon*.

This was the first phase of Vasari's acquaintance with the art and personality of Michelangelo. Four years later his lucky star led him to Rome. I am not going to repeat the story of this visit which made Vasari both an artist and a student of the history of art; but I should like to emphasize that in his own account of the visit Vasari mentions the Sistine Ceiling first, before the other works which he studied. Thus, with Michelangelo's early works already known to him, Vasari made a thorough study of the principal monument of the next stage in Michelangelo's development, the Ceiling. He also saw in Rome, in the garden of Jacopo Galli, the *Bacchus*, and he saw the *Pietà* in a chapel of Old Saint Peter's; and so he was able to complement his knowledge of Michelangelo's early period. His picture of Michelangelo's career, up to the time of his return to Florence in 1516, was almost complete; and this must have increased Vasari's curiosity to know what was happening inside the Sagrestia Nuova.

He did not have to wait for long. His exertions in Rome brought on a serious illness; but after his recovery, in November 1532, he could go to live in Florence again—this time in the house of Ottaviano de' Medici who, both as collector and as Maecenas, was spiritual heir to Lorenzo il Magnifico. Now this is how Vasari begins the account of his second Florentine period:

Returning to my usual studies, I received facilities by means of that lord [that is Ottaviano de' Medici] to enter at my pleasure into the new sacristy at S. Lorenzo, where are the works of Michelangelo, he having gone in those days to Rome. And so I studied them for some time with much diligence, just as they were standing or lying on the ground.

We know that at the time in question Michelangelo was indeed in

Rome once more, trying to finish the tomb of Julius II; and so Vasari had the opportunity to continue his studies in the chapel until the end of June 1533. He saw there all the seven statues which were executed by Michelangelo—and only those, for the *Saints Cosmas* and *Damian* by his assistants were not yet begun; he saw them very nearly in the state in which they are now. (Five of them were put in their proper places with Vasari's assistance thirteen years later.)

One of the immediate results of these studies was Vasari's full-length portrait of Duke Alessandro de' Medici, now in the Uffizi, and this portrait is simply a copy of Michelangelo's *Giuliano de' Medici* with another head (1, 2). Another effect of the new experiences and surroundings was that Vasari began seriously to study architecture.

Late in the summer of 1534 Michelangelo left Florence for good. His first large undertaking in Rome was the fresco of the *Last Judgement*. The task was immense; it took nearly three years to plan the work and another five years to carry it out—years which once more were filled with excited expectations for an ever-growing circle of admirers. After its unveiling, and as soon as his own affairs allowed it, Vasari went to Rome to see the fresco. There he witnessed a new Michelangelo—a Michelangelo who appeared to be entirely different from the one he had so thoroughly studied in the Sagrestia Nuova.

During this Roman visit of 1542/3 he was introduced to Michelangelo. Vasari had painted a picture for Bindo Altoviti who was then the Consul of the Florentine colony in Rome and also a friend of Michelangelo. 'This picture when finished', wrote Vasari, 'was not displeasing to the gracious judgement of the greatest painter, sculptor, and architect that there has been in our times, and perchance in the past.' And summing up the account of this whole Roman sojourn, he said:

At this time I paid constant attention to Michelangelo Buonarroti, and took his advice in all my works; and he in his goodness conceived much more affection for me. His counsel, after he had seen some of my designs, was the reason that I gave myself anew and with better method to the study of architecture, which, probably, I would never have done if that most excellent man had not said to me what he did say, which out of modesty I forbear to tell.

Vasari died with his secret—but would that he had followed the advice of the real expert! His galleries of the Uffizi are one of the most original and most splendid architectural inventions of the later Cinquecento, whereas in painting he never really produced anything above the average.

This survey shows that by the time he reached his early thirties, Vasari had become well acquainted with all Michelangelo's principal works. He became acquainted with them—and this is, I think, a not unimportant point—in much the same sequence as that in which they were produced in the course of half a century. This was, I believe, the

great experience of Vasari's youth. It helped him as an artist; but, more important than that, it had a decisive effect on his conception of the development of art—on the conception that we find expanded in his writings.

The most characteristic features of Vasari's theory are these. First, the development of art proceeds in stages, each of these stages representing a definite progress beyond the previous one. Progress means the gradual overcoming of difficulties as they are defined by the aim of art—that is, to represent the world as it appears to us. Therefore,

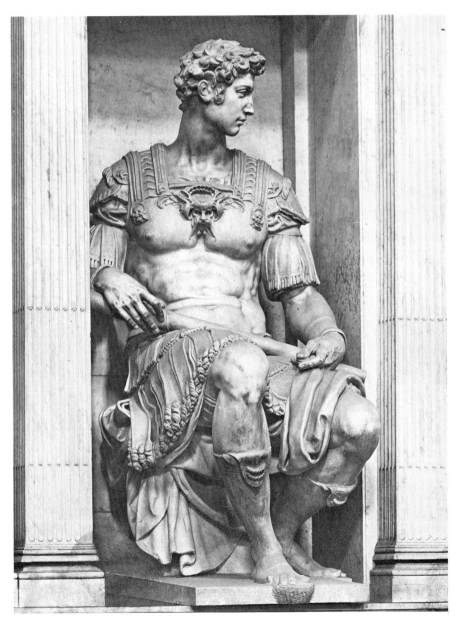

1. *Giuliano de' Medici.*
Florence, San Lorenzo,
New Sacristy.

and this is the second point, the evolution of art is a steady approach towards natural appearance, and its ultimate aim is a complete mastery over all forms—it is a competition with Nature in which the artist selects her best forms. In modern times, this process also means an increasing approximation to antique art and the appropriation of its rules. Finally, this process should eventually lead to a stage of complete freedom. At this stage the artist is no longer bound by any rule other than his own individual taste and will (this is the meaning of the much disputed term *maniera* as used by Vasari). It seems likely that this whole

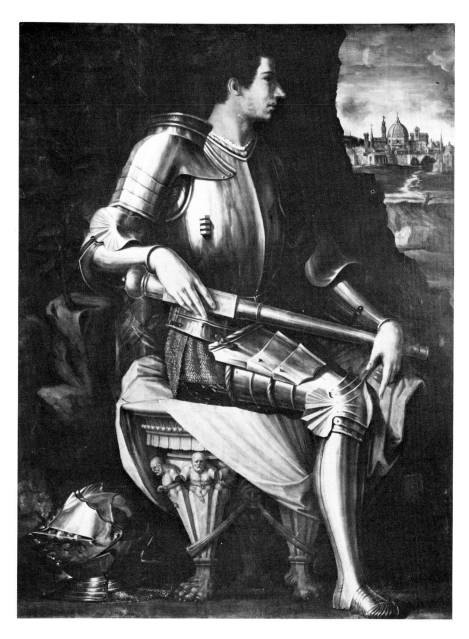

asari, *Alessandro de'*
ci, Florence, Uffizi.

conception was largely determined by Vasari's intensive studies of Michelangelo's art and by the experience of individual development as revealed in Michelangelo's works; and that it was then adopted as a scheme for the general history of art.

So much for Vasari's autopsy. As for the information he derived from oral tradition, although extensive, it was uneven. Thanks to his position in Florence, Vasari knew most of the artists there, including those of older generations, such as Granacci and Bugiardini, who were witnesses to Michelangelo's spectacular rise. He was less well acquainted with the events that had occurred in Rome. And, naturally, the later the events the more detailed the information he could collect. Hence the relative completeness of the story of Michelangelo's third Florentine period, the years 1516 to 1533, is quite natural; whereas Vasari was in difficulty over constructing a consistent picture of Michelangelo's early career. But then, in the first edition, he wanted to concentrate on Michelangelo's principal works, the milestones in his career, and not to be led astray by irrelevant details. Short though Vasari's first *Vita* is, it is a very vivid and impressive study.

'Giorgio presented his work to Michelangelo personally, and he received it very gladly.' Thus Vasari relates in the second edition of the *Lives*, where he also prints the sonnet in which Michelangelo thanked him for the present. He further publishes all the letters, both significant and insignificant, he received from Michelangelo in the course of ten years following that event. What he does not mention is the fact that Michelangelo thoroughly disagreed with the contents of the book as far as his own affairs were concerned—that he disagreed with them to such an extent as to cause another biography to be written and published. This is the little book with the title *Vita di Michelagnolo Buonarroti* which came out in Rome in the middle of August 1553, that is to say less than three and a half years after Vasari's book. Now this is a rather extraordinary story and nothing like it had occurred before: Michelangelo, whose shyness and modesty were emphasized by his contemporaries, must have had very serious reasons for acting in this way. Ascanio Condivi, the ostensible author, hints at some of these reasons in his preface. He says that while he had been in daily contact with Michelangelo for a long time as a pupil, he carefully recorded all his teaching and all the biographical dates he had heard from him. He had done so with the intention of eventually publishing his precious material for the benefit of other students. And he continues

While this material of two kinds had been still growing, it occurred that I was forced to accelerate, nay to precipitate, the publication of my notes concerning the life of Michelangelo—and that for two reasons. First, because certain persons who wrote about this great man without knowing him as intimately as I do, partly related events that had never occurred, and partly omitted such as would be very much worth while noting. Secondly, because other persons, to whom I confided my papers, want to make use of them to their own advantage.

What the latter allusion means is unknown to us—the former plainly refers to Vasari. It gives the clue to the real motives which produced this second *Vita di Michelagnolo*. All we have got to do is to compare the two texts carefully, list their differences, and then try to explain their meaning. This procedure has been made easy by the circumstance that, in consequence of its polemical purpose, Condivi's *Vita* substantially conforms in its disposition to Vasari's chapter, so much so that long passages in it read like a running commentary on the earlier text.

But first, a few words about the alleged author of the little book. We do not know very much about Condivi beyond what he himself says in the dedication and the preface of his work. He went to Rome when he was young, and he had the honour of becoming a pupil of Michelangelo. Further, we learn from documents that, some time soon after 1553, he married and returned to his native town Ripatransone in the Marche, where he lived the life of a modest provincial artist, producing some very insignificant paintings still extant, and dying there in an accident in 1574. Nothing is heard later of the theoretical writings, or of the edition of Michelangelo's collected poems, both promised in his *Vita*. From the years during which he enjoyed Michelangelo's protection in Rome, two works of his have been recorded. One is lost; it was a bronze bust of Cornelius Sulla and was made for Lorenzo Ridolfi, the brother of Cardinal Ridolfi. Both these men were Michelangelo's friends; like him, they belonged to the party of opponents of Duke Cosimo's regime. Michelangelo began his marble bust of Brutus (now in the Bargello) as a present for Cardinal Ridolfi, and it was to be a glorification of liberation from tyranny (3); it remained unfinished because of the Cardinal's death in 1550. The pupil's work seems to have been closely connected with it, for Sulla, too, as the dictator who relinquished power by his own free will, was a republican hero.

Condivi's other Roman work is preserved: it is an altar-piece, not quite finished. Vasari has this to say about it in his second edition:

> Ascanio dalla Ripa Transone [that is Condivi] took great pains, but of this no fruits were ever seen either in designs or in finished works. He toiled several years over a picture for which Michelangelo had given him a cartoon. In the end, all the good expectation in which he was held vanished in smoke; and I remember that Michelangelo would be seized with compassion for his toil and would assist him with his own hand, but even this profited him little.

Michelangelo's cartoon is in the British Museum (4). Condivi's picture, now in the Casa Buonarroti, shows an appalling degree of incompetence.

We also possess a letter addressed by Condivi to Michelangelo soon after he had returned to his native village: a rather silly piece of writing.[1] It gives the impression of a faithful fellow who was however a simpleton; and it is extremely difficult to believe that this man, single-

handed, would ever have been able to produce such an eminently read-able book as the *Vita di Michelagnolo*. Apart from the information received both by word of mouth and in writing from Michelangelo, Condivi must have been helped, in disposing his material and in form-ing his complete sentences, by some able stylist. And there are passages in the book which, for stylistic reasons, obviously cannot originate from Michelangelo—for instance, the description of the decorative system of the Sistine Ceiling. Who, then, was the author of these passages?

I believe certain considerations lead to the assumption that Condivi's unnamed helper was Annibale Caro, a person known on other accounts in the history of art. He was a distinguished prose-writer and poet, the

3. *Brutus*. Florence, Bargello.

4 (*right*). *The Holy Fami* (Cartoon). London, Briti Museum.

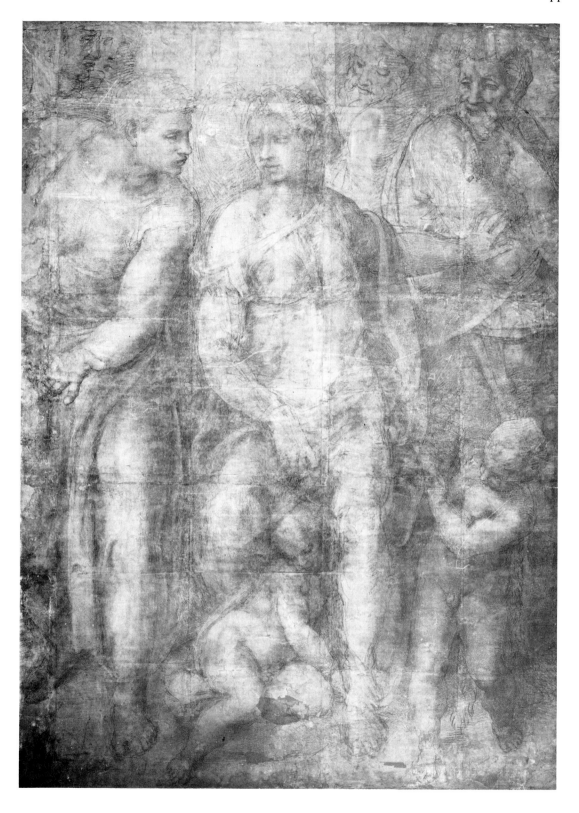

translator of Virgil into Italian; at the time in question he belonged to the household of Cardinal Alessandro Farnese. I mention some of the pointers: first, the way in which Caro is twice referred to in the *Vita* (he has lately become a close friend of Michelangelo—but no other record of this friendship exists). Second, the enduring examples left by Michelangelo should, we are told, be as strictly followed by the best artists as Petrach is followed by the best poets: Bembo, Sannazaro, Vittoria Colonna, and Caro. A fifth name is added, that of the relatively minor poet Giovanni Guidiccioni who had, however, been active as diplomat in Farnese service. Third, there is the personal relation between Caro and Condivi (the latter married Caro's niece soon after the publication of the book). Lastly we have two significant letters of Caro: one, of December 1547, was addressed to Vasari, who had submitted to him the manuscript of the *Lives*, and in response Caro gave his comments and instructions about style, instructions which were strictly adhered to in Condivi's *Vita*. The other letter, of August 1553, reveals that Caro knew not only the Condivi manuscript before its publication but also its *raison d'être*.

It would be the task of a well-trained philologist to compare Condivi's *Vita* with Caro's own prose-writings, and to prove or disprove this hypothesis.

Now I return to our two texts. As Caro states in the letter just mentioned, the particular concern of the new *Vita* is the true history of the tomb of Julius II and the justification of Michelangelo's behaviour in this whole affair. Now, this is certainly the main point on which the two texts differ from each other. Vasari had hardly any direct information on this subject; the few remarks he makes are out of place in his chronological survey and, still worse, two of his statements are definitely wrong. He refers to a resounding quarrel between Julius II and the artist (and to Michelangelo's subsequent flight from Rome), but he gives as its reason the artist's reluctance in allowing the Pope to see the Sistine Ceiling before it was finished. And he states that the execution of the tomb in its present form was made possible by the munificence of the Duke of Urbino. Michelangelo must have felt deeply hurt by both statements, and he probably took these errors for fresh products of the campaign of gossip that had been going on against him for more than forty years. But quite apart from this, he regarded that undertaking, the papal tomb, as the tragedy of his life, just because, in his belief, it should have become his greatest triumph. He regarded the commission when it was given to him as a unique opportunity to show the world what he was able to achieve as an artist; and he was prevented from using this opportunity by an alliance of jealousy, selfishness, and malice. His genius was the only victim in this tragedy. Moreover, he was accused not only of having desecrated the memory of his benefactor by erecting an unworthy monument, but also of having deceived the

heirs of the Pope and having embezzled large sums of money. And so, both his reputation as an artist and his integrity were at stake, and it became for him a matter of honour to have the true story publicized.

Indeed, the 'Tragedy of the Tomb' has been recited by Condivi in four long, some very long, acts, forming the framework of the history of Michelangelo's mature years, from 1505 to 1533. It ends in 1533 logically (although the present monument was completed twelve years later), because, for the artist, the undertaking was concluded with his last design for it, and this design, and the conception of the two new statues it demanded, date, I believe, from 1533. With the exception of the Sistine Ceiling, all other works by Michelangelo that belong to this period were more or less neglected by Condivi. And it can also be stated that the events that took place after 1533 have been handled in a rather summary way, as if the interest of the author, or authors, had been exhausted after the principal concern had been dealt with.

There is one more important point on which one finds substantial differences between Vasari's first *Vita* and Condivi's: it concerns Michelangelo's first steps towards art. What has Vasari got to say about this? He begins with the tale (told in many of his other biographies) of the irresistible impulse that forced the boy to use every scrap of paper and every whitewashed wall for drawing figures. Then he says that Michelangelo's father, on the advice of his friend Ghirlandaio, sent his son to the painter as an apprentice for three years; Vasari refers to a written agreement between Buonarroti senior and Ghirlandaio, dated 1 April 1488. Michelangelo was thirteen. Somewhat later Lorenzo de' Medici founded a school of art, especially of sculpture, in his garden opposite the monastery of San Marco. He put in charge of it a distinguished follower of Donatello, the aged Bertoldo; and he asked Ghirlandaio, the head of the largest studio in Florence, to send him some able pupils. Ghirlandaio transferred among others the young Michelangelo. While he was working in the painter's studio Michelangelo revealed great talents in drawing and painting; later, under Bertoldo, he proved a promising sculptor.

This is Vasari's account. What we learn from Condivi's *Vita* is somewhat different. Here, too, the story begins with the boy's artistic inclinations, but we are told of his struggles against the folly of his father and his uncle who wanted to make him a learned man and opposed his bent. His only support was from a play-mate, Francesco Granacci (they lived in the same street), six years his senior, who was a pupil of Domenico Ghirlandaio. Granacci provided his friend with drawings as models, and took him along to places where artists were working—sometimes also to his master's shop; but out of jealousy Ghirlandaio was unfriendly towards his would-be competitor. One day Granacci introduced Michelangelo to the garden at San Marco, and Michelangelo remained there, 'the best school of all arts', soon to be discovered by Lorenzo de'

Medici. No mention is made of Bertoldo.

Michelangelo's curriculum as given by Vasari conforms to that of all other art students in Florence. According to Condivi, he was an apprentice without a master, or—as it was later said of him—all Florence was his school: he learned where he liked, and learned what he liked. Apart from Granacci's help and the support of Lorenzo de' Medici— and neither was essential—he had no need to feel any obligation in what he ultimately achieved. In this respect, too, he represented a new type of artist for whom art was an inner calling, not a profession that could be learned. No one could ever commission him; he had no shop, and he only served the popes because he was forced to do so.

This is how the aged Michelangelo looked back at his youth. The order and the meaning of things and events had become clear to him— and he obviously liked the story. He had it recorded in his pupil's book in great detail, correcting almost all Vasari's statements and adding many new features.

This first part of Condivi's *Vita*, which deals with Michelangelo's rise to fame, is a dramatic prologue to the tragedy that follows. The book was conceived in this way. It concludes with a remarkable characterization of Michelangelo as a man and as an artist. This conclusion was probably written entirely by Condivi's literary helper, Annibale Caro.

These two texts, his own first *Vita* and Condivi's little book, lay before Vasari when he began to compile his monograph on Michelangelo, the chapter for the new edition of the *Lives*. But he also had a third source at his disposal: the file of his notes collected in the twenty years that had passed since 1547. They contained very rich material. For four years, from the beginning of 1550 to the end of 1553, Vasari was resident in Rome. He was a favourite of Julius III and was his adviser in artistic matters; and as the Pope wished that all his ideas and projects should first be submitted to Michelangelo's judgement, Vasari often saw the master in an official capacity. From this connection there developed a friendship, oddly enough at the very time when Condivi's *Vita* was being compiled in Michelangelo's house. Michelangelo was clearly attracted not only by the keen intelligence and high culture but also by the genuine devotion of his younger colleague, and liked to talk to him about things which interested both of them. One is reminded of the reception given to Emile Bernard by the aged Cézanne. To make the analogy closer, we are told by Vasari that he composed a book on these discourses in the fashionable form of dialogues; and he continued working on this book during his next, longer visit to Rome in 1560. Unfortunately, this manuscript is lost.

The friendship between the two continued after Vasari's return to Florence; as a testimony to it there remain fourteen letters addressed to him by Michelangelo. In his capacity as the chief adviser, painter, and architect of Duke Cosimo, Vasari inherited some of Michelangelo's

projects: the San Lorenzo façade, the New Sacristy, and the Library—although actual work was only done on the last-named. But Vasari felt the obligation to care for Michelangelo's Roman projects as well, and it seems that it was owing to his initiative that Michelangelo's designs for the Area Capitolina, for the Farnese Palace, for Saint Peter's, and for the Porta Pia were published in engravings after his death.

Thanks to this friendship, Vasari had the opportunity directly to address Michelangelo with questions concerning his future biography—and he did so, as he repeatedly states in his book. Moreover, he also asked many other persons, checking and comparing their statements; and as he was not in Rome at the time of Michelangelo's death, he wrote to those who were with Michelangelo in his last days, asking for information about his latest projects and about the contents of his studio. We see from his correspondence that Vasari tried to make his notes as complete as possible.

Now, how did Vasari handle these three kinds of material? The answer is simple. He merged the two printed texts into one—they do in fact cover the same period; and to the conflation he added a second part. This became even longer than the first, and is entirely based on Vasari's own notes.

It may seem surprising that Vasari appropriated Condivi's whole text, including its conclusion, at a time when its editor was still alive. But Vasari was in all probability well informed about the circumstances in which this little book was written and knew that its contents were absolutely trustworthy. And so he did what a conscientious historian has got to do: he used the best sources available to him. However, his vanity and a false concern for his own reputation did not allow him to state this fact plainly; on the contrary, he refers to Condivi's book only once, and this on an occasion when, as an exception, he was right. This point is Michelangelo's apprenticeship to Domenico Ghirlandaio. Vasari prints the text of the written agreement to which he referred in his first edition, with the following introductory remark:

He who wrote Michelagnolo's life after the year 1550 . . . has said that some persons, through not having associated with him, have related things that never happened, and have left out many that are worthy to be recorded, and has touched on this circumstance in particular, taxing Domenico with jealousy and saying that he never offered any assistance to Michelagnolo; which is clearly false, as may be seen from an entry by the hand of Lodovico, the father of Michelagnolo, written in one of Domenico's books, which book is now in the possession of his heirs. That entry runs . . .

And then Vasari goes on:

These entries I have copied from the book itself, in order to prove that all that was written at that time [in his first edition] as well as all that is about to be written, is the truth. Nor do I know that anyone has been more associated with him than I have been, or has been a more faithful friend and servant to him, as can be proved even to one who knows not the facts; neither do I believe that there is anyone who can show a greater number of letters written by his own hand, or any written with greater affection than he has expressed to me.

Vasari concludes: 'I have made this digression for the sake of truth, and it must suffice for all the rest of his career. Let us now return to our story.'

Clearly, this means saving face. But it also means misleading the reader. As we have seen, Vasari's familiarity with Michelangelo, and the letters received from him, date from the time after the publication of his first *Vita*. He mentions Condivi's name only once, in the paragraph on the monstrous altar-piece now in Casa Buonarroti; and on this occasion he says that Michelangelo unfortunately never met a young man sufficiently intelligent in whom to confide his ideas about anatomy, proportion, and movement; he says this, because Condivi promised to publish a treatise on these very subjects.

And so, Condivi's little book was both killed and preserved by Vasari's clever and cruel plagiarism. It took 200 years to discover that it existed at all.

To sum up: as a source of information Vasari's monograph of 1568 may be consulted without recourse to the two biographies which preceded it; it contains their information, amplified by valuable additions. But if you want to understand the process that led to this elaborate and most influential codification of the judgement of history on a great artist, the study of its sources is inevitable. Among these sources the Condivi *Vita* is the most trustworthy and most interesting; it is also, I think, a great pleasure to read.

1488–1506

In this survey I shall try to illustrate the sources which I discussed in the first chapter. As these sources do, we too have to confine ourselves almost exclusively to Michelangelo's principal works; and my comments must be very short: they have to follow an artistic career that covered seventy-six years.

As you remember, the first recorded event of this career was Michelangelo's entrance as an apprentice in Ghirlandaio's studio in April 1488. He was thirteen. A few months later we find him among the students in Lorenzo de' Medici's and Bertoldo di Giovanni's 'free school of sculpture', in the garden at the monastery of San Marco.[2]

The earliest works we possess from Michelangelo's hand seem to be his relief of the *Virgin of the Steps* (5, 6) and two or three drawings. We know that at the time of Michelangelo's death the relief was in the possession of his family, and we may infer from this that he had made a present of this work to his father. Its stylistic isolation in the last quarter of the Quattrocento was not the consequence of its particular technique, the *rilievo schiacciato* as the Italians call it (the term means: squeezed flat), nor of its soft surface modelling. Though this type of relief was a favourite with Donatello in his pre-Paduan period, it also occasionally occurs in the second half of the century, and it was constantly used in medals and plaquettes; and this wax-like softness of the modelling, which gives the marble the appearance of alabaster, is often found in the works of Desiderio da Settignano and his followers. The piece of marble chosen by Michelangelo is 56 cm by 41 cm—its greatest thickness is 2·5 cm; on this thin slab he managed to obtain a vivid plasticity, and a sharp recession of space by means of linear perspective—another Donatello-like device, one of which he would hardly have approved later. But typical of the later Quattrocento was the formal significance given to the main figure: it fills the whole height of the rectangle. Perspective does not apply to this figure: it is shown, as it were, in elevation, its forms spread out as far as possible, and its outlines emphasized by tight, thin folds (the detail, 6, shows how consciously this has been done in order to produce an effect of contrast between convex forms and indented lines). And entirely without parallel are the truly superhuman proportions of the figure—imagine it for a moment erect, how tall it would be! This expression of almost brooding

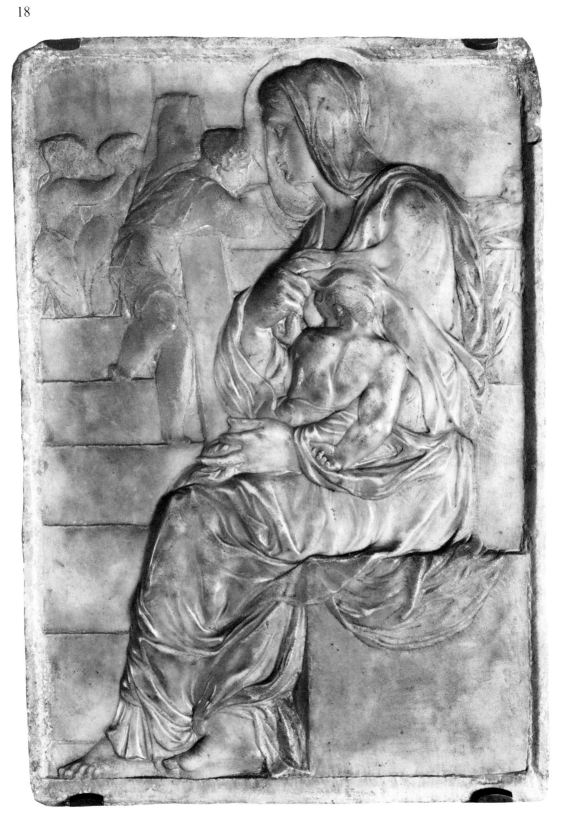

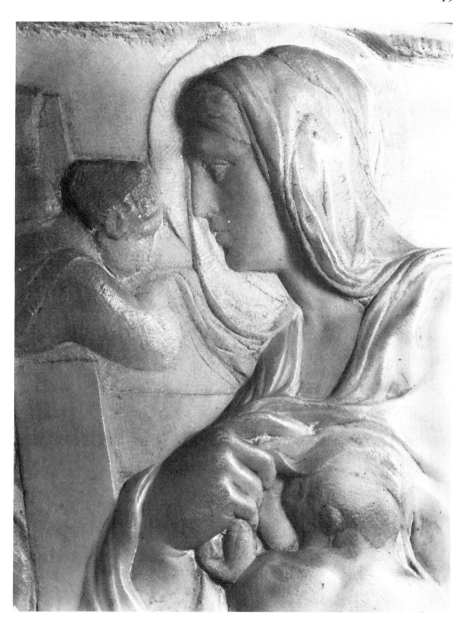

etail of fig. 5.

seriousness is enhanced by the contrast between the classical profile, doubtless borrowed from some Greek coin, and the playful Quattrocentesque background: two *putti* behind the Madonna with the traditional 'cloth of honour', but in a very untraditional way, and on the left another couple of *putti* embracing each other. What were the sources with which this taste was nourished?

We learn from Vasari and from Gelli,[3] a contemporary of Vasari, about the admiration the young Michelangelo had for the art of the Trecento and the early Quattrocento. His studies after Giotto's and

Masaccio's frescoes had been so famous in their time that they were remembered in Florence sixty years later. Figure 7 shows one of them. It is contemporary with, or even somewhat earlier than, the Madonna relief—it is, at any rate, the work of a young boy—and is no less remarkable than the relief.

The drawing is unusually large. Even in its present state, trimmed on all four sides, the sheet is 31 cm high; Quattrocento drawings are, as a rule, very much smaller. Here, as well as in the relief, the whole height is occupied by one figure (the other figure, a mere silhouette, is only a foil, or support, and is kept in very low relief). The drawing was made, of course, from a fresco painted by Giotto more than 160 years earlier, the *Ascension of St John the Evangelist* in the Peruzzi Chapel in Sta Croce. But the copyist was not interested in the composition as a whole, he selected a single monumental figure from its context (9).

9. Giotto, *Ascension of St John* (detail). Florence, S. Croce, Peruzzi Chapel.

10. Masaccio, *Tribute Money* (detail). Florence, Carmine, Brancacci Chapel.

Giotto's figure, a framing pier to an extensive scene, is statue-like, as though it were hewn out of a block of stone; and it is expressive, displaying a solemn gravity that suits the scene. Both these qualities also characterize the boy's copy; their effect is even increased—a sign that he well understood their significance. The figure has been made more plastic by the higher relief of its forms and the greater weight of its volume, by the correction of the position of the left foot (which has been made a firm support for the body) and by the raising of the horizontal division at the belt and the shortening of the left arm. In monumental sculpture you will often find figures like this, with the arms not only pressed in to the body, but also on a smaller scale than the body. Thus the drawing reminds us more of a sculpture by Giovanni Pisano than of a detail in a painting by Giotto. Of course, it is a somewhat modernized Giovanni Pisano; the body is perceptible under the garment, and where it is uncovered some details are given, such as joints and muscles; and their function is indicated as far as the young student was capable of rendering it. But it is the drapery that has undergone the greatest changes; it is more clearly articulated, the folds are deeper and, in the lower half, their fall is determined by the action of the right hand.

These late compositions of Giotto had been one of the main sources of inspiration for Masaccio. Above the scene from which Michelangelo made his study Giotto had painted another fresco, the *Raising of Drusiana*; the Saint John in this composition corresponds with the Saint Peter in Masaccio's *Tribute Money* in the Brancacci Chapel (10). There also exists a drawing which was made by the young Michelangelo after this figure of Masaccio's (8). But first, notice the difference between Masaccio and Giotto. We may observe in Masaccio's painting changes similar to those we have just seen in Michelangelo's study after Giotto: the greater weight of the figure, its firm poise, the natural fall and deep hollows in the drapery, and the telling energy of the gesture. In other words, the youthful Michelangelo's interpretation of Giotto is in a way similar to Masaccio's some sixty years before him, and from this fact we may conclude that the young artist's great experience at the opening of his career was his discovery of Masaccio's monumental art. His study after Masaccio's Saint Peter is on the same scale as his drawing after Giotto (the painting-out of the ground is by a later hand). Compared with the painting, this figure has an even more monumental appearance, its inner scale is bigger and the proportions have been fundamentally changed. It is also very plastic, the movement is more clearly expressed, and the system of folds has become more logical.

These earliest products that came from Michelangelo's hand clearly reveal his taste and inclinations. I have called his interest in Masaccio, and via Masaccio in Giotto, a discovery—and a discovery it was in the subjective sense of the word. But Michelangelo was not the only artist

 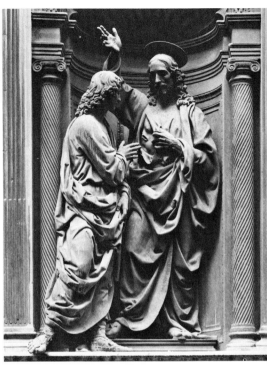

to make it. There was a certain trend towards simplicity, gravity, and monumentality in Florentine art in the last two decades of the fifteenth century, a movement that was opposed to the fashionable, sophisticated style represented by the majority of contemporary artists. This tendency led to a new appreciation of, and to new studies in, the art of the first generation of the Quattrocento. And so you find in the paintings of Ghirlandaio or Leonardo figures or groups which were inspired by Masaccio's and Donatello's examples: for instance, in Leonardo's unfinished *Adoration of the Kings* the so-called philosopher on the extreme left. Ghirlandaio, primarily a narrative painter who inherited those devices in a direct tradition, gave them a new emphasis in some of his works.

Another artist whose work exemplifies this trend is Signorelli. A comparison between his *Doubting Thomas* and that of Verrocchio is much to the point in our context (11, 12). Verrocchio's bronze group, finished in 1483, is surely an outstanding monument of the second half of the Quattrocento; it shows what had become of the forms of the first generation in the hands of later artists. Now Signorelli's fresco at Loreto, the date of which is uncertain though no doubt later than that of Verrocchio's group, is obviously only a free replica of this invention; but it conspicuously displays qualities very similar to those which we have found, in a modest form, in Michelangelo's earliest drawings, qualities which here too were inspired at least to some extent by

11. Signorelli, *Doubting Thomas*. Loreto, Santa Ca:

12. Verrocchio, *Doubting Thomas*, Florence, Or San Michele.

opy after Masaccio.
a, Albertina.

Masaccio's monumental art. What is new in Signorelli's figures—the
suggestiveness of gestures and movements, the uninterrupted flow and
the energy of the outlines, the deep hollows—all this can be discovered
also in our drawings. Another of Michelangelo's early studies (13) was
made, in all probability, from a grisaille fresco by Masaccio once in the
cloister of the Carmine. There is, surely, a great similarity of purpose
between the young Michelangelo and Signorelli.

Historically speaking the difference between the two artists is one of generation. All three of the older painters I have mentioned, Leonardo, Ghirlandaio, and Signorelli, were born in the middle of the century. In their work this renewal of the monumental style of the early Quattrocento was the result of their own early development, a development which led them to oppose the analytic attitude of their immediate predecessors. For Michelangelo, who was born a generation later, this opposition was the starting-point.

The *Battle of the Centaurs* is the work which concluded the period of his free apprenticeship; it should be compared with one of the very few authentic works of his second master, Bertoldo (14, 15). According to Michelangelo's biographers this apprentice period lasted four years, from his entry into Ghirlandaio's studio to the death of his first patron, Lorenzo de' Medici, in April 1492. He was then seventeen. Bertoldo had died a few months earlier.

The marble relief of the *Battle of the Centaurs* is approximately 90 cm wide. A letter of 1527, in which it is described for the first time, states that it was commissioned by a great lord—that is, obviously, Lorenzo de' Medici—and that it was left unfinished. This conforms to what is said about it by Condivi. Condivi, who never saw the work, gives us Michelangelo's own judgement on it: that whenever he saw this relief he realized how wrong he had been in not following the sculptor's profession single-mindedly, and how much he had been harmed by those who had forced other work upon him (Julius II, Clement VII, Paul III), for this relief proved how well he could have succeeded.

Indeed, the *Battle of the Centaurs* is extraordinary in almost every respect. Perhaps the least so with regard to its subject. Antique themes were welcomed by the artists who belonged to the Medicean circle (though none of them tried them in a marble relief); and we are told that this particular subject was suggested, and its literary sources were explained, to the young artist by the tutor of Lorenzo's sons, the humanist Poliziano. But in representing this subject, Michelangelo found a new form of composition and a new style of relief. There is no neutral ground, no empty space here, there are only figures, which all penetrate deep into the stone with the same violence. The plastic substance is merely a result of active forces, and space of figures in movement. The marble block is the outward limit to this general movement, which is governed by a hidden symmetry. One discovers three principal figures, a centaur and two Lapiths or human beings (one of them possibly Hercules), and each of them embodies a vertical axis: the central axis and those of the two halves. In the corners there are half-length figures, each of them turned towards the centre. The continuity of movement and this concealed symmetry together constitute the compositional unity. A similar scheme, though a simpler and more static one, underlies the main group in Masaccio's *Tribute Money*, and

Bertoldo, *Bellerophon.*
...a, Kunsthistorisches
...um.

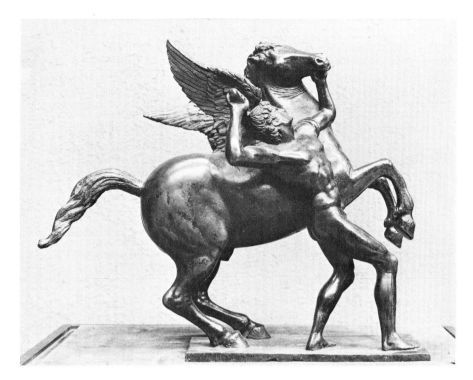

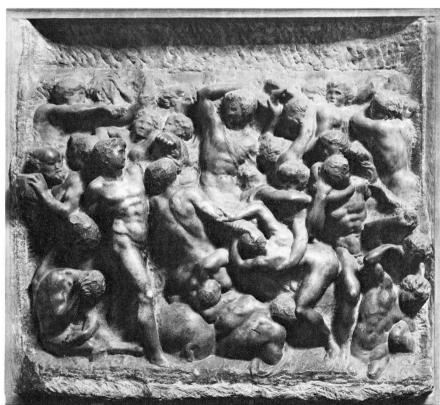

*...he Battle of the
...urs.* Florence, Casa
...arroti.

it is not unlikely that Michelangelo was inspired by this famous example. (Piero di Cosimo's picture of *The Battle of Lapiths and Centaurs* in the National Gallery, sometimes mentioned as one of his sources, is in fact considerably later and is dependent on the relief of the younger artist.) The composition Michelangelo built up on Masaccio's classical scheme is incomparably richer, and it shows a new, a dynamic conception of representing an event (Piero di Cosimo was to go further in both respects). This conception was, no doubt, inspired by antique art, which was also a norm for Michelangelo's second master, Bertoldo. Although stated very long ago, it is little known that his famous *Bellerophon*, rightly called the finest bronze statuette of the Renaissance, is only a spirited transformation of a fifth-century Greek relief into a free-standing group. But in dealing with the antique subject, Michelangelo, unlike Bertoldo, did not choose antique models for his figures; these are, as far as we can see, all of his own invention, showing the astonishing capacity and range of his imagination. Only the protagonist on the left, the supposed Hercules, appears to be a free replica, or variation, of the *Bellerophon* and is therefore, indirectly, derived from classic art. Bertoldo's influence can, I think, also be traced in the modelling, in the unity of the figures' movements, and in the clear articulation of their limbs. In all this, one is also reminded of Antonio del Pollaiuolo, probably the main inspiration for Bertoldo.

One may safely state that this early masterpiece contained a programme for a whole lifetime. We shall meet it in Michelangelo's work again and again, of course in revised forms, until his last years. We meet it first in his next extensive composition, the cartoon of the *Bathers*, the work which concluded the period of his early maturity, in 1505. This time the group is only part of a much larger unit which was not executed, and this group itself is known to us only from a late copy (31). But this copy is reliable enough to allow us to measure the progress made by Michelangelo in the course of twelve or thirteen years.

These were the years of his struggle for a position adequate to his talents and to his self-esteem. Later he used to speak with much bitterness about the hardships, the privations, and the hard work of these years. And yet this period saw him rising from the position of a young *garzone* without any support, to that other stage at which he was publicly called, by the head of the government of Florence, the greatest artist in Italy and perhaps in the world, and was summoned to Rome for a task of unprecedented magnitude. After Lorenzo the Magnificent's death he had to rely on his own resources, since he did not belong to any workshop and he was too young to establish one of his own. But again and again he met friends and patrons who recognized his genius and were ready to help him.

I shall try to outline the main stages of this part of his career. First,

the time of learning was not yet over. Michelangelo made his first studies in the anatomy of the human body, as Pollaiuolo and Leonardo had done before him, a practice which was to become his lifelong passion. He continued to use the garden at San Marco as his studio, but none of his works of the next years has survived. Then, there followed the great change in Florence, the overthrow of Medici rule and the proclamation of the people's republic. As a former protégé of the Medici, Michelangelo was afraid of possible adverse consequences for him and shortly before the event, in October 1494, he fled to Bologna where he found temporary work on the Tomb of Saint Dominic.

The figures on this tomb, each about 60 cm high, show that the young master preserved his liking for the early Tuscan Quattrocento. At the same time I think that he drew some inspiration from a very different movement in contemporary art.

His *Saint Proculus* (16) is strikingly reminiscent of the figure of the publican which appears twice in Masaccio's *Tribute Money*, and is rendered in combination with the framing and supporting mantle of Donatello's *Saint George*. And it has been generally assumed that the peculiar style of his *Saint Petronius* (17) was derived from Jacopo della Quercia's sculptures at Bologna. Indeed, there is a certain affinity between their two statues representing the patron saint of Bologna. But I believe that another source for the style of the later figure can be found in the contemporary painting of Bologna and of nearby Ferrara. In the panel by Cosimo Tura, representing the Blessed Jacopo della Marca (or Saint Anthony), executed in 1484 (18), you find a classical *contrapposto* which is not present in Quercia's late-Gothic figure; and you also notice a strong, abstract movement in the drapery, similar to Quercia's but expressed in a rather different language. The folds seem not to fall but almost to creep upwards, covering the forms with a strange arabesque and fastening them together like iron clamps. You find the same in Michelangelo's *Saint Petronius*—with this difference that here Tura's sharp and sometimes edgy forms have been softened, probably under the influence of Quercia's sculptures. At the same time great stress has been laid on details and technical perfection. Like ancient Roman sculptors, Michelangelo now gives preference to the drill among his tools to achieve the appropriate depth of the forms.

This new approach to a more modern style and the multitude and faultlessness of details, both absent before Bologna, are also the distinctive marks of Michelangelo's next works. After a short stay in Florence, he spent the period from the summer of 1496 to the spring of 1501 in Rome. In this time he executed three statues, two of which, the *Bacchus* and the *Pietà*, have survived. They illustrate the two main interests of his early period.

The *Bacchus*, like the lost *Hercules*, the *Sleeping Cupid*, and the *Young Apollo*, is an emulation of antique art. This is his earliest

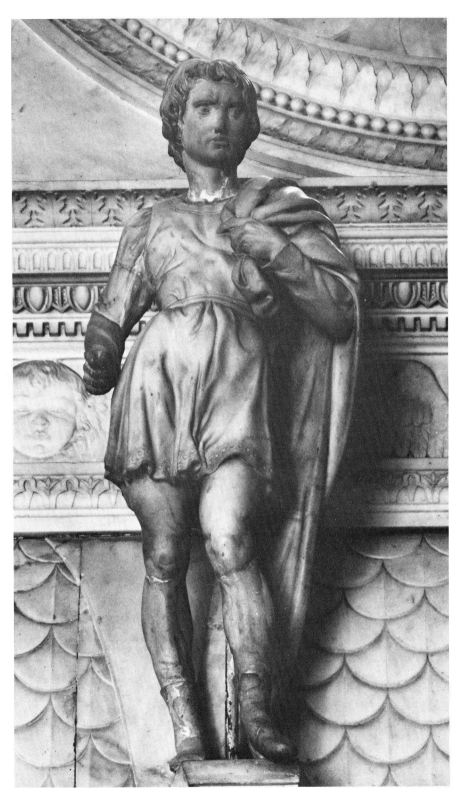

16. *Saint Proculus*. Bolog
S. Domenico, Tomb of Sa
Dominic.

17. *Saint Petronius.* Bologna, S. Domenico, Tomb of Saint Dominic.

18. Cosimo Tura, *Blessed Jacopo della Marca.* Modena, Galleria Estense.

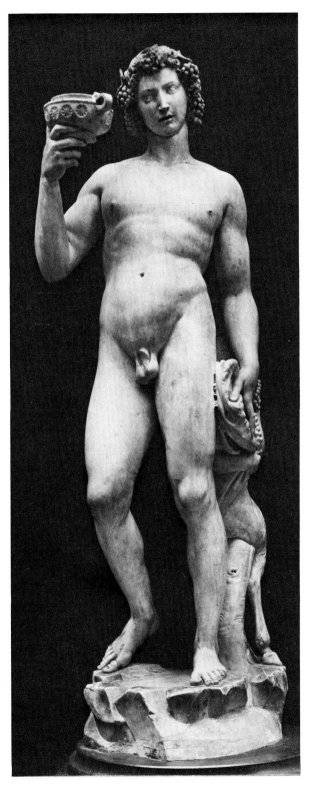
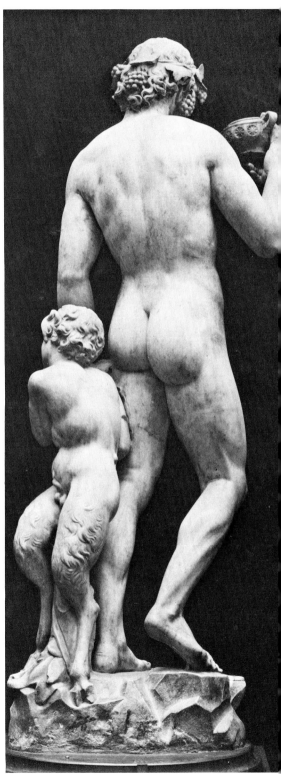

eft). *Bacchus.* Florence, *ello.*

large figure in the round known to us (19).[4] If I am right in interpreting the sources, the task given by Cardinal Riario to Michelangelo on his arrival in Rome was to make a life-size statue to be placed among the antiques in the courtyard of the Cardinal's newly-built palace, the Cancelleria. Michelangelo therefore conceived the figure as filling the block diagonally—Figure 19 nearly corresponds to the front of the block—and he arranged the forms in such a way that they do not allow the viewer's eye to rest on any one predominant view: indeed, he feels compelled to circulate around the statue (20), as became the norm in Italian sculpture half a century later. This was not the classical approach. But some precedents for it can be found in Quattrocento sculpture—for instance, Donatello's marble *David* of 1408/9 which was also conceived as a free-standing statue. The type and the soft modelling of the *Bacchus* show the influence of that renaissance of classical art which took place, under the Emperor Hadrian, in the first half of the second century A.D. But there is also a fair amount of modern naturalism displayed, and the content—the lack of will-power, the sensuality and, as a consequence of both, drunkenness—contrasts with everything for which classical art stood. In brief, Michelangelo's *Bacchus* is not the image of a god.

The later and more important of the two Roman works is the life-size marble group of the *Pietà* in Saint Peter's (21, 22). Its iconography is derived from a late-medieval Northern type, which had been adopted in Italy, particularly at Ferrara and Bologna, in the second half of the fifteenth century.

The group was commissioned in the autumn of 1497; its carving began more than a year later and it took nearly two and a half years—about as much time as the execution of Michelangelo's next work, the colossal marble *David.* This is not surprising: the *Pietà* has been brought to a matchless finish, and this minute chasing and polish are the most wearisome phase in the sculptor's work. The progress achieved in this respect since Bologna is astonishing. As for the style, you still find an exuberance of details and movement of forms, but their system is less extravagant. Just as he had earlier studied the nude from the life, so now the drapery has been studied from the model, probably in drawings of the type of the well-known studies by Leonardo. Some of Masaccio's large framing folds have reappeared. Their uninterrupted flow helps in rounding off the group on the left and in giving it that firmness of structure at which the now predominantly classical tendency aimed. Of all Italian art this group may be considered the nearest parallel to what Leonardo achieved at Milan at the same time. You may take as an example the second *Virgin of the Rocks*, the *Last Supper*, or the National Gallery's cartoon, and you will be surprised to find the same mood and sentiments, and the same formal means of expressing them. The difference of a generation separating the two

ght). *Bacchus.* Florence, *ello.*

artists has been bridged: Michelangelo has arrived at the forefront of modern art and has gained the first great public success of his career.

After completing the *Pietà* at the age of twenty-six, Michelangelo returned to Florence in the spring of 1501. He was now an acknow-

21. *Pietà*. Rome, Saint Peter's.

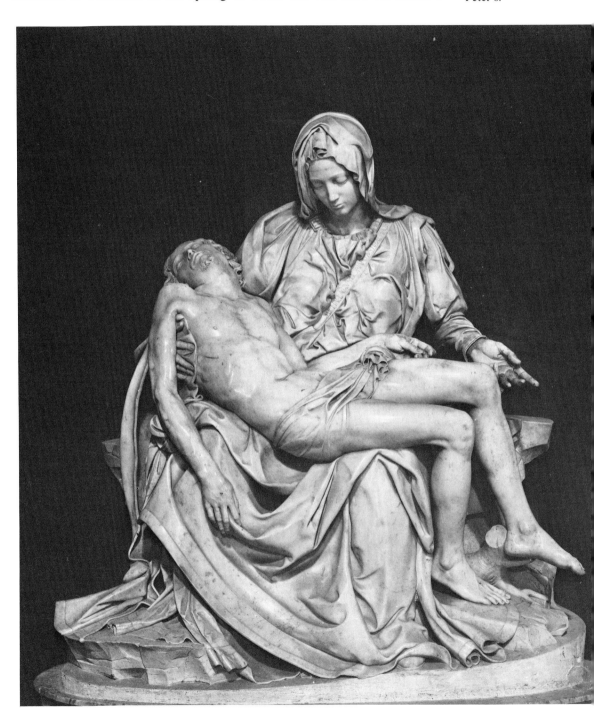

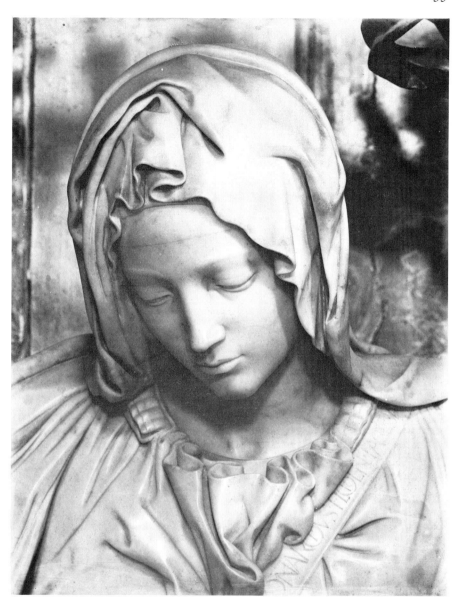

Detail of fig. 21.

ledged master and was overwhelmed with commissions both public and private. In this respect the two periods, the years spent in Rome and those in Florence, are in striking contrast with each other. The history of this second Florentine period—it ends with his summons to Rome when he was thirty—has been variously recounted by modern writers. Taking into account the combined evidence of all the available sources, we find that this period can be conveniently subdivided, corresponding to the two greatest tasks: the first three years during which Michelangelo mainly worked on the *David*; and the last in which he prepared his equally colossal battlepiece.

36

Contemporary with the *David* are the four statues decorating the Piccolomini Chapel at Siena (23, 24). Until quite recently these statues had a very bad press. Many critics disposed of them as works handed over to assistants; some critics entirely rejected them. With a wilful interpretation of sources, it was even suggested that they were by Baccio da Montelupo. However, these statues, which are twice the size of those in Bologna, are fully documented as Michelangelo's works and some of them are very fine, though part of their surface details such as the tiara of *Saint Gregory*, or the hair of *Saint Peter*, may have been completed with the help of an assistant. In a modest way the Sienese figures revive the tradition of a particular type, the 'figure in a niche', which was so important in the first half of the Quattrocento; it was to become important again later.

Another work, the cast of a bronze *David*, one and a half metres high, modelled in all probability in the summer of 1503, is lost. In this case we know that, for external reasons, Michelangelo had to leave the last phase of the work, the chasing of the bronze, to a colleague. The drawing in the Louvre (25), which is certainly connected with this work, leads the mind back to the *Battle of the Centaurs* and to Bertoldo's statuettes.

23. *Saint Gregory* (*right*) Siena, Cathedral, Piccolo Chapel.

24. *Saint Peter* (*left*). Sie Cathedral, Piccolomini Chapel.

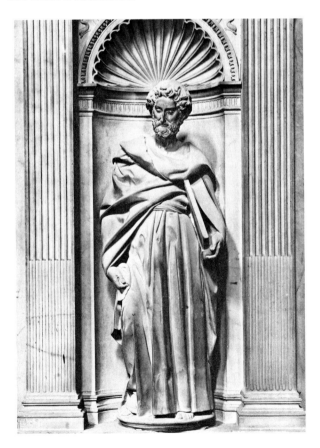

Contemporary with Michelangelo's preparations for the battle-fresco were the unfinished Taddei *tondo* in Burlington House, and the *Virgin and Child* at Bruges. The marble *tondo* (26) shows how suggestive Leonardo's living example could be even for a character as strong as that of his much younger competitor. The relief was carefully prepared in studies which are among Michelangelo's loveliest creations: they are part of the *ambiente* in which the youthful Raphael felt so happy. The opinion that this work, too, was left to a *garzone* is not borne out by a close examination of the original.

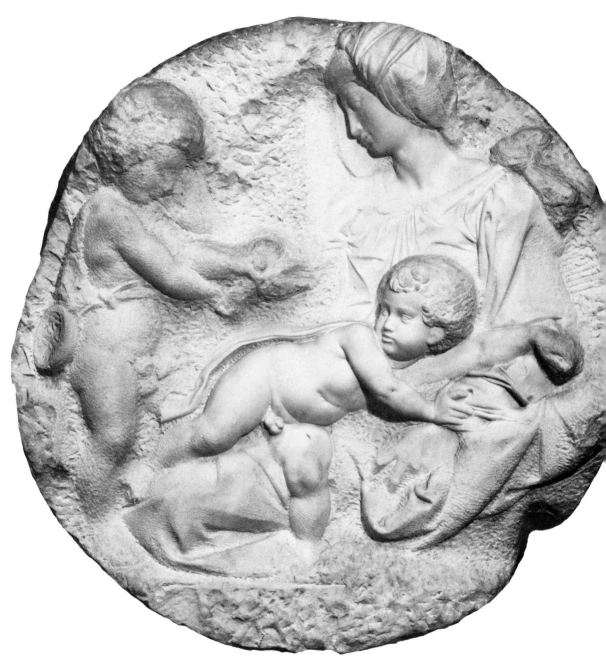

The group in Notre-Dame at Bruges has usually been regarded as a work preceding, not following, the marble *David*. This, I believe, is incorrect. There is documentary evidence that the group was ready for transport by the summer of 1506, and studies for it occur on the same sheets as Michelangelo's earliest studies for his Battle Cartoon. This combined evidence makes it certain that he worked on it before his summons to Rome in the spring of 1505, in other words that it is

26. The *Taddei tondo*. Lo
Royal Academy.

contemporary with the Burlington House *tondo*. This is, I think, intelligible if one gets rid of the false impression given by most current reproductions, which show a view in which the Madonna's face is seen strictly from the front. But this is far from coinciding with the front of the rectangular block from which it was carved and therefore with the principal view intended by the artist (27). From here one sees that the form of the block, which is deeper than it is wide, has been retained as far as possible. Here for the first time in his work we meet this principle, which became so important for Michelangelo later.

These are the minor works which, as I have said, accompanied the two principal ones, the *David* and the Battle Cartoon. It is an impressive list, although it does not include some which, in all probability, were also conceived, and to some extent perhaps prepared, in the same period, such as the *Apostles* for Florence Cathedral, the marble *tondo* in the Bargello, and others. These four years were one of the most prolific periods in Michelangelo's life.

Let us, in conclusion, look at the two principal works, the *David* and the Cartoon. We have found that the main objective of Michelangelo's art was the plastic or three-dimensional human figure in movement. Now, in this classical period of his development which begins with the Roman *Pietà*, his figures and groups become comparatively calm. The *David* (29) seems to have been conceived as a paradigm of classical *contrapposto*. The body rests on the right leg which is accompanied, and accentuated, by the heavy vertical of the hanging arm; on this side the contour is closed. On its other side the figure is, as it were, open. And yet, if you compare this figure with any ancient statue of the same type, you will find that this contrast of the two sides has here been exaggerated in a way that occurs only in Gothic art, in Italy especially in the early Trecento. We can compare it with a detail of Duccio's *Three Maries at the Tomb*, on the back of his *Maestà* (30). (For the benefit of those who like to follow an artist's itinerary in detail and to draw conclusions from it, it may be pointed out that in the summer of 1501, just before he began work on the marble *David*, Michelangelo had to go to Siena to inspect the Piccolomini Chapel in the cathedral, a few steps away from Duccio's *Maestà*.) In both, the calmness and harmony inherent in the classical motive have been replaced by a kind of movement which gives a certain expressiveness to the figures; this is, of course, more conspicuous in the nude. As I suggested many years ago, it seems possible that Michelangelo aimed at a concrete meaning. David was a fighter of the Lord. In one of his Psalms he calls his right side Immovable because it is guarded by God—so that his left side might safely be exposed to any hostile force.[5] This idea, this moral discrimination of the two sides of the body was common throughout the Middle Ages; it also occurs in Dante. We shall find that the same expressive contrast underlies Michelangelo's *Moses*.

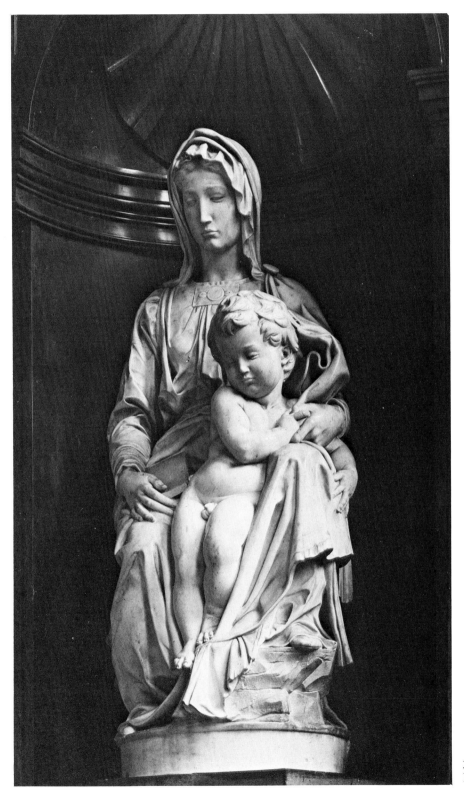

27. *Virgin and Child.* Br
Notre-Dame.

Classical tendencies are not favourable to a complete 'roundness': they demand one view only. Michelangelo's *Pietà* is a high-relief rather than a free-standing group; his figures in the Piccolomini Chapel and his *David* have no side-views at all. Even the statue at Bruges, deep though it is, appears relief-like if viewed from the correct point. Consequently this classical period of Michelangelo is also the last in which we find him actually working on reliefs.

The other principal work of this period, the four years between the spring of 1501 and that of 1505, was the cartoon of the *Bathers* (31).

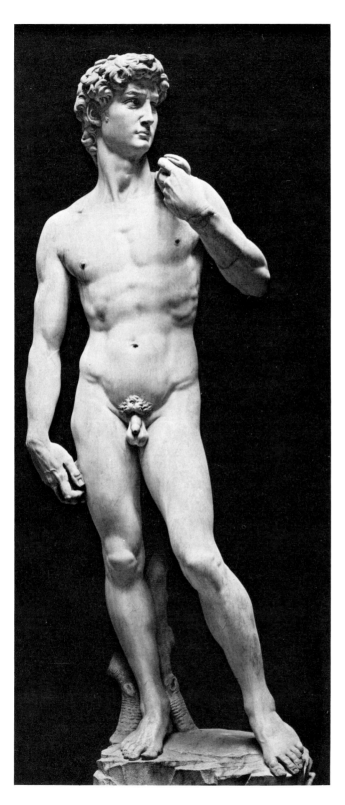

29. *David.* Florence, Accademia.

30. Duccio, *The Three Maries at the Tomb* (detail). Siena, Opera del Duomo.

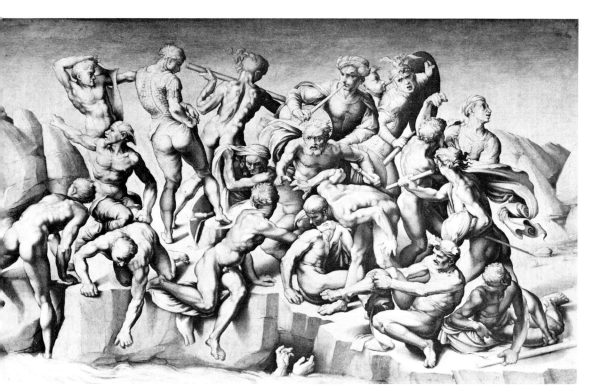

Aristotile da Sangallo, Michelangelo, *The ...rs* (or *The Battle of ...na*). Holkham Hall.

No classicist tendencies are manifest in this composition although, paradoxically, here for the first time Michelangelo directly followed certain antique prototypes in some of his figures: one is modelled on the *Dioscuri* of Monte Cavallo, another has been borrowed from an antique gem. But both these prototypes belong to the late period of antique art, and the figures derived from them in no way differ from all the others invented by Michelangelo himself.

In the cartoon Michelangelo returned to his original, dynamic conception of representing an event, first realized in the *Battle of the Centaurs* (15). But this group is not a relief. It consists of figures completely in the round and in most vigorous movements. It may be that in the small-scale copy now at Holkham Hall, painted in oil by Aristotile da Sangallo in 1542 (that is in the year following the unveiling of the *Last Judgement*), they appear even more distinctly isolated one from another than they were in Michelangelo's full-size drawing. The 'forest of statues', as the *Bathers* has been called, very likely did not look quite so rigid, so still—it showed more of that continuous flow of movement which is so striking in the early relief. And the figures, to judge from Michelangelo's original studies of which quite a number have survived, were less bulky and ponderous, and were not modelled with such heavy shadows. So, the study in the British Museum (32) should be a welcome corrective to the style of Aristotile's copy. This continuous, screw-like twist of the body is a completely new motive in

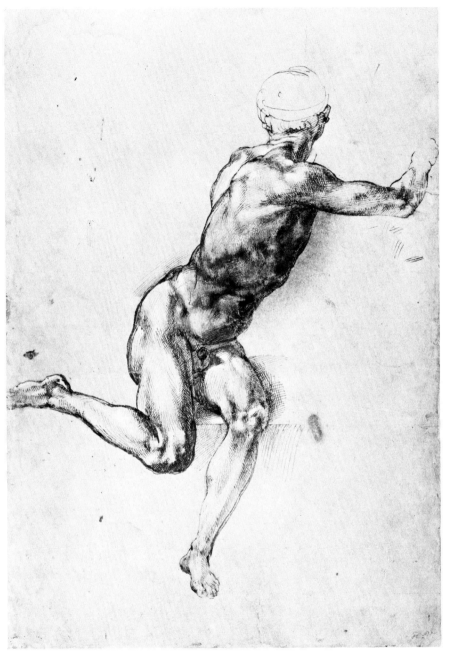

32. Study for *The Bather.*
London, British Museum

post-antique art. The drawing reveals a profound knowledge of the structure and functioning of the human body. And, as it is a study for a painting, it also proves that at this stage of his development there was no substantial difference for the artist between the aims of the two arts, sculpture and painting. This conception, promoted by Michelangelo's authority and his exemplary works, was to have far-reaching consequences for Cinquecento painting.

The *Battle of Cascina* was to be a fresco on a colossal scale. It was, in all probability, commissioned from Michelangelo by the Signoria immediately after he had completed the marble *David* in March 1504. A few months earlier Leonardo had started his preparations for a companion painting, the *Battle of Anghiari*. Inevitably, this was to become a trial, a competition, and the Florentines realized that two powers of extraordinary vigour were matched against each other.

A number of problems are connected with this highly significant project. I believe that some of these problems could be solved definitively by using the available historical evidence more thoroughly and more systematically than has been done so far. The most important and most difficult question concerns the form of the two *modelli* which served the artists in working out those parts of the full-scale cartoons of which we possess copies (the *Bathers* and the *Battle for the Standard*). No really satisfactory solution of this problem has been offered so far. But in the case of the *Battle of Cascina*, the reconstructive work of the imagination may be helped by a glance at the second monumental narrative designed, and this time also executed, by Michelangelo (49).

For ten years, until 1516 when it was destroyed, the cartoon of the *Bathers* was the 'academy' of Florentine artists. Remembering this, Benvenuto Cellini suggested that Michelangelo never surpassed this work, not in the Ceiling nor even in the *Last Judgement*. But, after all, it was only an immensely large drawing. What would it have looked like executed in colour?

The *Deluge* on the Ceiling and the *Doni tondo* in the Uffizi (33), the only finished panel painting we possess from Michelangelo's hand, can answer this question. The *tondo* is closer in date to the Cascina cartoon than to the *Deluge*: for reasons of style it cannot be earlier, and, for external reasons, it can hardly be much later. In all probability it was painted in the summer of 1506. It shows an almost artificially involved group of three figures, closely knit together in a solid unit, iconographically closer to representations of the Virgin and Child with Saint Anne than to Holy Families. It is like a free-standing sculptural group, a group at least as deep as it is wide. Just as Michelangelo worked in marble, beginning at the front surface of the block and going deeper and deeper in consecutive strata, you find some of the highest points kept and the shape of the block preserved. The concave architectural form in the background inversely corresponds to the roundness of the group. Apart from this, the recession is also helped by the colour.

Generally speaking, colours in Florence in the Quattrocento were a means of clarifying the drawing and enhancing the plastic effect. They are, in principle, the same for Michelangelo: and in this picture the colours are partly those of his first master Ghirlandaio. But they are brighter, in almost every part transparent, and are of a shining brilliance in their combination. They seem to have no substance, no texture

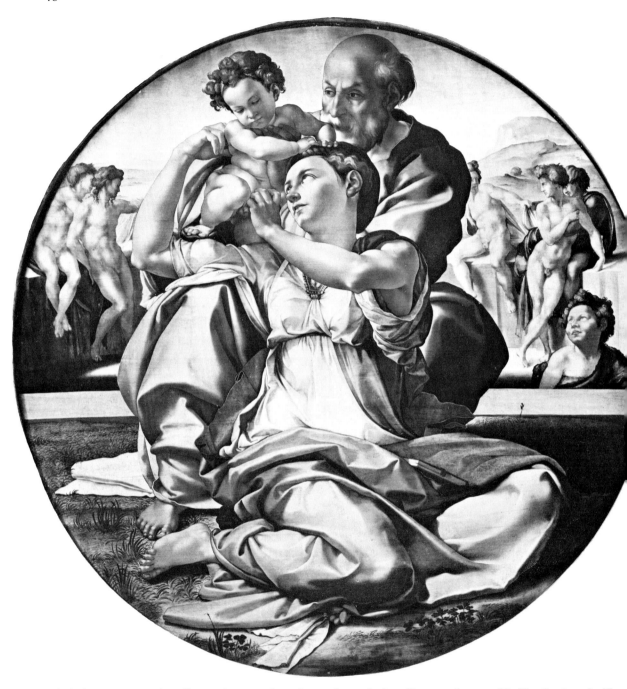

of their own, you hardly notice any brush-strokes; their effect, at least in the main group, could be compared with that of coloured rays reflected from polished marble. Colour almost disappears from the points of highest relief and the forms are nearly white (at any rate they were nearly white before the present varnish changed them into yellow), thereby emphasizing the hardness of their substance.

33. The *Doni tondo*. Florence, Uffizi.

Saint Matthew. Florence,
ademia.

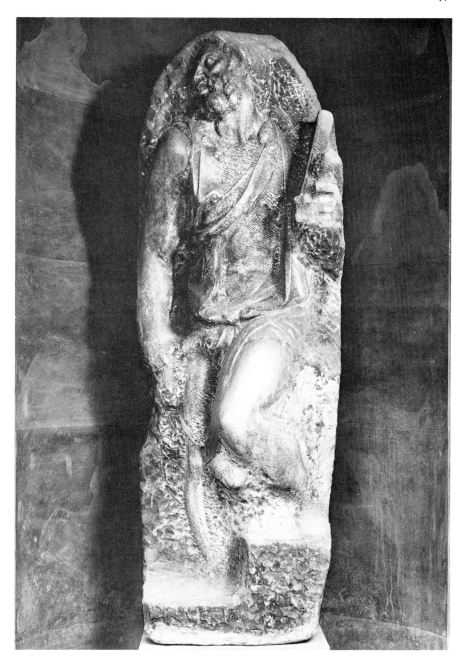

Another work close to the cartoon, one which demonstrably dates from the summer of 1506, is the unfinished *Saint Matthew* (34). The stylistic affinity between it and the painted *tondo* is striking. Both go beyond the stage arrived at in the *Bathers* by reviving that early vision of superhuman proportions which was revealed in the *Virgin of the Steps* (5), an ideal here based on a full mastery of form. Both works clearly indicate the way which led to the frescoes in the Sistine Chapel.

The Sistine Ceiling

The two great commissions, the twelve Apostles for the Cathedral and the Battle fresco for the Council Hall, were tokens of the gratitude the Florentines felt for the *David* presented to them by their young compatriot, and were intended to keep him in Florence. But it was surely the fame of the *David* that induced Pope Julius II to summon Michelangelo to Rome in the spring of 1505. There he was given the task which, in his own belief, was the most appropriate of his whole career—the task which, however, was to become the tragedy of his life and the 'thorn in the flesh' of his maturity and old age. Condivi built up his picture of Michelangelo's career upon this fact, and all the facts known to us from contemporary documents confirm his narrative. They also show that the history of the tomb of Julius II is closely connected with that of all Michelangelo's great enterprises in painting. His first great pictorial undertaking, the *Battle of Cascina*, was sacrificed to the tomb; each later one was forced upon him, either as a substitute for the tomb—this was the case with the Sistine Ceiling—or in order to make his working on it impossible, as with the *Last Judgement* and the frescoes in the Pauline Chapel.

The exciting first chapter of this story is supplied by Condivi. We also possess some letters dating from the time when Julius II changed his mind and gave up the idea of erecting his own mausoleum and when, in consequence of this, Michelangelo fled from Rome. One of them is our earliest document concerning the history of the Ceiling. It is a letter addressed to Michelangelo in Florence, dated 10 May 1506, three weeks after his flight.[6] The writer is Piero Rosselli, a Florentine builder and carpenter who lived in Rome—the man who two years later erected the scaffolding in the chapel and did the mason's work on the Ceiling. Rosselli gives an account of a conversation between the pope and Bramante which took place in his presence the previous night; it was about Michelangelo's flight. The pope wanted to send Giuliano da Sangallo to Florence to bring him back. We learn from Bramante's remarks that Michelangelo had already been offered the Ceiling to paint, with a prescribed programme, as a substitute for working on the tomb. Bramante declared that Michelangelo would never do it, for several reasons, first of all because 'he hasn't got the courage. So far he has had very little practice in painting; and those figures are to be

painted at a great height and are to be represented foreshortened, and that is rather different from painting here below' (that is, on a wall— clearly a reference to the abandoned battle-piece). Then Rosselli rebuked Bramante and on his own initiative gave an assurance that Michelangelo would return.

The end of the story which began with Michelangelo's flight is just as well known; it took him two years to overcome his indignation and disappointment and to be ready to exchange his dream of the tomb for the reality of a work in painting. In the spring of 1508 he was summoned again to Rome, and on 10 May, exactly two years after Rosselli's letter, he recorded on a sheet of paper—and this is our second document concerning the history of the Ceiling—that he was beginning work 'on conditions set forth in a written agreement'.[7] Unfortunately, the contract itself is lost.

What was the task given by the pope to Michelangelo first in the spring of 1506, and again two years later? The chapel, built by the pope's uncle, Sixtus IV, in the late 1470s, is well known; its first decor-

The Sistine Chapel 00 (Reconstruction rnst Steinmann).

36. Pier Matteo d'Amelia design for vault of Sistine Chapel. Florence, Uffizi.

ation was completed in 1483. The decoration of the whole chapel con-formed to a venerable iconographical tradition which left the vault decorated with no more than a starry sky. The reconstruction (35) of the original state of the interior, from Steinmann's standard work on the chapel, may be corrected by reference to the original design for the vault, by Pier Matteo d'Amelia (36). This important document shows that the vaulted part of the ceiling was separated from the walls by large acanthus leaves (doubtless made of stucco) which continued and completed the pilaster strips above the highest cornice. Over the entrance wall and over the altar wall it was planned to separate the pendentive from the central area of the ceiling by a painted cornice, and to decorate it with a large coat-of-arms in a medallion. Julius II, who soon after his election had his uncle's favourite building repaired, wanted to improve and complete its decoration by replacing this painted firmament with images of the twelve Apostles on the penden-tives and with ornamental panels on the nearly flat part of the vault, both in accordance with the fashion of the day.

Michelangelo, in a later letter, told the story of the beginning of his work. 'After I had made some designs it became clear to me that the whole decoration would turn out rather meanly. Then the pope gave me a new commission: to paint down to the histories and to do with the vault what I liked best.'[8] The phrase 'down to the histories' means that the new scheme was also to include the lunettes above the window arches and the vaulted triangles which connect these lunettes with the vault: in other words, all the spaces both vertical and curved above the highest cornice of the chapel.

Two of the drawings which are mentioned in Michelangelo's letter as made by him for the first project having been preserved (37, 38). In

both, the artist considers the pendentives as an upward continuation of the chapel walls, as was the case at the two ends in the original decoration. They are surmounted by a fourth, painted cornice. And he regards the central area of the low barrel-vault as a straight horizontal surface, and has filled it with panels of different shapes along its whole length. In order to connect these horizontal and vertical parts of the system, in the first drawing (37) he has cut the cornice by the throne niches, in the same way as the real cornice below is cut by the arched windows, and he has given them canopies which reach far into the field of the horizontal part. In the second drawing (38), the corresponding niches of the two long sides are in their whole width connected with each other across the vault by a sequence of forms: oval, rectangular, oval. In the spaces between these connecting belts of panels, the previous smaller panels reappear unified in large octagons, which seem to demand more than a mere ornamental filling; very probably they were designed to frame histories (they would have been about six metres across had they been painted). This is a novelty in ceiling decoration, for there is no ceiling earlier than this decorated with large histories.

At this stage a sudden change occurred: Michelangelo gave up the original plan and asked the pope to allow him a free hand. To appreciate his final solution one must compare it with the systems previously used in ceiling decoration. There were two such systems. First, there was an illusionist one which gave the decoration the appearance of being a real continuation of the room and its walls. This system was first adopted by Melozzo da Forlì in Santi Apostoli (in the semi-dome of the apse), and in San Biagio at Forlì; it was fully developed

*ft). Study for the
ne Ceiling (detail).
lon, British Museum.

*ght). Study for the
ne Ceiling (detail).
oit, Institute of Arts.

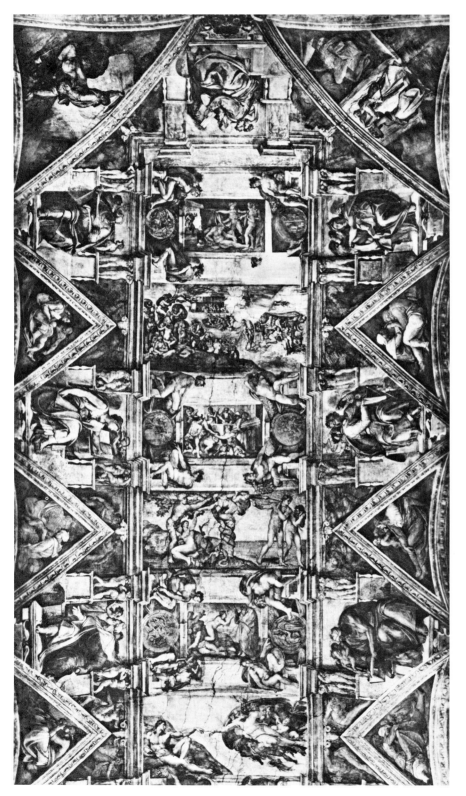

39. Sistine Ceiling (first
Vatican, Sistine Chapel.

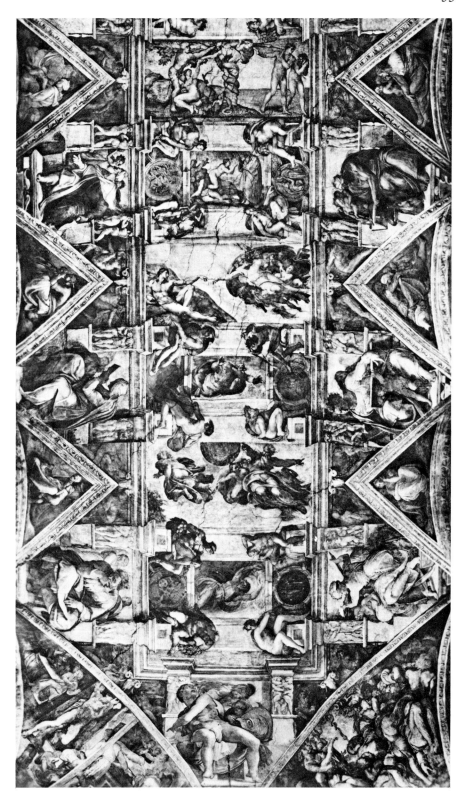

Sistine Ceiling (second
Vatican, Sistine
pel.

54

later by Correggio and Baroque painters. Then there was a second system, decorative in the literal sense of the word. It accepted, and even emphasized, the existence of the ceiling, or vault, by giving it a planimetric division or articulation. This was universally used in the late Quattrocento, more particularly by Umbrian artists—one thinks of Pinturicchio's ceilings in the Borgia Apartment.

Michelangelo, while he adopted elements of both systems, arrived at an entirely new solution. As in the drawings, he regards the decoration of the pendentives as an upward continuation of the side-walls—yet, he does it, if I may say so, only in a metaphorical sense, without producing the effect of illusion. For, as we can see in Figure 41, his painted attic is detached from the top cornice of the chapel walls; the thrones have no architectural support, their weighty piers rest on the triangular frames, and the *putti* who hold the inscriptions are not caryatids but decorative motives. In contrast to this, the ribs which connect the

41. Diagram of the fictiv structural system of the Sistine Ceiling.

throne-piers across the barrel-vault can be taken as symbols of its span. Those sections of the vault which are between the ribs have been eliminated, and we discover at each end of the vault narrow strips of blue sky (42). Consequently, the scenes which fill these intervals are to be understood as taking place beyond and above the actual chapel space. They are not paintings framed by the ribs and the cornice, nor are they rendered in the illusionistic manner of the scene in the centre of the vault in Mantegna's Camera degli Sposi. Michelangelo's solution is different again.

In his final scheme the horizontal part has become as important as the vertical and has been firmly linked with the latter in every second bay, where the thrones are extended over one third of the span. The thrones are painted in perspective as if they were painted on vertical walls on the spectator's eye-level (51); and this the eye accepts without difficulty, since, owing to the curving of the vault, we in fact view them

Sistine Ceiling (section altar). Vatican, Sistine pel.

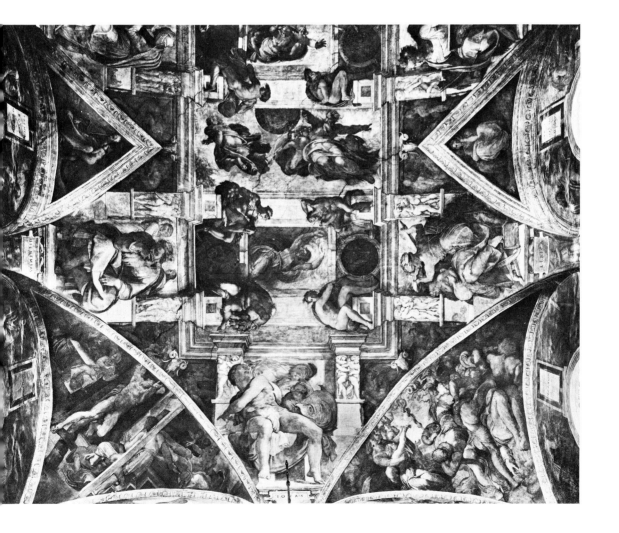

at right angles to the painted surface. The Nudes (55) belong to both parts, topographically to the horizontal part, visually to the vertical part. They too are seen at normal angles. As a consequence, there must be a break in the perspective of the blocks on which the Nudes are seated; unlike the cornice they are not seen from below, and the artist takes pains to conceal this break. The lunettes (57) have been accepted for what they are, parts of the side-walls, and they have been given a more relief-like decoration. But the concave triangles, which connect the lunettes with the vault, have been treated as flat areas, as have the corners of the vault, in each of which two such triangles have been joined to form one space (43).

What is the meaning of this constant change in the decorative system from one principle to another, from the acceptance of reality to its illusion? The answer is given by the effect produced by this new system. It is a means of transforming the painted ceiling into a self-contained whole, of transposing a decoration into a work of art in its own right, suspended, as it were, above our heads—the highest sphere in the architecture of the chapel and yet completely independent from it, a floating amalgam of architectural framework and figure-decoration. The artist, who was prevented from working on the mausoleum of the pope, found the means to make good his lost opportunity, and to do exactly as he liked. All the accumulated riches of his invention and imagination poured into the work, with the result that this substitute for the tomb of Julius II became the greatest and most successful of all his creations.

For this completely original decorative system was conceived together, and in complete harmony, with a new content which was to replace the simple iconography of the pope's project. Two kinds of figures fill this frame-work of painted architecture. First, there are figures of a merely decorative function: the *putti* who hold the tablets, the pairs of *putti* who are parts of the architecture of the thrones and are therefore painted in stone colour, and the bronze Nudes who fill the spandrels between the vaulted triangles and the cornice. The larger Nudes, seated on blocks above the thrones, may also be reckoned to belong to this class; they hold garlands of oak leaves and acorns, which are part of the coat-of-arms of the Rovere, the family of the two popes Sixtus IV and Julius II. On the other hand, by far the greater part of the figures, those on the thrones and those in the histories, represent a theological programme, intended to complement the programme of the Quattrocento decoration. The latter contains two corresponding series of frescoes, to the left events in the life of Moses, and to the right events in the life of Christ. Theologically, these represent two of the three main ages of history: the period *sub lege*, under the Law given by God to Moses, and the period *sub gratia*, in the state of Divine Grace, the age since the establishment of Christianity.

The series of histories from Genesis on the ceiling represent the first

43 (*right*). *David and Goliath.* Sistine Ceiling.

44 (*right*). *Judith and Holofernes.* Sistine Ceiling.

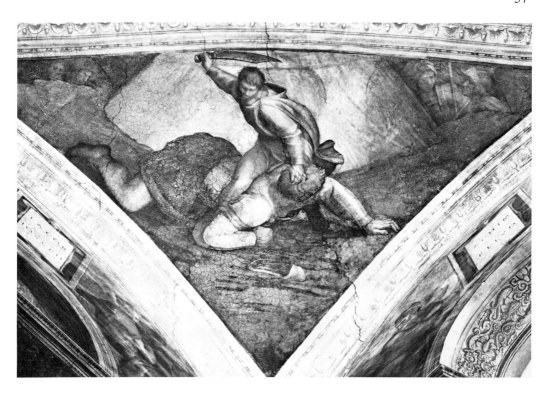

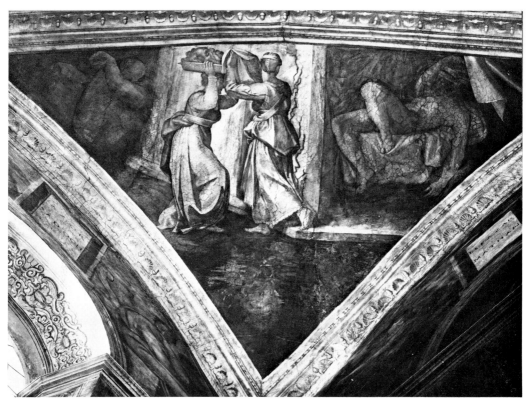

main period, the period *ante legem*, before the Law. This series of nine paintings consists of three trilogies: the History of the Creation of the World, the History of Adam, and the History of Noah, the second Adam. The pictures in the lower spheres take up the history of Mankind under the Law. On the thrones are the Prophets and Sibyls, God's elect who foresaw and announced Salvation. In the triangles and lunettes are the Ancestors of Christ, the generations from Abraham, the first patriarch of Israel, to Joseph, as they are listed in the Genealogy of Christ in the first chapter of Saint Matthew's Gospel; their cult was connected with that of the Virgin to whom the chapel is dedicated. Lastly, in the large concave triangles in the corners, there are four miraculous salvations of the Chosen People from great perils (43–46): the heroic feats of David and Judith, and the stories of Haman and the Brazen Serpent, which are precursors or symbols of the promised Salvation. And so the idea of Salvation underlies the whole decoration of the chapel, old and new alike.

45 (*right*). *The Crucifixio Haman*. Sistine Ceiling.

This, in short, is the theological programme of Michelangelo's Ceiling. More details about its typological meaning and its religious connotations can be found in a paper published some years ago by Frederick Hartt;[9] and still more can be expected from a promised book by Edgar Wind on Michelangelo's religious symbolism.[10] The mass of material collected by these scholars from the theological literature of the Middle Ages and the Renaissance is overwhelming, in its cumulative effect perhaps somewhat bewildering, and, although it is often controversial, nobody would dare to deny that it has a bearing on the subject, nor indeed to reject the suggestion made by both scholars that Michelangelo was helped by some learned theologian in working out his programme. And yet the question remains: how much of what may have been present in the mind of Michelangelo's scholarly helper did actually find its way into the work; and how far was that transformed by the artist? For there seem to be signs suggesting that the realization of this programme is imbued with ideas of Neoplatonic origin, transforming the subject-matter into what might be regarded as a revelation of the artist's own creed. The house of Lorenzo de' Medici, where Michelangelo spent the most decisive years of his youth, was the centre of the Neoplatonic movement in Italy. This movement tried to reconcile Plato's teaching with Christian dogma by means of a complex interpretation of life and its relations to the Absolute. Michelangelo expanded the same ideas in his poetry and also to some extent in his figurative work.

It was a German literary critic, Hermann Hettner, who a century ago made the first attempt to look at the pictures on the Ceiling in the light of Platonic doctrine, as it was interpreted in this Florentine circle of the late Quattrocento.[11] There follows a short abstract of what he found, in order that you may judge whether the idea is sound.

46 (*right*). *The Brazen Serpent*. Sistine Ceiling.

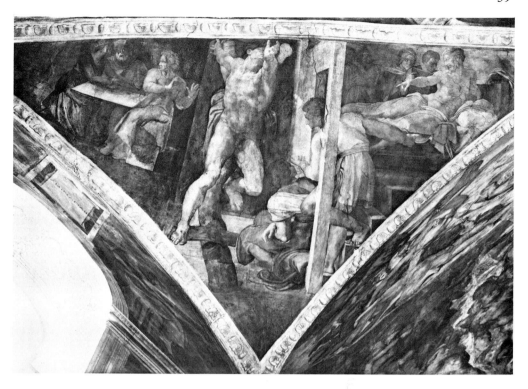

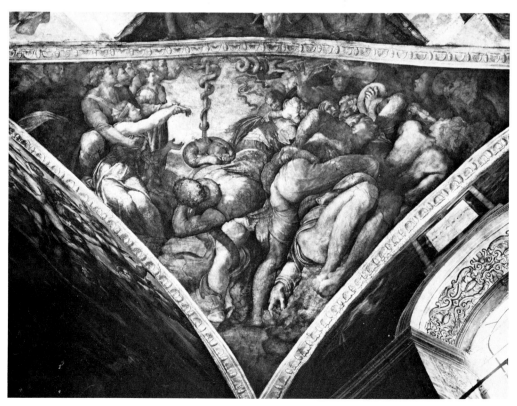

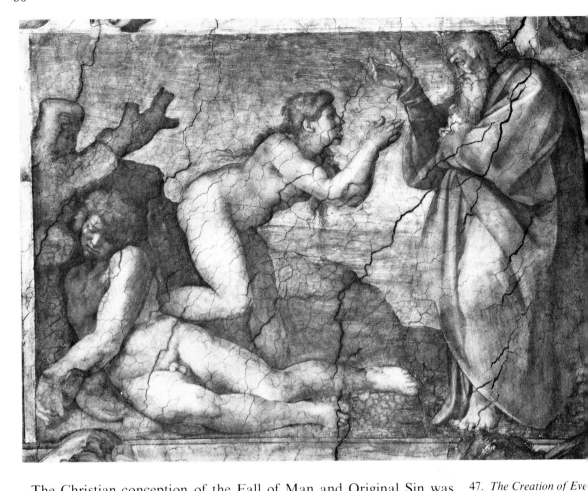

The Christian conception of the Fall of Man and Original Sin was complemented by the Florentine Platonists with the conception of the innate tragedy of the Human Soul. The Soul, originating from Heaven, is on earth imprisoned in the body, and so, subject to pleasure and passion, is bound to descend from the purity of the divine archetype into finiteness. This tragedy of the Soul is, according to Hettner, the content of the great circle of pictures in the centre of the vault. The first trilogy shows God in the glory and magnificence of His unlimited creative power. The second trilogy shows the Creation of Man and Woman, their Fall and their Expulsion from Eden. Here is the *peripeteia* of the tragedy, the metamorphosis of the divine *creatura* through the sin of sensuality, inherent in human nature. The third trilogy shows, as the consequences of this Fall, the miseries and the hopes of human life.

And so the great trilogy, the sequence of three lesser ones, is a dramatic unit—the turning-point, the creation of Eve, being exactly at its centre (47). This interpretation would account for Michelangelo's deviation from the biblical chronology on one point (though this devia-

47. *The Creation of Eve*
Sistine Ceiling.

he Creation. Sistine
g.

tion may have been necessitated by other considerations): *Noah's Thanksgiving* has been placed before, not after the *Deluge*, so that the two ends of the cycle show the greatest conceivable contrast: at the beginning, over the altar, the creative Power as a purely spiritual force (48), and at the end, over the entrance, the *Deluge* (49) and, in the last space, *Noah's Drunkenness* (50), signifying the Soul as victim of sensual enjoyment: Man returning to the dust from which he came. However, it should not be forgotten that the same scenes also allow other kinds of interpretation—that, for instance, *Noah's Drunkenness* was regarded in medieval iconography as an anti-type, as a symbol of the Derision of Christ, and that this meaning, too, may well have been intended in the Chapel of the Popes. The task is to find and define the scope and the limits of the two trends of interpretation.

It is an important point in the Platonic doctrine that the imprisoned Soul preserves the memory of its lost state and with it a longing and striving to regain it. This homesickness of the Soul is the moving force behind both philosophic cognition and prophetic inspiration. The Platonist literature of the Renaissance is full of passages describing this

49. *The Deluge*. Sistine Ceiling.

50. *Noah's Drunkenness* tine Ceiling.

rapture towards God, which is never completely absent, and so are Michelangelo's poems. He writes 'the Soul is craving for the splendour of her prime creator', or 'the ardent fire of her primordial state is reflected and alight in the Soul'; and there are many similar passages. The Prophets and the Sibyls (51, 52) represent this inspired contemplation of Divinity.

Hettner was unable to find a satisfactory place for the Ancestors of Christ in his interpretation (57). This gallery of images at the foot of the Ceiling deserves much greater attention than was accorded to it until quite recently; perhaps an adequate survey of the whole would ideally start here. Descendants of Noah, they appear to represent generations lacking Divine inspiration and are, therefore, appropriately given the darkest spaces immediately above the windows. They are representative of a Mankind which, so to speak, could not find the way to God by its own efforts. Many of them are absorbed in the narrowness and misery of everyday life. In the Platonic hierarchy of the whole, if there be one, these scenes would take the lowest place. Even the Nudes, seated above the thrones of the Prophets and Sibyls, may have a place in this scheme (55, 56). Although their role is seemingly a decorative one, the holding of the Rovere swags, they are on too large a scale and are given too prominent a place, alongside the main narrative cycle of substantial events, to be of so little significance. Perhaps they were intended to represent terrestrial Beauty, for Beauty is, according to the Neoplatonists, 'the ray of God infusing all creation', the reflection of Divine Truth in our world.[12] Once more, one could cite scores of passages both from the writings of Florentine philosophers—my quotation is from the head of their Academy, Marsilio Ficino—and from Michelangelo's poetry, to show how familiar and how fundamental to their creed was this idea. As regards their form, these Nudes are descendants of the youthful figures that stand in the background of the *Doni tondo*.

The comprehensiveness and complexity of this programme and the consistency with which it was carried through secure a place for the Ceiling in the history of Italian art comparable with that of the *Divine Comedy* in the history of Italian literature.

To this brief account of the decorative system, the theological programme and the content of the Ceiling, I should like to add a few words about the labours that realized them, and give the main dates of its history.[13]

We already know the earliest date, 10 May 1508, from Michelangelo's own note. At that time he started planning the decorative system, making drawings like those in the British Museum and at Detroit (37, 38), and he also took the first steps towards the practical organization of the work. From May to July the scaffolding was erected and the vault was prepared by the mason. The chapel was divided by

DELPHICA

51. *The Delphic Sibyl.*
Ceiling.

52 (*right*). *Jeremiah.* Si
Ceiling.

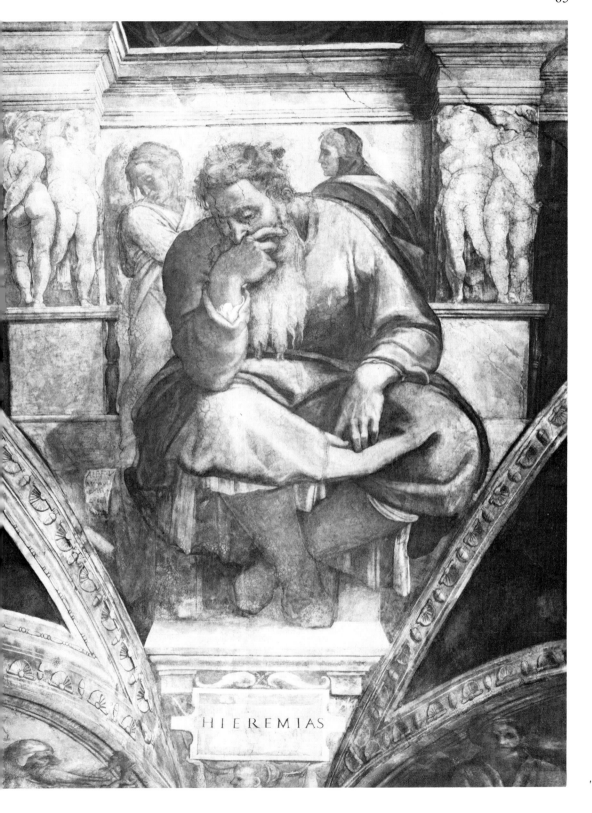

HIEREMIAS

the Quattrocento screen into two almost equal parts: the chancel, or presbytery with the altar, and the somewhat shorter space allotted to the laymen. The screen still exists but it has been moved much nearer to the entrance; its original position was exactly in line with the division between the *Creation of Eve* and the *Fall of Man* (39). Incidentally, one notices how well the iconography suited this liturgical division of the chapel: all the scenes in which God the Father appears are above the former chancel, and all the scenes of human misery are above the space that was reserved for the people. Michelangelo was to begin with the latter section, so that the chapel could continue to be used for services. He had had no experience of fresco painting and therefore engaged six assistants, all of them experts in this technique. Their foreman was Francesco Granacci who had guided his first steps towards art. Evidently Michelangelo's original intention was to get the work done quickly by using assistants. But this collaboration did not last long; it ended in complete failure. The assistants could not live up to Michelangelo's expectations; he was forced to destroy most of what they had done and to make a new start quite alone, helped only in matters of minor importance by some young *garzoni*. The difficulties were great, and they brought him repeatedly near despair. Michelangelo's letters of this period make stirring reading. There also exists a poem of bitter irony in which he describes his tribulations.[14]

By the end of August 1510 Michelangelo had finished the first half of the Ceiling. Then there followed a long break. The pope left Rome to direct the war against Bologna and payments stopped; Michelangelo had to travel twice to headquarters to get the necessary money. Perhaps in the spring or summer of 1511 the second half of the scaffolding was erected; then, after the pope's return to Rome, an unveiling of the finished part of the paintings took place on 15 August 1511. At almost exactly the same time Raphael finished his frescoes in the Stanza della Segnatura. The Romans rejoiced at two extraordinary artistic sensations, giving them an opportunity to exercise their judgement.

I believe that with the help of an anecdote told by Condivi we are able to draw the line that divides the part of the Ceiling unveiled then from the part that was executed later. Condivi's anecdote implies that in this second half Michelangelo used no more gold. And there is in fact no trace of gold beyond a line between the *Creation of Eve* and the *Creation of Adam*. There are many signs that the change was due to artistic considerations. For there are symptoms not just indicative of more rapid progress with this part of the work (Michelangelo finished it in less than fourteen months, as against the three years he needed for the execution of the first section); there are also, as we shall see, signs of a quite radical change of style. This is not surprising. Thanks to the partial unveiling, the artist himself was, for the first time, in a position to see and judge his own paintings in the proper light and from the right

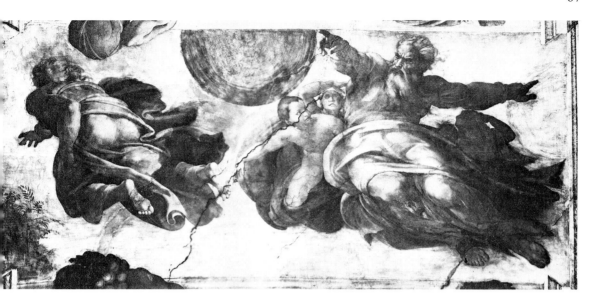

The Creation of Sun and
. Sistine Ceiling.

distance. One may imagine what this means by taking account of the actual measurements of these figures: the seated Prophets and Sibyls range in height from just under to well over 3 metres high.

On the last day of October 1512 the rest of the Ceiling was unveiled and on the following day the chapel was reopened to the public. Michelangelo reported the event to his father in these words: 'Io ò finita la chappella che io dipignievo: el papa resta assai ben sodisfato.' The next sentence of his letter seems to give vent to his disappointment at not being allowed immediately to take up work on the tomb of Julius II.[15]

After this factual survey concerning the system, the programme, and the history of the work, let us consider its style in general. In the previous chapter we looked at the *Doni tondo* (33) and the unfinished *Saint Matthew* (34) as stylistic links between the two major works, the Battle Cartoon (31) and the Ceiling. Broadly speaking, the *Doni tondo* was a kind of model for the paintings which cover the vaulted part of the Ceiling. Here the statue-like figures of the Seers and of the Nudes received an appropriate setting in the painted architectural framework of white marble and bronze—a setting which enhances the brilliance and transparency of their colour. The histories between and behind the ribbed arches of the painted vault constitute the second zone, corresponding to the figures behind the central group in the *Doni tondo*; here the colours are on the whole somewhat subdued but show the same gradations as on the panel. These two zones are the domain of the sculptor-painter. All the figures placed in front of the architecture originally appeared to be lit through the two large windows of the altar-wall, the windows which were sacrificed to the *Last Judgement*. They cast shadows on their setting, on the north side from left to right (51), on the south side from right to left (52). This is an important point, for

this device conforms to that used in the two Quattrocento series, the cycles from the New and Old Testament and the Gallery of Popes, and was therefore intended to create at least some degree of visual harmony between the two parts of the decoration, the old and the new. (Owing to the disappearance of the windows this fact has been generally overlooked.) In the histories the light falls, as is usual, from the left (50). Thus one finds two realms of corporeal existence suspended, as it were, over the chapel, distinguished one from the other in their lighting as well as in their colour.

At the foot of the vault run the series of lunettes and vaulted triangles as a darker foil to the display of splendidly lit forms above (57). (This intended effect of contrast has been diminished by the artificial light installed for the *Anno Santo* of 1950; on the other hand, this lighting has drawn the visitors' attention to this previously much neglected part of the decoration.) We should recall that it was the artist's wish to include these spaces in his scheme, probably because they seemed to him indispensable for realizing his programme in full. Now, these figures are not painted statues—they are rather pictures, or fragments of pictures, in the Venetian sense of the word. The colour, deep and full at the beginning, more homogeneous in tone later, is not a coat put on the form, it is substantial, for it alone defines the form. The brush, not restricted here by the use of a full-scale cartoon, moves freely, often improvising details or giving them unexpected accents. Michelangelo was never more truly a painter than at the time when he conceived and executed these scenes.

As I have mentioned already, the unveiling of the first half of the Ceiling also provided the artist with an opportunity for judging his own work adequately. Therefore the changes one can observe in the second part of the Ceiling must be regarded as introduced intentionally—as corrections made by Michelangelo to his own scheme. This second part begins with the *Creation of Adam*; it includes, as had the first half, the corresponding lunettes and triangles as well. This is my personal interpretation of the documents; it is contrary to the generally accepted view that the two phases were first, the whole of the vault, and then the series of lunettes and vaulted triangles. One of the arguments often brought forward to support this view is that the two parts needed different scaffoldings. But this is, I think, naïve; the *Prophets* and *Sibyls* could only be painted from the same scaffolding as the lunettes (their bottom level is the same: 41). However, the decisive argument is offered by the different stylistic characters of the eastern and western halves of the Ceiling, lunettes and triangles included. The most striking difference is that in the later section, the Ceiling, in its whole length and width, has been conceived as a unit. The long break in the work, caused by external circumstances, made it possible for the artist to plan the whole of the second half in detail beforehand. So, first of all, one notices that a

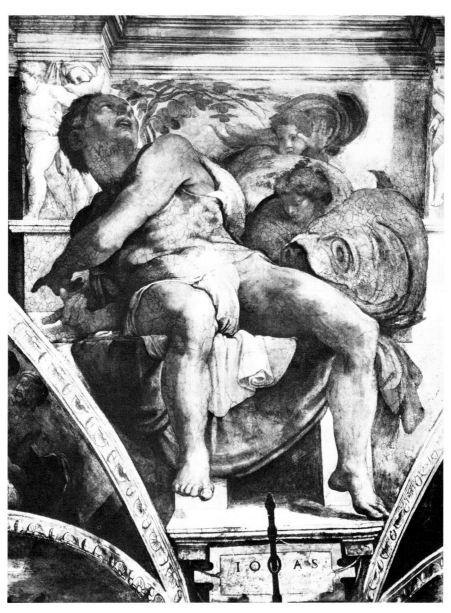

powerful movement connects the pictures in the centre of the vault. It is carried by the diagonals on which each of the compositions is based, doubled in the larger ones (53); and it traverses all histories in a gigantic zig-zag, ending, almost like a stroke of lightning, in the contorted figure of Jonah (54). The Nudes, too, seem to be seized by this movement; they have abandoned postures governed by calm symmetry (55): some of them are no longer sitting at all (56). Then, as a rule, all the figures, including the decorative ones, are on a considerably larger scale. As a consequence, the architectural framework has been partially suppressed and its details have been neglected; they show the careless

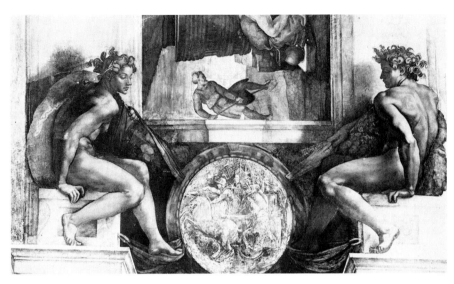

55. *Ignudi* above *Joel*. Sis
Ceiling.

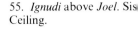

56. *Ignudi* above *Libyan
Sibyl*. Sistine Ceiling.

execution of inexperienced *garzoni*. At the same time the colours appear
more unified and their gamut is mainly based on violet and silvery grey;
and where there are local colours, they have been equalized in tone and
intensity by the addition of white. The omission of gold in the second
half of the Ceiling, noted by Condivi, is only a symptom of this general
striving after a complete unity of form and tone.

How different in all these respects is the first section! There (39) you
find no subordination of the parts to a general, unifying impression.
Each section of the composition is a separate unit, a balanced part in a
strictly observed system of horizontals and verticals, and the forms are
exactly at right angles to each other. Frames have been kept as frames
in their own right, with all their details beautifully executed, and they

Abiud and Eliachim (lun-
between *Joel* and
rea). Sistine Ceiling.

Booz and Obeth (lunette
en Persica and
niah). Sistine Ceiling.

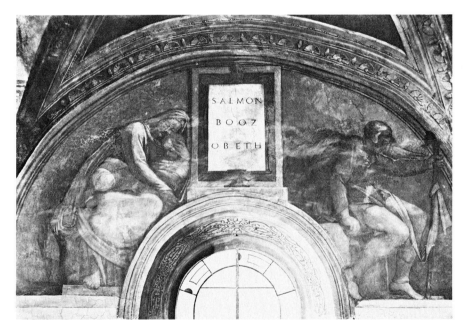

are not overwhelmed by the figures. The colours are as distinct one
from another as in the *Doni tondo*; some are deep, some brilliant, and
no general hue prevails among them. In short, all the forms convey the
harmony and the static balance of the High Renaissance, whereas in the
last section of the work Michelangelo's dynamic conception triumphs.

 In conclusion, I should like to comment on a few more examples

taken from the several categories within the Ceiling. First, two of the
fourteen surviving lunettes (two were destroyed), one from the begin-
ning of the work, one from the later part, but both with very simple
motives (57, 58). The ease with which these later figures have been
drawn—one could almost say improvised—distinguishes them sharply
from the heavy-handedness of the early pair. The register in Saint
Matthew's gospel contained names only, many of which do not occur in
any other part of the Bible. As Edgar Wind has shown, theologians of
the Middle Ages tried to give a kind of allegorical existence to these
persons by translating their Hebrew names into Latin and then looking

59. *Eleazer* (lunette to left
Zechariah). Sistine Ceiling

ft). Studies for the
g and lunettes of the
e Chapel. Oxford,
nolean Museum.

ght). Studies for the
tes of the Sistine Chapel.
rd, Ashmolean
um.

for passages in the Scriptures in which the same Latin words occur; in Michelangelo's lunettes the persons have been made to represent the corresponding phrases.[16] Wind suggests that these representations of the *Antenati* were based on verbal abstractions of this type. They may well be so—one must await the publication of his full text to be able to judge. In any event, it was doubtless Michelangelo's imagination that transformed those freakish products of abstract speculation into images of striking vivacity.

They reveal a common mood. Although Michelangelo's *Antenati* seldom represent personalities, these family scenes are reflections of his experience of life in the Tuscan middle class to which he belonged—a rather practically-minded class, with its love of property, arranged marriages, competitions, and struggles (59). Some of the scenes are of an enchanting beauty, some are grim, some humorous or acidly sarcastic. The riches of Michelangelo's notebook seem to be inexhaustible. The Ashmolean Museum possesses a unique document, eight leaves of a small sketch-book which he used when he started preparing the second half of the Ceiling; and they contain more ideas for *Antenati* than he could dispose of in the eight lunettes still to be painted (60–61). Two more half-lunettes (62, 63), also from the second half of the Ceiling, are the only ones among the Ancestors of Christ which in their design very closely follow antique prototypes: one the relief of a River-God on the Arch of Septimius Severus (64), the other the statue of a resting Hermes known from replicas in the Vatican and in Copenhagen. But who would think of classical models here? Michelangelo's independence from the meaning of his prototypes is as marked as his independence from the theological programme he had to illustrate.

74

62. *Abia* (lunette, detail).
Sistine Ceiling.

63. *Naason* (lunette, de▪
Sistine Ceiling.

64. *River-God,* Arch of
Septimius Severus, Ron▪

The compositions in the eight vaulted triangles above the lunettes display scenes of family life again. The limits of their existence seem to be as narrow as those of the spaces in which these families are placed. The groups in the four earlier spaces (65) follow the iconographical tradition of the *Rest on the Flight into Egypt*. As he progressed with the work the artist found the best way to fill these triangles, sometimes even with a single figure, either by following the triangular frame or by placing within it some other geometrical form (66). In the case of Jesse, for instance, the silhouette is of an ornamental simplicity. The early group shows the formidable plasticity of the *Doni tondo*.

The harmonious filling of the spaces was a more difficult task in the four corners of the vault where two spherical triangles are joined to form a larger one, with one corner pointing downwards. In the early *David and Goliath* (43) all three corners have been left empty; there is a central group not unlike that in the *Doni tondo*, but it fills only a relatively small part of the picture-space. In the late *Brazen Serpent* (46) an extensive composition has been built upon—one could almost say developed out of—the two lower sides of the triangle; in the centre the anti-type of the Cross is silhouetted against the sky. The contrast with the earlier composition is most informative; it is an index of all the changes that occurred in Michelangelo's art in this period of four years. In the early *Judith* (44) the artist has filled the triangular frame with an oblong composition of Giotto's clarity and simplicity, again entirely ignoring the lower corner. In this frieze-like composition a strong accent has been given to the centre. That central accent has been expanded into a dominant central axis in the late *Crucifixion of Haman* (45), the fresco to the left above the altar, and this allowed Michelangelo to fill the upper corners with independent compositions. There is no empty space left here and the composition is in a most effective way complementary to that of the *Brazen Serpent* on the right (46), where the greatest plasticity is on either side and the recession in the centre. The space is organized with the help of a setting similar to that used by Giotto in his *Birth of Saint John the Baptist* in the Peruzzi Chapel. Michelangelo's earliest ideals make their reappearance; for instance, the whole upper half of the figure descending the stairs is, in all its details, a literal quotation from Masaccio's *Tribute Money* (the figure of the publican demanding the tax from Saint Peter).

The forms painted on the concave surfaces of the triangles and double-triangles are, as a rule, much more plastic than those which fill the vertical planes of the lunettes. So are those on the pendentives. The choice and the arrangement of the seven Prophets and five Sibyls on the pendentives are questions which, although much discussed, remain to be solved; that is to say, the underlying theological principle is not quite obvious. But one may notice that *Zechariah* (67), historically the latest of the Prophets represented in the series, has been placed at the end,

66. *Jesse* (between *Libic* and *Daniel*). Sistine Ceil

above the entrance; and that *Jonah* (54) who is an antitype of Christ—he was in the belly of the whale for three days, as was Christ in the sepulchre—has been placed above the altar where there was, in the centre of the wall between the two windows and immediately below this figure, a large image of the Saviour, beginning the series of the early heads of the Church. These two Prophets well represent the two main phases in the execution of the work, although in fact *Zechariah* was not the one Michelangelo painted first (this figure was certainly preceded by

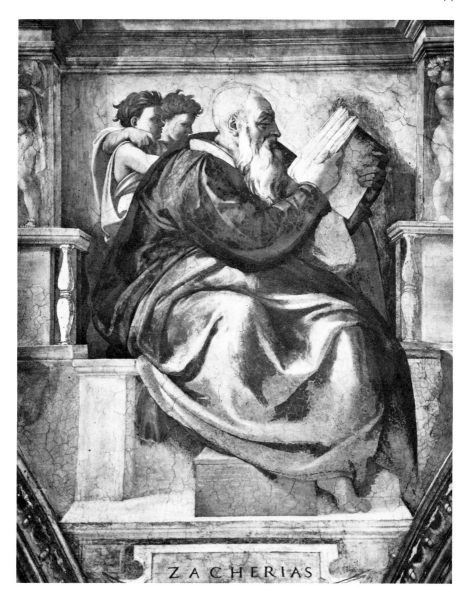

ZACHERIAS

that of *Joel*). Of all figures of the Ceiling *Jonah* was the most admired
by Michelangelo's contemporaries. At any rate, it is a good answer to
Bramante's taunt that Michelangelo was unable to paint foreshortened
figures.

Let us consider two of the Sibyls, one from the first and one from the
second half, but in comparable poses (68, 69). One notices in the later
one the deliberate abandonment of those harmonies and delightful
details cherished by the artist in the earlier. The omission of gold is not
an insignificant change; as in the *Doni tondo*, gold was also used on the
figure of the *Erythraean Sibyl*. There is no place for it in the *Persian
Sibyl* and consequently the golden balusters have been left plain. For

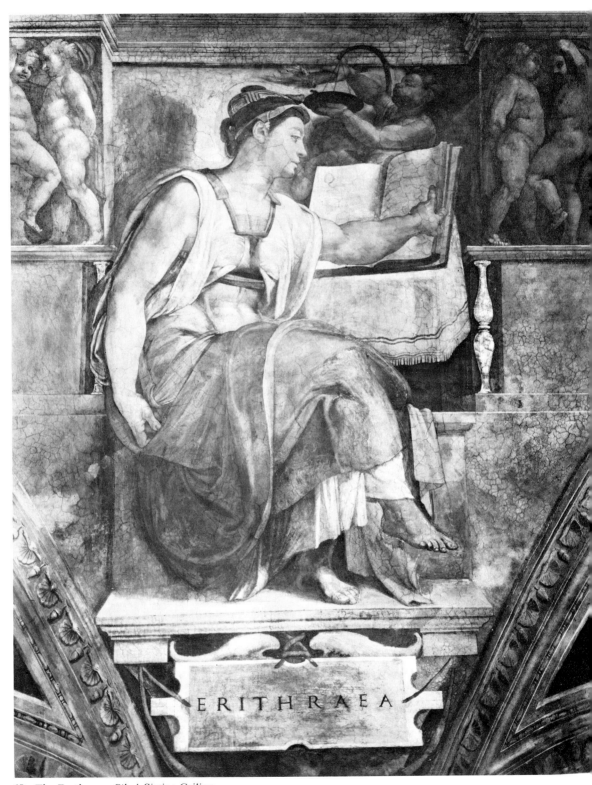

68. *The Erythraean Sibyl.* Sistine Ceiling.

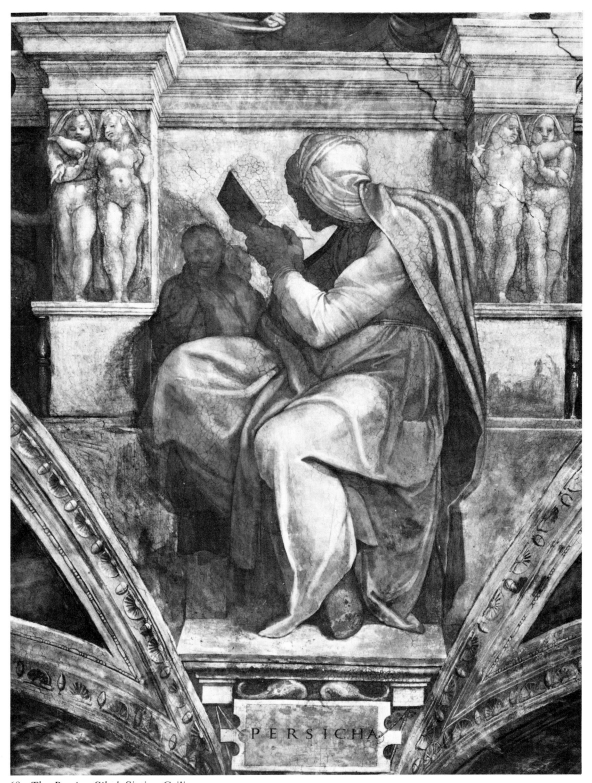

69. *The Persian Sibyl.* Sistine Ceiling.

 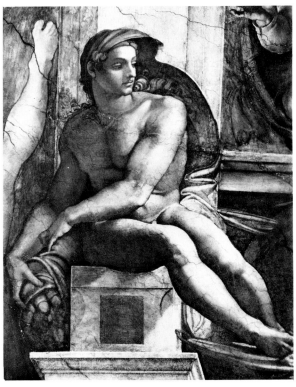

the later figure the architecture is no longer a receptacle and still less is it a frame, an equivalent part of the composition; it has become one mass with the figure, a foil subdued both in its design and its colour.

Next, let us compare one figure from the corresponding pairs of *Ignudi* (70, 71). Again the poses are similar and make a direct comparison easy; the figures are shown here on the same scale and the later one is half as large again. But the measurements are not the main thing. You notice the increase of the inner proportions, and also the tendency towards a more abstract beauty: the purity of Platonic form. This is already present in the preparatory life-study (72). It may be taken as representative of those which we still possess. Drawings of this type were made by Michelangelo immediately preparatory to the full-size cartoons for his frescoes. They have been rejected by many modern writers, who have believed them to be copies after the frescoes. I mention only one argument for the genuineness of this particular drawing (which seems to me to be very beautiful but which has frequently been rejected in the past). If one compares the two thoroughly, one notices that the fresco shows the figure in a slightly different projection; it is seen from a somewhat lower viewpoint and is, therefore, more foreshortened. To assume that the study was made from the fresco implies that a consistent transposition of its perspective took place, and this is an operation with which a copyist can hardly be credited. Here is another

70 (*left*). *Ignudo* above *Delphica*. Sistine Ceiling.

71 (*right*). *Ignudo* above *Persica*. Sistine Ceiling.

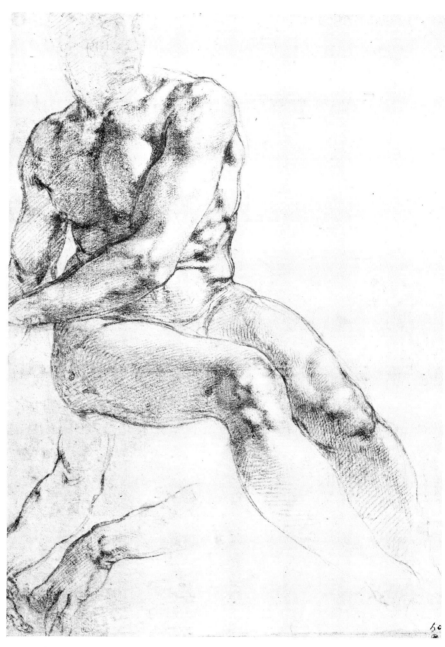

Red chalk study for
do. Vienna, Albertina.

example (73); once more, the drawing has been generally rejected as a copy. I hold that it is a genuine study—the portrait of an old fisherman, or of a stevedore from the Ripa Grande—made by Michelangelo in preparation for the *Cumaean Sibyl* (74). While the expression in the two is much the same, almost all the contours are different—again, inexplicable if the drawing be a copy. But assume the reverse and everything becomes intelligible. One then, I think, admires the way in which, in the process of transferring the study to the cartoon, the ac-

73. Study for *The Cumaean Sibyl*. Turin, Biblioteca Reale.

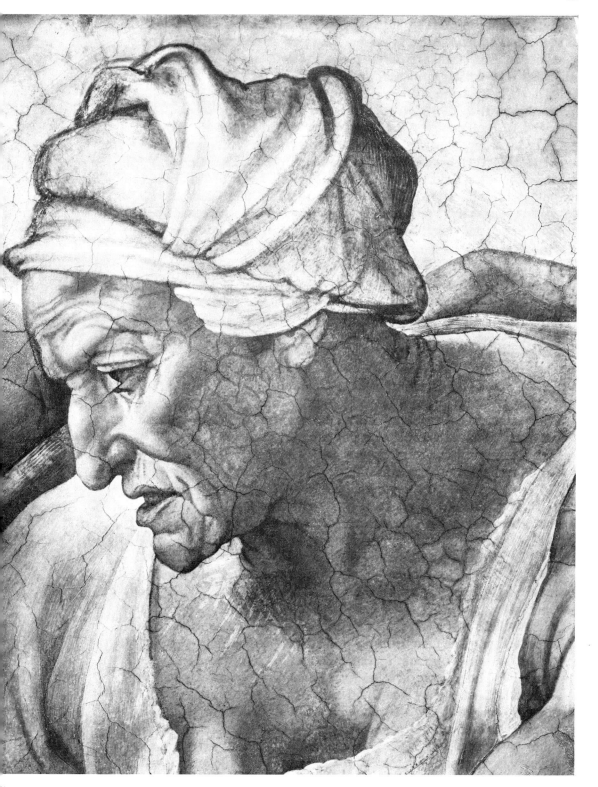

The Cumaean Sibyl (detail). Sistine Ceiling.

cidents of natural appearance, which still remained in the former, were either suppressed or replaced by more abstract and more expressive forms; and this process of sifting, simplifying, and intensifying continued during the execution itself. Typical in this respect is the treatment of the chin, or that of the curve which starts from the nostril. This is a document which allows us a deep insight into the creative process. For the method used in these red chalk studies, Michelangelo is certainly indebted to Leonardo; but it was owing to Michelangelo's example that for two centuries it became the norm for studies preparatory to monumental works.

We have already compared, with regard to their content, the first and the last of the five smaller oblongs of the vault. The first and the last of the four larger oblongs (49, 53) show the same differences, but are also representative of the changes of style which took place between the two main sections of the work. There is much movement in Michelangelo's *Deluge*. It is the earliest composition in modern art entirely based on dominant diagonals—diagonals both on the surface and in space, and answered by counter-movements, or enhanced by parallel movements. One important form, a tree on the right, has been destroyed. However, the groups placed in the near and middle distances are themselves static. In the *Creation of the Sun and Moon* the movement, much increased in force, pervades all the forms and is also the governing principle for the smallest of details. This fresco may be called an epitome of the new conception underlying the whole second half of the Ceiling and, indeed, of an altogether new art.

The Tomb of Julius II

The *Prophets* and *Sibyls* on the Sistine Ceiling are clearly related to the work on which Michelangelo had started shortly before the Ceiling and was to start again after having completed it: the tomb of Julius II (75, 76). Before dealing with the history of this work I should like to say something about Michelangelo's attitude towards the two arts, painting and sculpture.

If we consider the whole of Michelangelo's *œuvre*, we find that a high proportion of the completed works are paintings. This fact seems to contradict Michelangelo's often repeated assertion that his calling was sculpture. Even during those long periods entirely devoted to painting or to architecture, he would sign his letters in silent protest *Michelagnolo scultore*; and he declared more than once that the times when he did not handle chisel and mallet daily were altogether lost to him. The achievement in painting might be simply explained by the fact that it was humanly possible to carry out the great pictorial enter-prises—to achieve them, as Michelangelo interpreted achievement, by executing everything aesthetically relevant with his own hand—whereas the same was not possible in sculpture. And so, the Sistine Ceiling, the *Last Judgement*, the two large frescoes in the Cappella Paolina—all these works were completely finished. The only exception in this respect, the Battle Cartoon, was not a failure on the part of the artist; it was given up for reasons for which he was not responsible. But the great sculptural enterprises, in which an assembly of statues and reliefs was to be set in a specially built architectural framework, show rather different results: the tomb of Julius II ended with a poor and painful compromise; for the façade of San Lorenzo Michelangelo sacrificed nearly three and a half years of his life without being able to start on its execution; and even the Medici Chapel is no more than a noble frag-ment. And as for the contradiction I have mentioned, one might try to resolve it by pointing out that all the great commissions for painting were forced upon the artist by persons whose power he was unable to resist. But this cannot be the whole truth. To be sure, Michelangelo did use every means to evade these commissions—we saw this in the case of the Ceiling, and the same holds true with the *Last Judgement* and the Pauline Chapel frescoes; but, after all, it was possible to force him—and

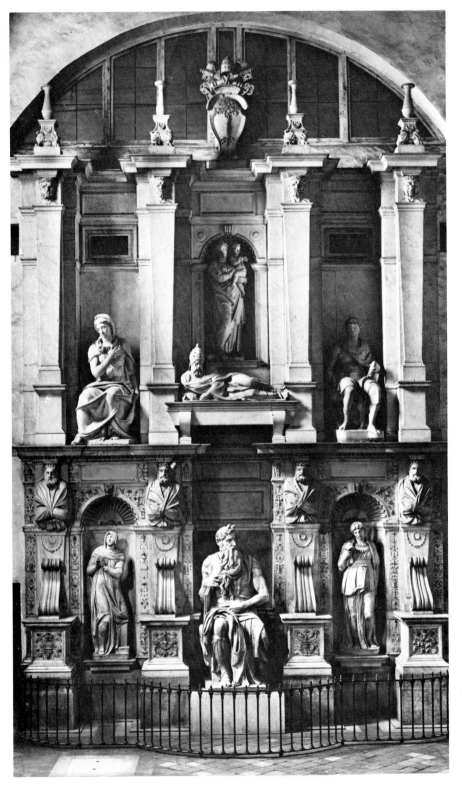

75. The Tomb of Julius
Rome, San Pietro in Vi▮

when he had finally undertaken such a commission, he always gave of his very best, and these works were his greatest triumphs.

The right explanation is, I think, to be found in Michelangelo's settled belief that the two arts, sculpture and painting, differ one from another only in the means they employ, not in their purpose. Their aim is identical: to render three-dimensional forms as convincingly as possible—or, as Michelangelo succinctly said, *to make figures*. Although expressed in old age, in his famous letter to Benedetto Varchi of 1547, this conviction had been fundamental to his practice from the beginning. His commitment to sculpture did not mean a negation of the other figure-art—on the contrary. In the same letter to Varchi he went so far as to demand that every sculptor should perform the same amount of work in painting as in sculpture, and vice versa.[17] And this principle was borne out by his teaching, for, as a rule, his pupils were instructed in both arts. It seems obvious that even for an artist whose imagination is possessed by the beauty and significance of the human figure, and whose interest is consequently centred in the free-standing statue, much is to be gained in the wider field of painting, both for solving problems of form and for presenting ideas. Nevertheless, it was a unique moment in the history of his profession—a moment that will for ever remain connected with Michelangelo's name—when the identity of purpose between the two figurative arts became reality.

In practice this identity favoured a smooth transition from one art to the other. And so, only a few months after the completion of the Ceiling, we find Michelangelo working on statues again. But he did not lose his interest in painting either. For contemporary with his work on the statues for Julius's tomb was his collaboration with the painter Sebastiano Veneziano; two products of this collaboration are very much to the point.

Sebastiano Veneziano, later called Sebastiano del Piombo, was nine or ten years Michelangelo's junior. In his youth in Venice he was one of Giorgione's most successful followers. In 1511 he moved to Rome where he soon became an admirer and devoted friend of Michelangelo and his first real follower in painting. Michelangelo, on his side, also appreciated Sebastiano's art and decided actively to support him in his efforts to make good in the Rome of Raphael. Vasari, who knew Sebastiano well, gives a detailed account of this first phase of their collaboration which lasted until the end of 1516. Many modern writers have been critical of this account and declared it to be an invention of Vasari's or, at best, to be highly exaggerated.

Vasari states that Michelangelo made the cartoon for Sebastiano's famous *Pietà* at Viterbo (77) and that 'Sebastiano diligently completed it in colours and made in it a twilit landscape which was found most beautiful'. The cartoon does not exist, but there is proof that it did. On the *verso* of the sheet which contains the beautiful study for one of the

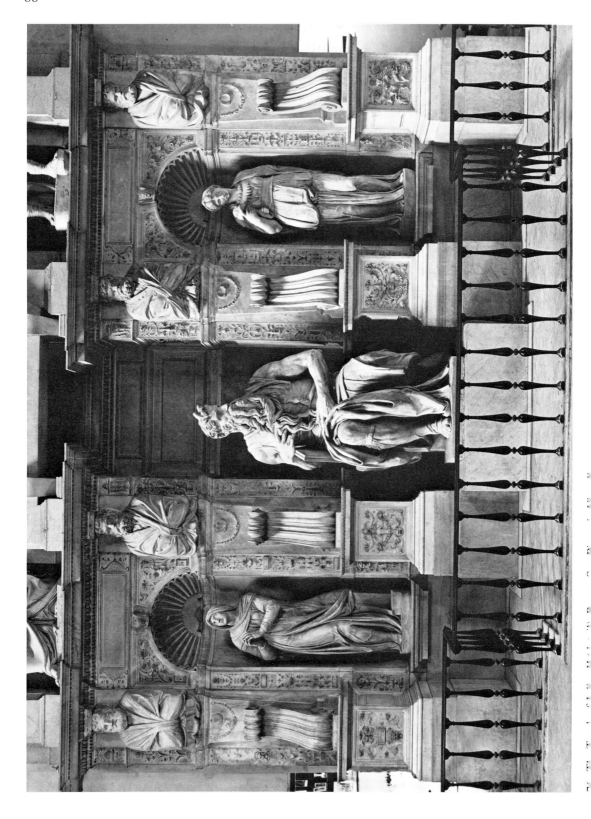

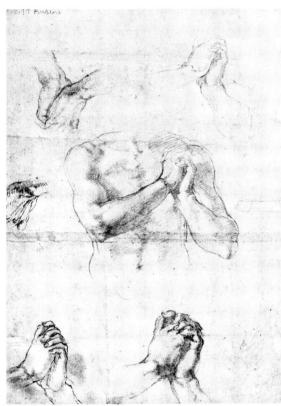

Sebastiano del
Pietà. Viterbo,
.

). Michelangelo,
or fig. 77. Vienna,
.

Ignudi discussed in the previous chapter (72) I found studies, also by Michelangelo's hand, for Sebastiano's painting (78). They are of the type which in Michelangelo's practice always preceded the full-scale cartoon. Furthermore nothing like these figures can be found in Sebastiano's previous work; they are clearly an extension of Michelangelo's work in the chapel. These figures are detached from us mortal beings. This *Mater Dolorosa* is alone in her sorrow, and, like a Christian Niobe, she addresses her question to Heaven only. She is no longer one with her Son, as she was in the group in Saint Peter's, finished twelve years earlier. The contrast between the horizontal of one figure and the upright bearing of the other is almost cruel. Sebastiano tried to tone down this effect by a landscape that should show the sympathy of nature with the Mother's grief, but its Giorgionesque forms do not make for unity with the group.

Sebastiano's principal work is the decoration of the Borgherini Chapel in San Pietro in Montorio; its altar-piece, the *Flagellation of Christ* (79), was again based upon drawings by Michelangelo. These were made in the summer of 1516, shortly before he left Rome for Florence; a compositional study in the British Museum (80) is one of the earliest.

90

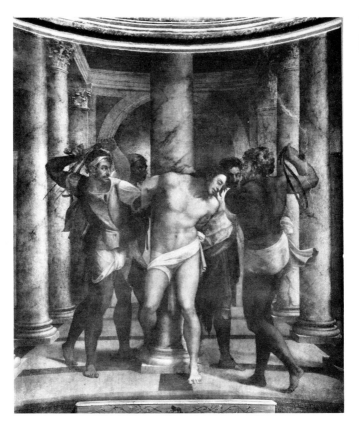

79. Sebastiano del Pio
Flagellation of Christ.
San Pietro in Montori

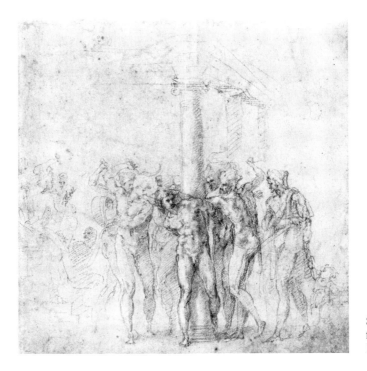

80. Michelangelo, stu
fig. 79. London, Britis
Museum.

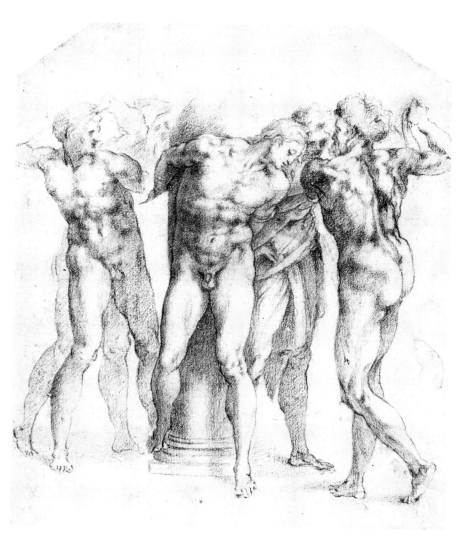

iulio Clovio, copy after
elangelo's *modello* for
. Windsor, Royal
ry.

Vasari states that a *piccolo disegno*, a synonym for *modello*, by
Michelangelo was the basis for Sebastiano's masterpiece, and we know
from Michelangelo's correspondence that his final design for the
Flagellation was made in Florence and arrived in Rome in August 1516.
This final design, now known from what seems to be a very close copy
by Giulio Clovio (81), was a variation of only the central group of the
first study. While reducing the composition, thereby making it more
monumental, Michelangelo also changed the lighting, for it was found
more suitable to the place which the picture was to occupy in the
church that the figures should be lit from the right. Sebastiano, con-
tinues Vasari, made several preparatory drawings for his cartoon which
were based on Michelangelo's final design, and we also know that he
made a small model of the figure of Christ in clay—an excellent illustra-
tion of Michelangelo's teaching about the mutual relations of the two

arts. The opinion, or rumour, referred to by Vasari, that Michelangelo actually outlined the principal figures in the painting, can be dismissed for chronological reasons. It was also Sebastiano who worked out the characterization of the figures, the drapery, and other details. He gave the group a harmonious setting on the lines of his own Venetian works—the niche framed by pilasters echoes the form of the whole chapel—and he made the space alive: his shadows, half-shadows, and reflections produce an atmospheric *ambiente* which is entirely absent from Michelangelo's design.

This picture and the others which surround it in the chapel are striking examples of that eagerness to understand, to learn, and to adopt the forms of the Sistine Ceiling which was one of the dominant factors in the development of Italian art during the decades which followed the unveiling of that great work.

Michelangelo's steadfast belief in an identity of purpose between sculpture and painting also had important consequences in his own practice. It allowed him, as we have seen, to turn, within a few months of the completion of the Sistine Ceiling, to working on the tomb of Julius; the latter was recommissioned from him by the executors of the last will of the pope, who died early in February 1513.

Now, before looking at the parts, let us first consider the system of the whole monument and the programme on which this system was based, as we did in the case of the Ceiling. Unfortunately, the contract of 1505 is lost, and we possess no drawing to cast direct light on the project. But we do possess Condivi's description of it: a clear, logical text, apparently written, or dictated, by Michelangelo himself. Further, we learn from Michelangelo's correspondence that the work was to be completed within five years, and this means that all its parts, including the sculptures, were to be executed with the help of assistants; for even an artist of Michelangelo's capacity for work would have been quite unable to finish eight over-life-size marble figures in a year, and to go on doing this for five years. The initial project entailed the same idea of team-work with which he started on the Ceiling three years later.

Some illustration of the first paragraph of Condivi's text is provided by Michelangelo's second design for the monument, the design of 1513. Of this project we possess both a small-scale preparatory drawing and a detailed description of the *modello* in Michelangelo's hand; the description is in the contract of 13 May 1513. Figure 82 reproduces an exact sixteenth-century copy of the drawing which is, to all intents and purposes, a facsimile of the original, now in Berlin, which is in very bad condition. This design of 1513 gives some idea of that of 1505, for it appears that the main features of the lower storey have not been substantially changed; in fact, they remain unchanged up to the end (76). Originally, in 1505, the tomb was planned as a single-storeyed, free-standing structure, with two shorter façades as in the drawing, and two

82 (*right*). Design for the 1513 project for the Tomb Julius II (copy). Berlin, Kupferstichkabinett.

lateral façades half as long again, only the central bay being extended. The recess in the back was to serve as an entrance to the interior, where the sarcophagus was to be placed. The three other recesses—the rectangle seen in the drawing and the two large oblongs on the sides—were to receive bronze reliefs representing events in the pope's life. On the four corners of the platform of this mausoleum large seated figures were to be placed, and in its centre, on a pedestal of steps, was to stand the bier of the pope supported by two, or possibly four, angels. That means, in all, about forty figures and three reliefs.

Condivi calls the fettered figures, placed on plinths in front of the herm-pilasters, allegories of the Arts; and we know from the later projects that the groups which were to be placed on the base, before the round-headed niches, were allegories of victorious Virtues. The four seated figures on the platform were to represent Moses and Saint Paul, and either a Prophet and a Sibyl or, according to Vasari, the *Vita Activa* and the *Vita Contemplativa*.

Apart from the statues of Saint Paul and of the angels supporting the bier, this programme hardly contained anything specifically Christian. Most of its elements were borrowed from the triumphal art of the Romans and so, indeed, was the idea of the whole edifice: a mausoleum or, as it was conceived by Michelangelo, a burial temple with a *cella* as its centre.

This programme was bound to fail, even in the era of the secular-minded High Renaissance. When Michelangelo made his new contract with the heirs of the pope, in 1513, this programme was to some extent Christianized, and was brought into line with the tradition of Italian sepulchral art. The idea of a temple-like interior was abandoned. The structure was to be connected by one of its smaller sides with the church wall, that is to say with that of the main apse of new Saint Peter's. The sarcophagus was to take the place of the bier, accompanied by four angels, two supporting the dead pope, two holding torches of perpetual light. Instead of four seated figures there were to be six; two, at right angles to one another, on each of the front corners; and two more at the rear, each with one of its sides turned to the church wall. Also against the church wall—and this is the most significant of all the changes—a shallow but lofty structure was to be erected: a kind of chapel (it is called 'capelletta' in the contract), with the Virgin and Child in high relief in its central niche and four more statues on its sides.

All this makes the scheme somewhat similar to that of Andrea Sansovino's Della Rovere tombs in Santa Maria del Popolo (83). Although these, too, were commissioned by Julius II—actually they were commissioned at the same time as his own mausoleum and finished by 1509—they are nothing more than High Renaissance versions of the traditional, Quattrocento type of wall-tomb.

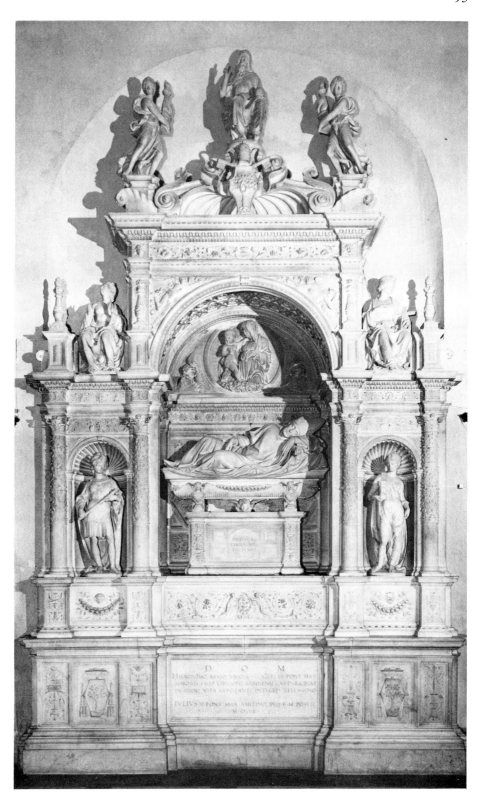

ght). Andrea
ovino, Tomb of
inal Girolamo Basso
Rovere. Rome,
aria del Popolo.

Andrea Sansovino was the main representative of the classical phase in the development of Florentine sculpture. Michelangelo's senior by some years, he was with him in the garden at San Marco. Later he went to Portugal and then, like Michelangelo, returned to Florence at the beginning of the new century to compete for the giant *David*. In 1504 or 1505 he was summoned to Rome by the pope. His tombs there are more classical in their forms and more monumental in their conception than Quattrocento wall-tombs; the figures show Roman gravity. But the parts still have a high degree of independence, the ornament is no less important than the statues and reliefs, and the unity is an essentially decorative one. This is not altogether different in Michelangelo's design, and this is probably due to the wishes of the pope's executors. I think one is right in assuming that the design of 1505 had a more impressive unity and looked more harmonious.

Work began on this basis in the summer of 1513. First, the architecture of the front of the lower storey was executed. While assistants were working on the elaborate, grotesque ornaments of the various panels and other parts, Michelangelo made a good start with the figures: in three years he finished two of the *Slaves* and nearly finished *Moses*. All these parts have been preserved: the architecture and the *Moses* are incorporated in the present monument (76, 84): the two *Slaves* are in the Louvre (86, 87).

If one compares this architecture with Michelangelo's preparatory drawing and the description of his *modello* in the contract of 1513, one finds that in the short interval (an interval of only a few weeks) before the execution in marble started, he had made very considerable alterations to his model. First, he increased the scale of the whole structure: he added almost a half to its width and a fifth to its height. This increase completely changed the proportions of height and width: from seven to ten, to five and a half to ten; and this has made the whole structure rather massive. Further, the herm-pilasters have become broader and the central recess wider. Both these changes also mean an increase in the scale of the projected figures. The common base connecting the two plinths of each bay has been cancelled; the groups between them were to be placed on the floor or, more probably, on a low stylobate (one step high) on which the whole structure was to rest. All these changes are symptoms of a stricter and more architectural conception.

Michelangelo's first concern was the Nudes that were to be placed in front of the herm-pilasters. They are descendants of the Nudes on the Ceiling, but they are more dramatic. Michelangelo himself called them *prigioni*, the captives of the body—a truly Platonic conception. A sheet at Oxford (85), first used by the artist for studies for the *Libyan Sibyl* a few months earlier, contains, apart from a study for the main cornice, six sketches for these figures, more than were needed for the front

84 (*right*). *Moses*. Rome, San Pietro in Vincoli.

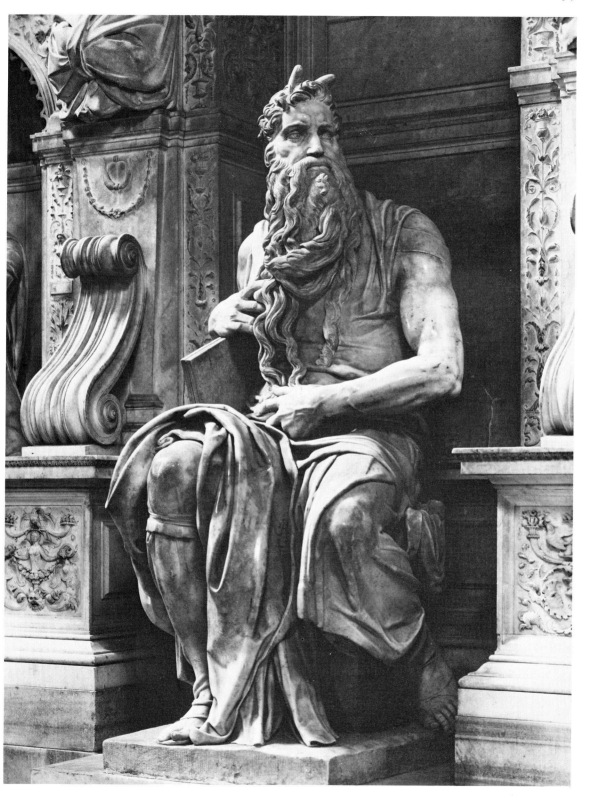

façade then in preparation (one is reminded of his sketches for the *Antenati*, also at Oxford, 61). Only one of these sketches was used, the second from the left. It seems to confirm Condivi's interpretation of the figures as allegories of the Arts; there is a trophy at the foot of the figure and that can only mean the Art of War (Julius II was a great warrior). In the execution of the so-called *Rebellious Slave* (87) this trophy has been changed into a block and, although it is perhaps not finished, its regular shape seems to suggest that it was intended not only as a support for the right leg of the figure but also as a different attribute: a block to be used for a capital, and the figure as an allegory of Sculpture or Architecture. The counterpart of this figure (86), the so-called *Dying Slave*, also in the Louvre, is accompanied by the image of an ape, just indicated in the otherwise shapeless mass of stone behind the figure. This attribute, as has been suggested, probably signifies painting: *pictura scimmia naturae*; painting was another of the predilections of the pope.

Let us assume for a moment that these two figures were to frame the right-hand niche of the front. Further, let us picture to ourselves a group of the type of the *Victory* (now in the Palazzo Vecchio, 99) standing between them on the floor, or rather on a very low stylobate to the whole monument, but reaching up to the same level as these two statues. And let us place in the mind's eye above this tripartite composition, on the platform, the statue of *Moses* (84) which, as I have already said, was begun while these two Slaves were in hand. This configuration may give some idea of what the project of 1513 meant to Michelangelo.

He was soon to realize that his undertaking had no prospect of success. As in the case of the Ceiling, while the execution of the architectural framework and its ornaments was left to specialists, he was unwilling to allow any collaboration on the statues and reliefs. However, it was simply impossible for a single person to bring into being this whole array of imposing marble figures. Michelangelo could not evade the consequences, and already in the spring of 1516, that is to say less than three years after the conclusion of the contract, he proposed some very considerable cuts and other changes in the scheme.

The architecture of his new scheme of 1516 (88)—which was at once accepted by the heirs of the pope—shows a number of significant changes. First, a very considerable reduction of the whole structure in depth was to be effected by reducing the side elevations to the width of one bay. Second, the *capelletta* was to be widened and brought forward so as to make it flush with the lower storey on all three sides. The herms were to be continued upwards in pilasters, and each pair of pilasters was to frame a rectangular recess, which was to be closed by an architrave at about half the height of the order, leaving a square space below the entablature. Finally, above the centre recess of the lower storey there was to be another, still deeper recess, which was to end in a

85 (*right*). Studies for the Sistine Ceiling and the Tomb of Julius II. Oxford, Ashmolean Museum.

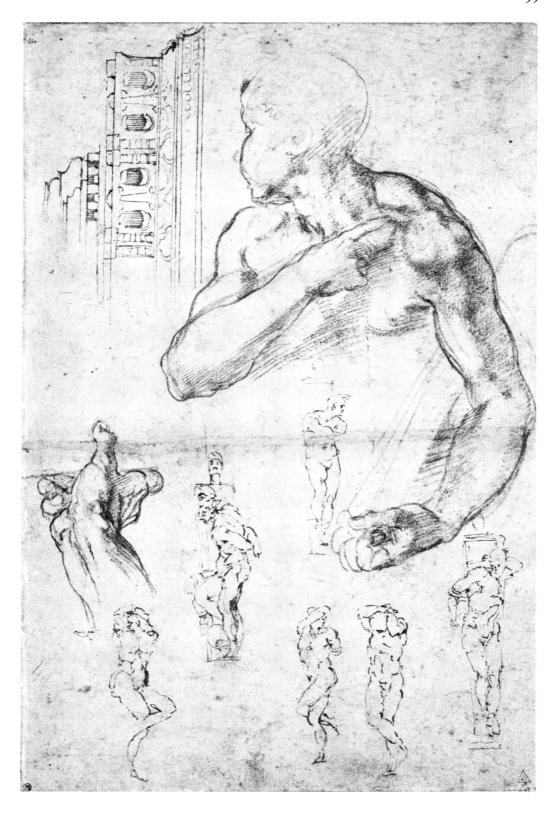

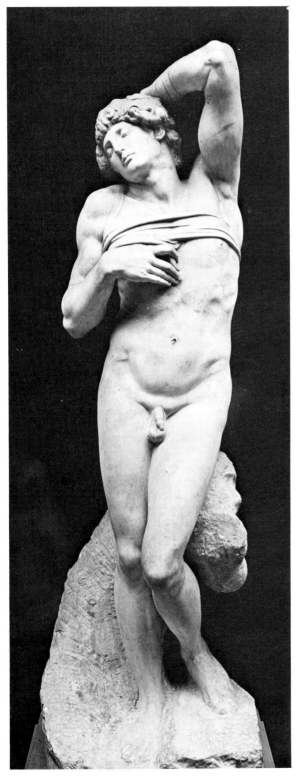
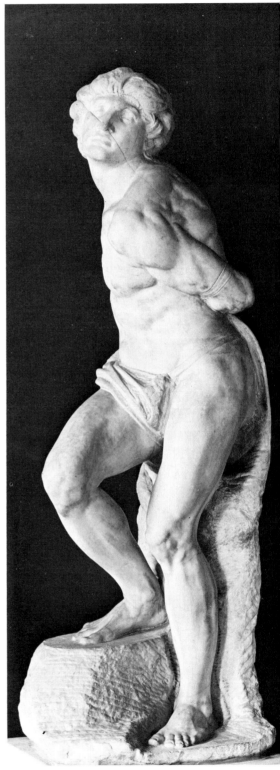

round-headed niche. The distribution of figures in the revised upper storey was to be as follows: the figure of the Virgin was to occupy the deep central niche, and in front of it at her feet the dead pope was to be supported, as if seated on the sarcophagus, by two angels; four large seated figures (among them the *Moses*) were to be placed in the recesses between pilasters, on the front and the sides, and there were to be reliefs in the square spaces above them.

To sum up: this project meant a reduction by about two-fifths both in the body of the architecture and in the number of figures; the project of

89. The Church and Piaz
of San Lorenzo, Florence

1513 contained forty figures, the new one only twenty-four, sixteen in the lower storey, eight in the upper storey. And instead of the two very large reliefs of the side elevations there were to be four new, but rather small reliefs, each a little over one metre square.

But this is only one aspect of the new design, the practical one. Another, and more important, is its startling novelty and its convincing unity. This composition (88) is no longer comparable with Sansovino's: the artist tried to secure in the architecture itself a block-like unity and monumentality for a structure which was designed to contain an assembly of statues and reliefs. Through the introduction of one-bay-wide side elevations the plasticity of the whole structure would have become measurable, and it would also have allowed the spectator to appreciate the rich gradation in depth of the front. There is only one principal view here, that from the front, while each of the two previous projects had three main views.

Michelangelo made extensive preparations for carrying out his new project within six years, as stipulated in a new contract with the heirs. Then the second, and this time decisive, crisis in the history of the monument followed: a conflict between the cause of the dead pope and the interests of the living one. The Medici pope, Leo X, offered a grandiose new task to Michelangelo, and the artist was lured into accepting it.

The task was to provide the missing façade to Brunelleschi's San Lorenzo in Florence, the favourite church of the Medici and the burial-place of their dead (89). Michelangelo always had a profound

admiration for Brunelleschi's genius, and Leo's offer came at a moment when the artist, for the first time in his life, had turned his full attention to the problems of architectural composition. His design of 1516 for the tomb is sufficient proof of this; but, among other documents, we also possess twelve leaves of a large sketch-book, full of studies of forms of classical architecture, which date from this time (90).

Two of his studies of 1517 for the San Lorenzo façade, an early one and the last (91, 92), give an idea of the lines along which his imagina-

Studies after antique
hitecture. London, British
seum.

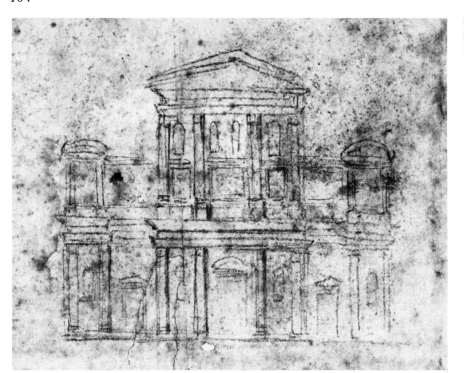

91. Study for the façade of
San Lorenzo. Florence, Cas
Buonarroti.

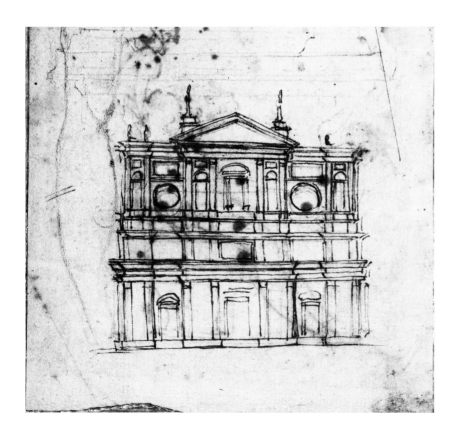

92. Study for the façade o
San Lorenzo. Florence, C
Buonarroti.

Copy after the model for
açade of San Lorenzo.
ence, Uffizi.

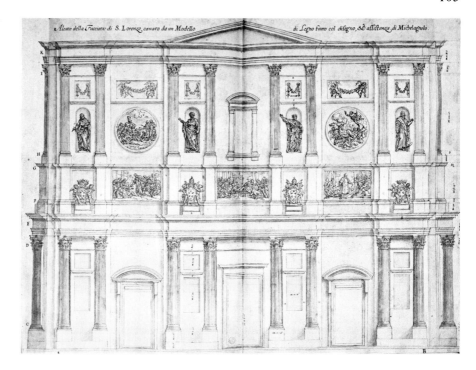

tion was moving. But the point that interests us now is that the new task provoked a radical change in his inner relation to the tomb. This part of the story has not been told by Condivi. To state it briefly, Michelangelo's final design for the San Lorenzo façade—he made it in May 1517—was a revised and improved version, a version on a gigantic scale, of his project of the previous year for the tomb. Both had side elevations of the width of one bay—a complete novelty in the history of façade architecture which can only be explained by a reference to this origin. But this design could be conceived in one piece, for unlike the tomb it was not composed of parts of different origins: a lower storey invented in 1505, re-shaped in 1513, with an upper storey designed in 1516. The drawing reproduced in 93 is an exact copy of Michelangelo's lost model for the façade (at least of its architecture). The projected figures and reliefs were: six statues of marble for the lowest order, four for the front façade, and one on each side façade; six bronze figures for the middle order, similarly disposed but to be represented seated; and for the top order, another six marble figures arranged in the same sequence but here placed in niches. And at least nineteen reliefs, varying in shape and scale in each order, were also planned.

The upper part of the reconstruction of the 1516 project for the tomb (88) and the drawing after the model for the façade (93) show that, as an architect, Michelangelo—like all his contemporaries—began as a classicist. The same purely classical forms appear in both; Bramante, in his late period, went no further in this respect. But both designs show

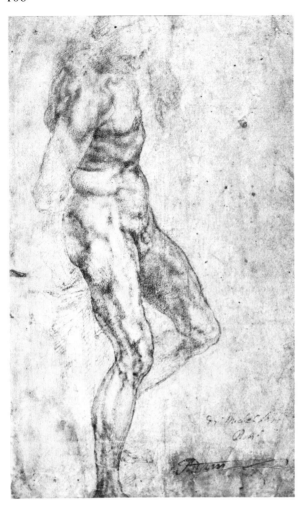

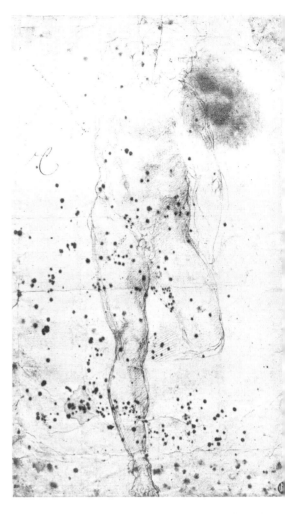

the same unclassical relation between the two orders: the weight which
the lower storey has to carry has been increased to an almost menacing
degree. This is, perhaps, the only feature in the façade project that
unmistakably reveals Michelangelo's independent spirit. He was very
proud of his first attempt at monumental architectural composition and
extolled it in a way for which there is no parallel in his life-story.

Bolder schemes were to follow soon: the Sagrestia Nuova and the
Library of San Lorenzo. As a consequence, the tomb of Julius II lost its
importance for Michelangelo's art, and therefore it lost its importance
for the artist. I think one is right in stating that the really important
part of the history of the monument ends with the master-plan of 1516.
But is perhaps best to continue with the rest of the story immediately
—it is easier to understand it in this context. From the crisis of 1517
onwards Michelangelo worked on the tomb only at times when he had
no other important work in hand. And at such times he would take up
the ideas of the creative years 1513 to 1516 which had culminated in the

94 (*left*). Study for a Slave
Paris, Ecole des Beaux-Ar

95 (*right*). Study for a Sla
Paris, Louvre.

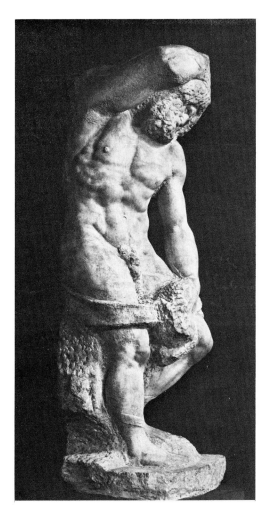

(left). The *Bearded Slave*. nce, Accademia.

(right). The *Youthful*, Florence, Accademia.

new design. This happened, for example, in the years 1521 to 1523, the first interruption in his work on the New Sacristy. It was, in all probability, at that time that he hewed out two *Slaves*, of which the first designs are preserved (94, 95), one dating from the middle, the other from the end of the second decade. In the execution they were changed (96, 97): they were placed in the blocks in a different way and their motives were recast. Contrary to the drawings, in each case the block is much deeper than it is wide, and it is more densely filled with the forms. The figures, moreover, are considerably larger than the two now in the Louvre (86, 87). Is this then the same development we found in the series of Nudes on the Sistine Ceiling? These figures are so large that they cannot be fitted into the existing architecture of the lower storey; they would completely cover the herms, and they are considerably deeper and wider than the plinths on which they would have to stand. One is led to ask whether Michelangelo was not by that time ready, or even glad, to sacrifice that whole dwarfish architecture, with all its

108

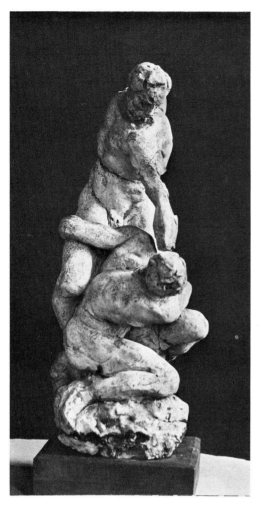 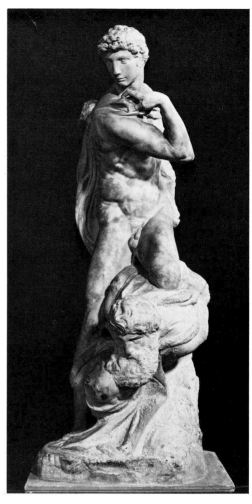

Quattrocentesque ornaments, and to replace it with a plainer one.

It was probably in the years 1527 to 1530, during the second break in his work in the Sagrestia Nuova, that Michelangelo was working on the group known since Vasari as *The Victory* (99). It can only be one of the allegories of Virtues planned as early as 1505. Its content appears to be clear: Virtue, by defeating Evil, makes the soul free and links it to the Divine. This is reflected in the ideal beauty of the protagonist, in his elastic upward movement and in his elongated proportions. The measurements of the group suggest the same considerations as do those of the unfinished *Slaves* in Florence: a change in the architectural framework. Unfortunately, no record has been found so far to cast light on the details of this change. Figure 100 reproduces a conjectural drawing to show on the same scale all the figures which, to our knowledge, were more or less ready or prepared for the front of the tomb by about 1530, and to suggest their possible location: the four *Slaves* in the Florentine Academy (the two we have seen and two others contemporary with

98. Clay model for an allegorical group. Florence, Casa Buonarroti.

99. The *Victory*. Florence, Palazzo Vecchio.

Reconstruction of
ted arrangement of the
of Julius II, *c.* 1527–30.

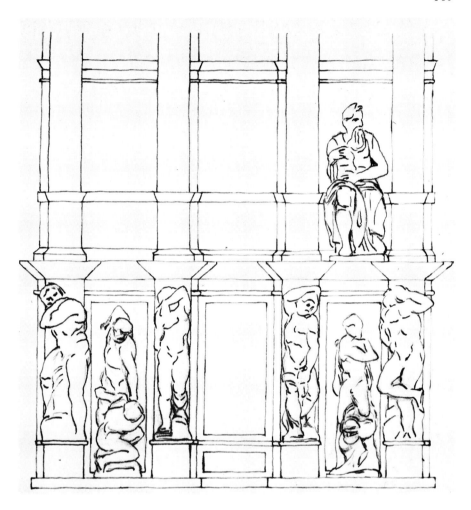

them but much less advanced), the *Victory*, its pendant (for which, I believe, there exists a clay model in the Casa Buonarroti (98), and the *Moses*. The simple form of the plinths and the recessed rectangular panels behind the groups (replacing the round-headed niches) have been taken from Michelangelo's final design for the San Lorenzo fa-çade.[18] Looking at the row of six figures below we find that its effect was to be based on a sharp contrast: effortless conquest of gravity in the two Victory groups and weightiness and a 'sagging' of all forms, in the four *prigioni*. And it appears possible that a similar contrast was intended to underlie the composition of figures in the upper storey. In that case, the elastic upward movement of the two *Victories*, which begins at floor-level, was to work through two barriers—the row of four *prigioni* and the large seated figures—leading up to the angels behind the pope and culminating in the *Madonna*, the peak of this very steep pyramid.

In the autumn of 1530 Michelangelo was forced to return to his work

in the New Sacristy, and his project of 1516 was finally abandoned. He was ready to compromise, at almost any cost, in order to regain his freedom. The other party was ready to do the same; their motives were to save spending any more money and to comply with the wishes of Clement VII. The opportunism of both sides did not fail to leave its stamp on the result. The design, which was the outcome of a contract of 1532 and was to underlie yet another of 1542, was, according to Condivi, a patchwork—and we need not be more appreciative than Michelangelo's own scribe.

The tomb was finally displayed, with its figures, in the south transept of San Pietro in Vincoli, early in 1545 (75). Apart from the *Moses* none of the figures executed earlier was used. On the spot one may observe how the artist tried to give it a composition which was at least appropriate to the site. To achieve this he had to adapt, and to re-model, fragments of his earlier designs. The structure is a wall-decoration which has been brought into line with the architecture of the church. A high, plain socle has been placed under the lower storey and a new upper storey has been added. The latter is a variant of the corresponding part of the 1516 project (88), but it is reduced in height; instead of the pilasters there are herm-pilasters once more, the recesses split the storey right up to the main cornice and the square reliefs are replaced by windows which serve the room behind. A deepening of the central recess was not needed; the small sarcophagus was placed lengthways in front of it. Great changes have also taken place in the figure-decoration. The herms are larger and heavier, and the *Slaves* are replaced by massive volutes. The *Moses* has been placed in the centre of the whole structure (84). As we have seen, this figure was originally designed for the platform, and later for one of the recesses of the upper storey—that is to say, in either case to be placed about four metres above the ground. The consequences of this change of position are grievous; the splendid motive of framing the right leg with a cataract of mighty folds has lost much of its significance, and the waist appears too long. The groups of *Victories*, which were to occupy the places in front of the niches between the plinths, have been replaced by the personification of the *Vita Activa* (*Leah*) and the *Vita Contemplativa* (*Rachel*), and these have been pushed into the niches.

The three statues of the lower storey are Michelangelo's work: the *Moses*, begun between 1513 and 1516, and finished between 1532 and 1544, and *Leah* and *Rachel* conceived, I believe, in 1533 and executed between 1533 and 1544 (101, 102). The four statues of the upper storey, the *Virgin*, the *Pope*, the *Prophet*, and the *Sibyl*, are in a different category: Michelangelo never even touched them; he only made models for them, in 1532–3, and then handed over these models for execution to some unusually feeble assistants. They have never pleased anybody, and are a shock to the beholder who looks up to them from the lower

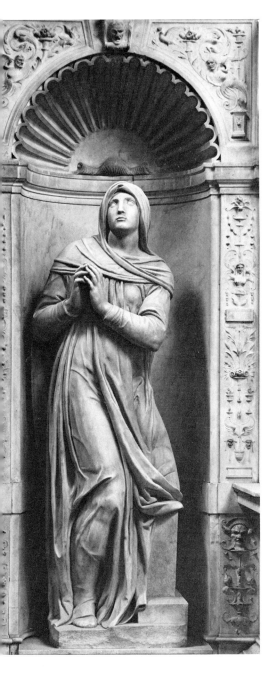

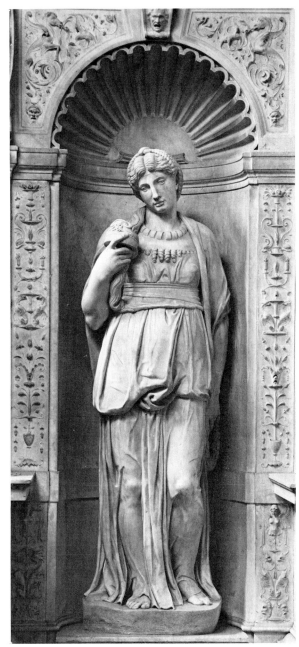

Rachel. Rome, San
in Vincoli.

Leah. Rome, San Pietro
:oli.

realm. Their architectural frame, too, is in painful contrast to the forms
below. It is based on Michelangelo's later principle which would not
allow any ornament in the vicinity of marble statues.

Such an incongruity of parts of different origins could not be
balanced by the now coherently Christian content. In his compromise
design (it is no longer a tomb, only a memorial to the pope)
Michelangelo found his way back to the tradition of Italian sepulchral

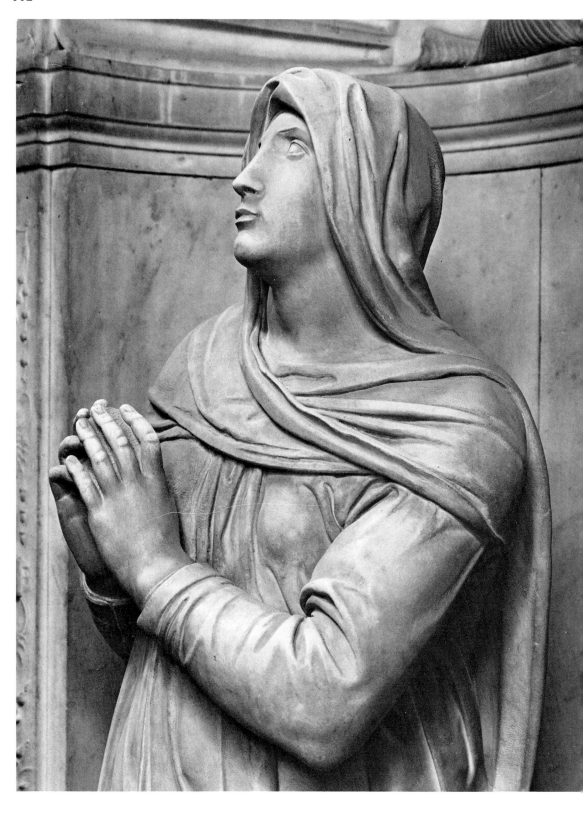

..achel (detail). Rome,
.tro in Vincoli.

art. He also solved the problem of how to make the figures appropriate to their place in the church. As I have mentioned earlier, the monument covers almost the whole end-wall of the south transept of San Pietro in Vincoli. It follows that *Moses* is turned towards the visitor approaching either through the right aisle or through the nave; while his right side is guarded, as it were, by the altar which stands in the right-hand apse of the church. The representative of the *Vita Contemplativa* and the *Sibyl*, both in prayer, turn towards the same altar; while all the remaining figures face the beholder who stands in front of the monument. At least the ingenuity of the composition may impress the visitor to San Pietro in Vincoli. And he will also find that the two new statues, however different they are from the *Moses*, are of very high quality. They are the only statues by Michelangelo dating from the period of the *Last Judgement* and are, therefore, important documents of the time when he became an intimate friend of Vittoria Colonna and of other leading members of the movement for church reform in Italy, and was absorbed in the problems of faith and personal salvation. A detail of *Rachel* (103) is an epitome of the change: Christian contemplation and prayer are shown as the right way of life. Art has become a means to impress the beholder with this truth.

The Medici Chapel and the Laurentian Library

In retrospect the Medici Chapel, the subject of this chapter, appears as the climax of a sequence of works, and projects for works, of a particular kind. They distinguish the period of maturity in Michelangelo's career. In each of these works an assembly of statues was placed, or was to be placed, in an architectural framework designed by the artist himself for this purpose. Such works do not occur in Michelangelo's *œuvre* either before or afterwards, but in his years of maturity, from his thirtieth to about his fiftieth year, they predominate. One can clearly see how much they meant to him and how they absorbed his energies. He himself praised two of them, his first project for the tomb of Julius II and his final design for the façade of San Lorenzo, in words of exceptional self-confidence. Also, a commission which was originally meant to be of a different character, the decoration of the Sistine Ceiling, was transformed, as it were, into one of this particular kind of combination of figures and architecture. And one should remember that the only two works of a different nature undertaken by him during this period, the single statues of Julius II for Bologna and of Christ holding the Instruments of the Passion for Santa Maria sopra Minerva (138), were intended by Michelangelo to be placed in tabernacles on church walls, that is to say, in architectural settings.

With the exception of the Sistine Ceiling, all these schemes remained mere projects. Only the last of the series and its climax, the Medici Chapel, was carried far enough to enable us to appreciate its intended effect. This scheme was no longer just part of a building, or a structure to be placed in a building: it was an independent unit within a complex whole, the church of San Lorenzo and its monasteries.

Its history carries us back to the most critical moment in the history of the tomb of Julius, of which I gave a very short summary in the last chapter, the moment when the perfectly reasonable, and artistically highly significant project of 1516 was abandoned under the impact of new tasks. In order to make good the failure of the San Lorenzo façade—a failure which was at least partly due to the financial difficulties of the patron—and to retain the artist in the service of the Medici, he was given this new commission.

Originally it was a commission rather restricted in scope: to build a chapel on to the north transept of San Lorenzo as a copy of, and a

counterpart to, Brunelleschi's Sacristy at the end of the south transept in which some older members of the family were buried; the new Sacristy was to contain the tombs of four younger members. The patron was Cardinal Giulio de' Medici, a cousin and the Vice-Chancellor of Leo X, and at that time the Archbishop and the *de facto* ruler of Florence. The new chapel was to serve the dynastic interests of the family. The four Medici to be buried in it were distinguished by high secular honours: two *Magnifici*, Giuliano and Lorenzo, the uncle and the father of the pope; and two dukes, the pope's younger brother Giuliano, Duke of Nemours, and his nephew Lorenzo, Duke of Urbino.

It appears that at first Michelangelo was only required to devise plans for the tombs and perhaps contribute a few statues to their decoration. There was an architect in charge of the building operations. This cautious procedure on the cardinal's part was the consequence of recent experiences which he and the pope had had with the artist in the affair of the San Lorenzo façade. There the work reached immense dimensions under Michelangelo's hand, and yet he wanted to direct all its aspects single-handed, so that little progress was made and ultimate failure was inevitable. This time the cardinal's idea was to present him with a *fait accompli* and to reduce his part to a minimum. But the plan did not work.[19]

Remember the artist's situation at that time. Since completing the Sistine Ceiling eight years before he had not finished any works except the two *Slaves* now in the Louvre, and these he left, together with the unfinished *Moses*, walled up in his house in Rome. He must have felt like a recluse. His letters show that he was the victim of deep depressions. He received the new commission at a critical moment. It inspired him, gave wings to his imagination, and very soon the restrictions set upon it meant nothing to him. Consequently, when his designs were ready he succeeded in winning the patron's consent and was free to embark upon the principal work of his middle years.

Michelangelo's final design for the New Sacristy was not restricted to the four tombs; it contained a consistent architecture for the whole interior of the chapel, an architecture in which the sepulchral monuments were no more than integral parts and which is very different from Brunelleschi's interior (104, 105). What he did respect was the chapel's place in the complex of the church fabric (127). Therefore he accepted the ground-plan—an oblong made up of a square (the chapel-space) and a smaller square (the chancel) flanked by two *lavamani* (that is to say, tiny sacristies)—and he chose an exterior the forms of which were as far as possible in harmony with those of the rest of the eleva-tion. This was necessary because this whole east end of the church, now hidden behind later buildings, then stood free in the prior's garden. Figure 106 is a reconstruction of the original aspect of the east end—which, by the way, is in the West, for San Lorenzo has a reversed

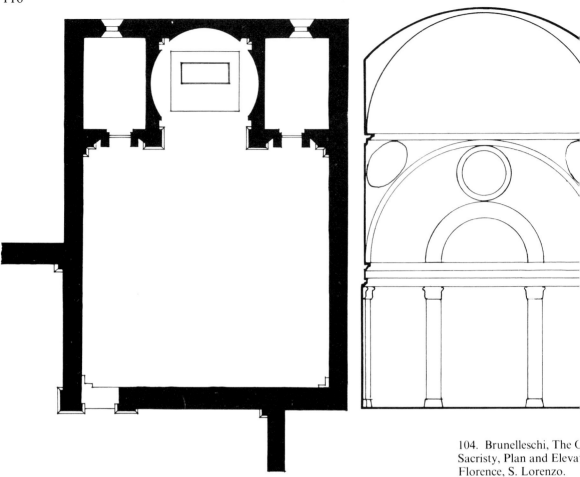

104. Brunelleschi, The C[
Sacristy, Plan and Eleva[
Florence, S. Lorenzo.

orientation.) Since this setting has gone for ever, it has been overlooked
that Michelangelo's tribute to the harmony of the exterior could only
be realized at the cost of an extremely difficult construction, for it is
entirely at variance with his interior. To mention only the most par-
adoxical difference, there is no drum (105).

As for this interior, let us first look at the ground-plans of the two
sacristies in more detail (104, 105). The most obvious difference between
them is that the order applied by Brunelleschi on the altar-wall has, in
the later building, been carried through on all four walls. This change
appears natural in a building of the sixteenth century and was doubtless
intended from the beginning. There exists a rapid sketch by
Michelangelo which dates from the initial stage of the building opera-
tions (107), and this already shows that systematic use of the order. It
reveals some ambiguity in the placing of the doors, as a consequence of
this decision. The position of the entrance door from the church could
not be moved without altering the structure, and that position was not
centred on the new side-bay of the interior of the Sacristy. In the Old
Sacristy there is no correspondence between altar-wall and entrance-

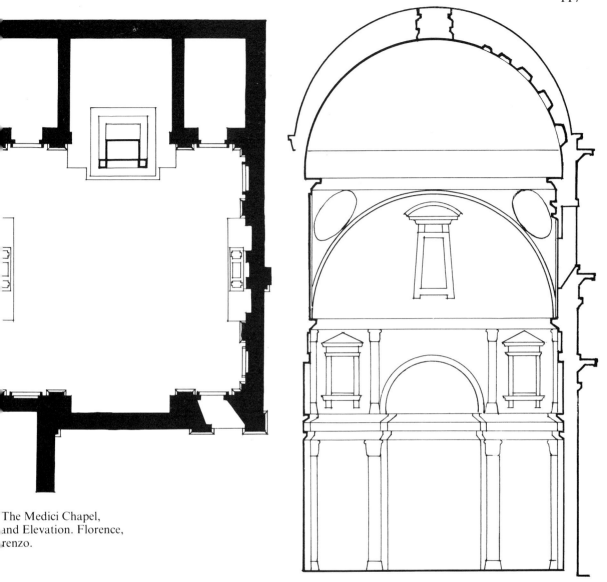

The Medici Chapel,
and Elevation. Florence,
renzo.

wall. Michelangelo, trying to keep a correspondence even for the doors, first designed those of the *lavamani* off-centre; then he recorded his intention to change this, just at the point where it was not possible to change it. The plan as executed shows how he succeeded (105). It caused a shock when it was made; now it is not noticed because one never enters the chapel from the church.

Now, if we look at this chapel-space with its strict axial symmetry and ask ourselves how four tombs could best be placed in it, we should probably try the following ways: first, a tomb in each of the two lateral bays of the two side-walls (as we see in the early sketch, 107); second, double tombs in the central bays of the side-walls; and third, all four

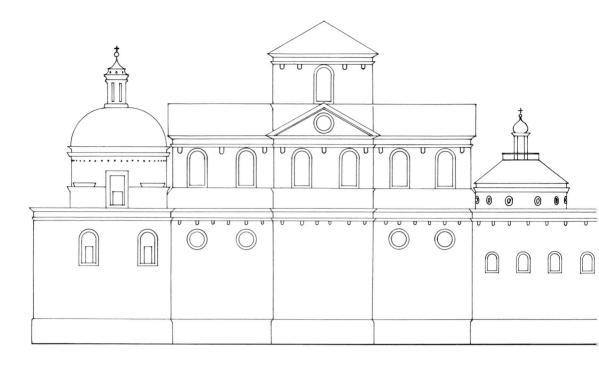

106. Western elevation o
San Lorenzo, *c.* 1530.

107. Sketch-plan for Me
Chapel. Florence, Casa
Buonarroti.

right). Study for free-
ing tomb. London,
h Museum.

far right). Studies for a
tomb. Florence, Casa
arroti.

below left). Study for a
tomb. London, British
um.

below right). Study for a
e wall-tomb. London,
h Museum.

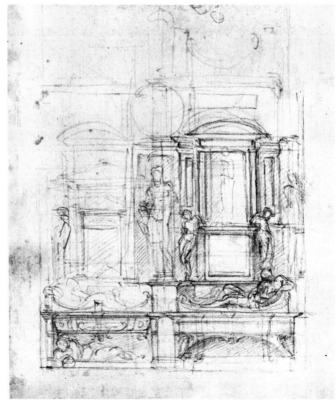

tombs in the centre of the room, forming a square, free-standing monument. Michelangelo's correspondence and his sketches, of which a fair number has been preserved, show that he had thoroughly tested all three possibilities before he found a surprising fourth one. We cannot examine all these sources in detail, but I should like to comment on a selection of his drawings to make the further changes in his interior understandable. I begin with one of his studies for a free-standing monument (108). He clearly cherished this idea, which was historically a novelty, for more than half of his surviving studies for the tombs are concerned with it. They are of different types, some more architectural, others more sculptural in character. This, one of the finest, maintains a satisfying balance. The relation of width to height of the whole block is the same as that of the central bays of the chapel walls, against which the monument was to be silhouetted; and, the better to display the architecture of the monument in spite of its relatively small dimensions (its greatest width was to be three metres), the artist shows only the end of the sarcophagus, its length being conceived as buried within the monument.

This scheme was derived from the idea of narrow wall-tombs erected against the lateral bays. A detail from another drawing (109) shows two alternative solutions for that earlier idea: the upper one is in the manner of wall-tabernacles, with the sarcophagus hanging in the air but serving as a base for the aedicule; the square panel was intended either for inscriptions or for a relief. The lower design is for a wall-tomb proper, with the sarcophagus placed laterally on a plinth (the height of this plinth has twice been increased), a tripartite upper storey, and three figures as decoration; the proportions are those of the lateral bays (114). In a later drawing (110) these odd proportions have been corrected and those of the free-standing monument adopted also for this scheme. This design means a temporary return to the idea of four narrow wall-tombs, after the cardinal's criticism has put an end to Michelangelo's project for a free-standing structure. It was a temporary return, because the solution represented in both drawings had the practical disadvantage that structures modelled in such high relief would have interfered with the entrance doors of the chapel, the position of which, as we have seen, had been fixed from the beginning.

Then the artist's attention turned, quite logically, to the central bays. A drawing in the British Museum (111) is apparently connected with another project for wall-tombs; a double tomb is now to be placed in the wide central section of each side-wall—in other words, the single tombs from the side sections are to be brought together in the middle. This has been done here more or less mechanically; the two halves were connected with each other by drawing first a pilaster, then a large figure, both standing on the central pier which separates the sarcophagi, and by adding a central medallion and a continuous cornice and attic

112. Study for a wall-to
London, British Museum

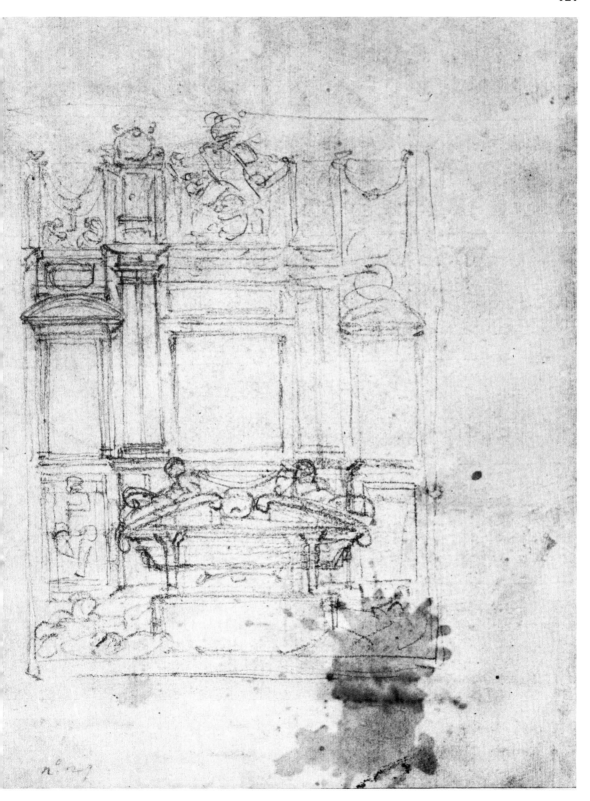

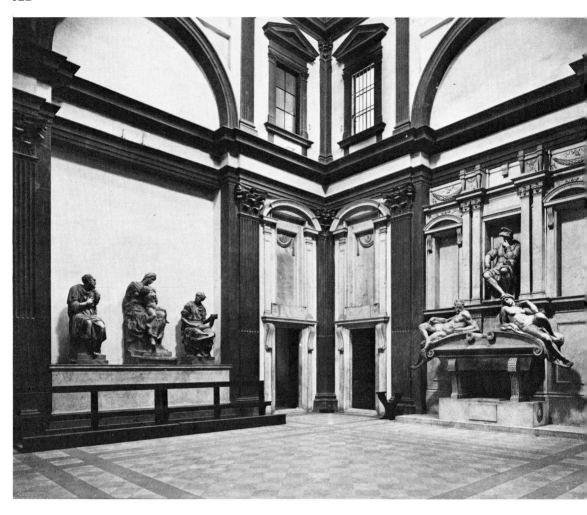

above them. But in spite of these links, the scheme would have superimposed on the tripartite wall-composition a division into four vertical sections, and that was found unsatisfactory.

Michelangelo's next design is strictly centralized (112). It was used, with some alterations, for his final plan for the Medici tombs. The artist decided to place single tombs, for the dukes, in the central bays of the two side-walls and a double tomb, for the two *Magnifici*, in the central bay of the entrance wall. But in order to make room for compositions on this monumental scale and of this rich plasticity, he replaced the plain central bays of the chapel by deep, arched recesses, separately framed, lest their architecture should clash with the main order. This revision involved a radical change in the whole interior structure (105). A second order was added to the first in a wonderful harmony, resulting in a new vertical division, different from Brunelleschi's, with windows in the attic and in the lunettes, those in the latter tapering towards the dome. The whole interior is not only higher but, with its propor-

113. Interior of the Medici Chapel. Florence, San Lorenzo.

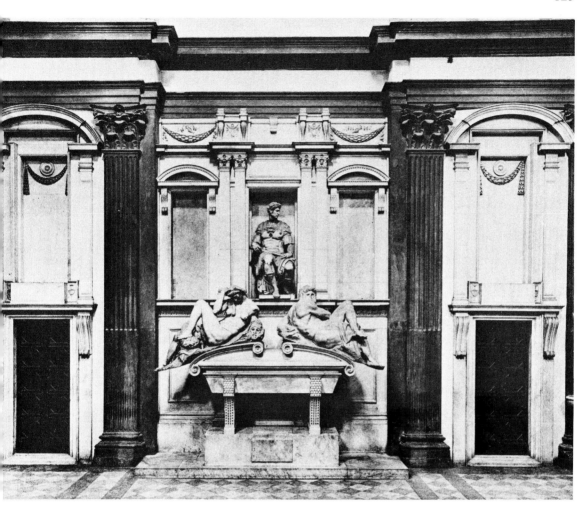

The tomb of Giuliano
..dici. Florence, San
..o.

tions of one to two, appears to be much higher than the Sagrestia Vecchia, and comparable in this respect to Gothic interiors. As in the latter, the structure seems elastic and almost weightless. So does its dome, modelled on that of the Pantheon. A comparison with the interior of the Pantheon, as it existed until its alteration in the mid-eighteenth century, shows that the second order, too, with the arch of the recess penetrating it, derives from the same classical example.

In this new scheme the highly plastic tombs in the centres of the walls demanded some kind of lateral extension; their architecture demanded a continuation beyond their *pietra serena* frames. To achieve this Michelangelo applied to each lateral bay an identical structure in marble, consisting of mighty tabernacles placed above plain and rather small doors (113, 114). This was an inversion of the form which Donatello had applied to the side-bays on the altar-wall in the Sagrestia Vecchia: there the doors are of a heavy plasticity and the niches above them are shallow. Repeated eight times, this system produces the effect

of complete unity in the lower realm of the composition. On the two side-walls these lateral structures are very closely connected with the tombs in the central bays. The underlying principle of their common composition is this: the positive forms (i.e. plastic frames) diminish, while the negative forms (i.e. recesses) increase, towards the centre, where the image of the deceased is placed. Further: a tangent meeting the curves of both pediments ends at this centre. And last but not least: this centre was to be the peak of a pyramid of figures. The base of this pyramid was to be a pair of river-gods, its sloping sides the *Times of Day*, and its peak the *Capitano*, each part receding as the pyramid rises upwards.

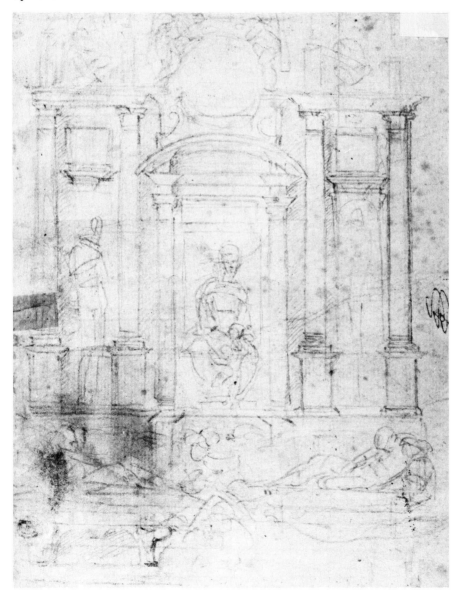

115. Study for the tomb the *Magnifici*. Paris, Lou

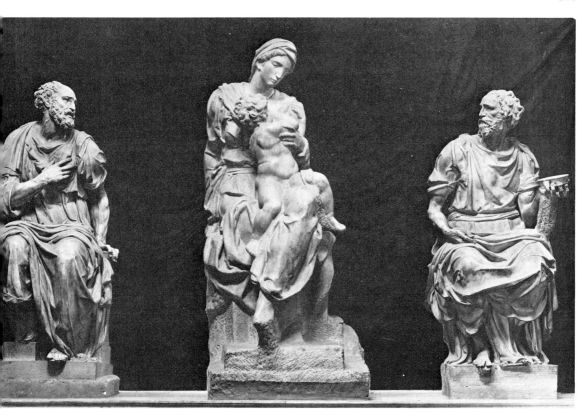

The Virgin and Child,
Damian and Cosmas.
ice, San Lorenzo.

So much for the two side-walls. But there are two more fundamental facts concerning the composition of the interior as a whole. The first is this: Michelangelo focused his composition on the monument which was to be erected in the central recess of the entrance wall. This monument was never completed, and this is the reason why the spectator has such great difficulty in finding his orientation in the chapel. Fortunately, two of Michelangelo's preparatory drawings for this monument have been preserved (one repr., 115). They show that only the lower part of the structure was to be given to the tombs of the two *Magnifici*. The upper part was to form the altar-piece of the chapel. Here, on a second base, were to be placed statues of the Virgin (in a tabernacle) and of the patron saints of the Medici, Cosmas, and Damian, in deep rectangular recesses framed by columns (116). The altar itself is placed under the entrance arch of the chancel (117) but, as in medieval baptistries, it is turned towards the chapel, and this means that it was to face the altar-piece planned for the opposite wall. It follows that the ideal standpoint—the only point from which the composition of the whole interior can be surveyed and appreciated—is that of the priest celebrating at the altar. Standing here one notices at once that the seated figures of the dead on the two sides, Duke Lorenzo and Duke Giuliano, are turned towards their patron saints who intercede for them with the

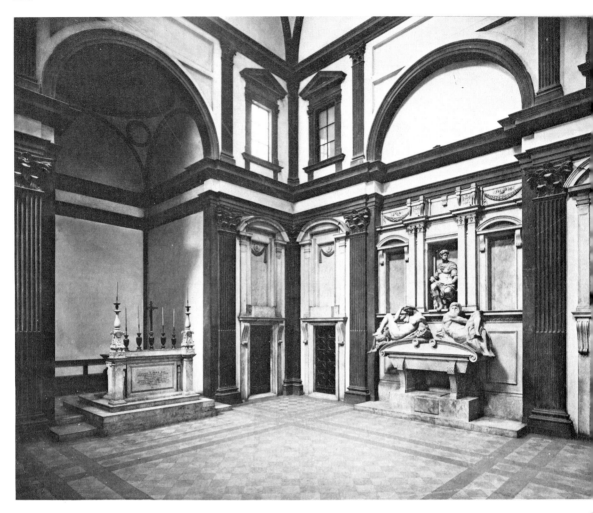

Virgin and the Child; consequently the present position of the statues of the patron saints should be reversed and, as the drawings show, all five statues should be placed on the same level. They were to form a *Sacra Conversazione* with two donors, arranged in space. It would be useless to try to point out further correspondences between the sides and the centre—they cannot be shown in distorted photographic views.

Another remarkable fact is the existence of eight identical doors in this interior. Two are entrance doors, one from the church, one from outside, and two open to the small *lavamani* to the right and left of the choir; the other four are sham doors. Since all are inconspicuous and there are no differences between them, from the moment when the real doors are shut and one has attained the right orientation, it is difficult to find again the points of ingress and egress. Undoubtedly this effect was intended by the artist. It means that his chapel was indeed planned as a mausoleum, and a mausoleum only—the home of the dead, not built to receive curious visitors.

117. Interior of the Medi Chapel. Florence, San Lorenzo.

Clay model for a River-
Florence, Casa
arroti.

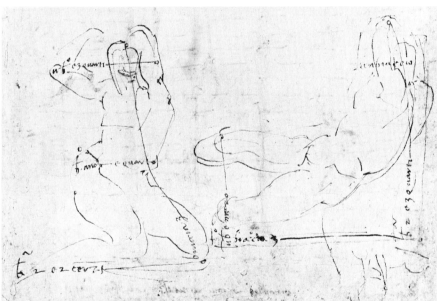

Drawings for a River-
London, British
um.

It was not finished. Its focus is missing, and the monuments in the
recesses of the side-walls are incomplete. As the preparatory drawing
(112) shows—and one learns the same from many other documents—
recumbent figures representing rivers (Michelangelo himself calls them
fiumi) were to be placed to the right and left of the socle on which the
sarcophagus stands. Michelangelo's full-size clay model for the left-
hand river-god of the tomb of Lorenzo is still preserved, though in a
much damaged state (118); it is still in Florence but it has always been
displayed incorrectly; it was intended to lie on its right side. (It is
known that, contrary to his usual practice, Michelangelo made such

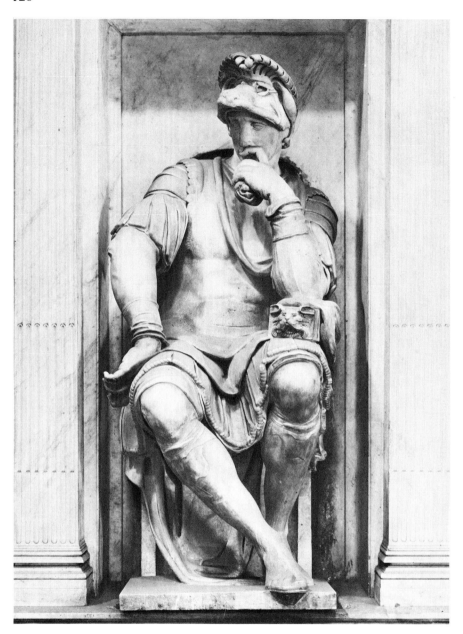

120. *Lorenzo de' Medici, Duke of Urbino.* Florence, San Lorenzo.

full-size models for all the statues in the chapel, except perhaps for that of the Virgin. That was the wish of Pope Clement who wanted him to be helped by assistants in roughly hewing-out the figures.) And we also possess a working drawing for the right-hand river-god of the tomb of Giuliano (119). These missing figures are very important, and Michelangelo reserved their execution for himself. The lateral tabernacles of the ducal tombs were to receive standing allegorical figures, Giuliano's tomb those of *Earth* and *Sky*. These were left entirely to assistants to be worked from Michelangelo's models, and so were the

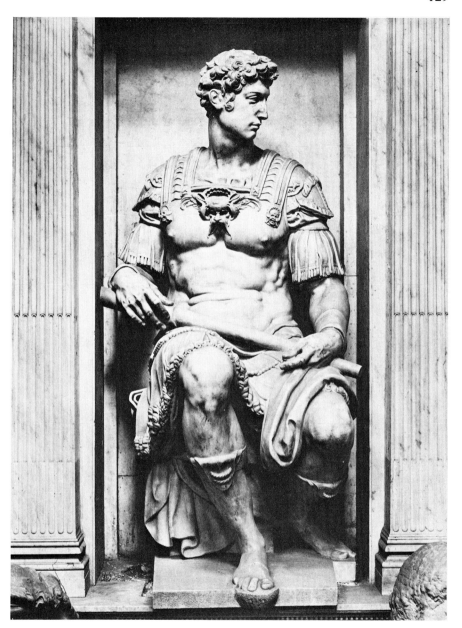

executed statues of the patron saints on the tomb of the *Magnifici*.

The two monuments of the side-walls had been conceived as the corresponding halves of a larger unit. The statues of Giuliano and Lorenzo—the *Capitani* as the artist himself called them—are not portraits: Michelangelo conceived them as representatives of the two ways of Christian life, the *Vita Activa* and *Vita Contemplativa* (120, 121). Lorenzo is calmly pensive, deep shadow is cast over his face. The two windows in the attic opposite this tomb are blind, and the figure receives light only from the highest realm of the interior, through the

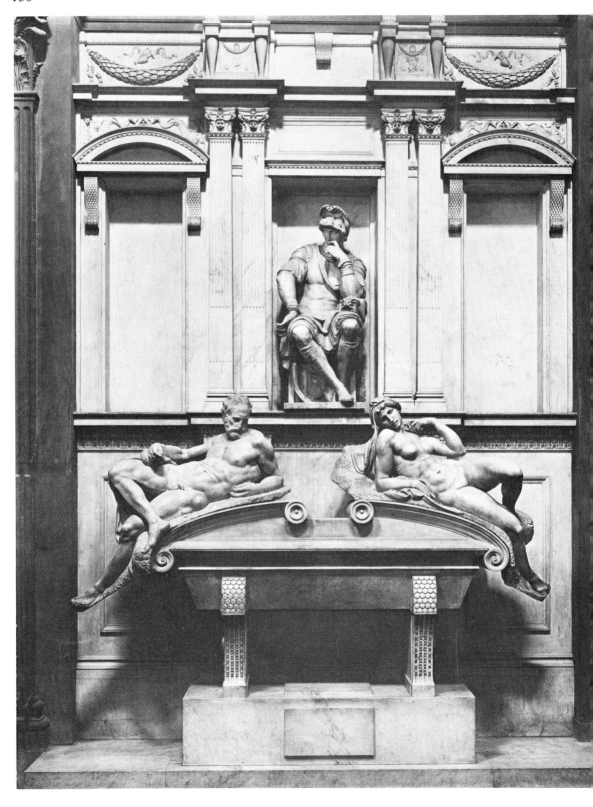

lunette windows and the lantern. (The attic windows on the entrance-wall are still closed; those on the altar-wall have been opened up since the last century, and so the intended twilight in the lower half of the chapel has been altered.) Giuliano is seated erect. A twisting movement runs through his whole body, and this is contrasted by his head which is turned in the opposite direction. Originally only this figure was well lit, from the attic windows opposite.

All the other figures on the tombs conform, both in expression and form, to this idea of complementary pairs. Iconographically they may be regarded as descendants of the traditional mourners. The figures on the sarcophagi are allegories of time: for that we have Michelangelo's own authority. The river-gods were, perhaps, meant as allegories of space, or else of the Underworld. The figures planned for the taber-nacles were probably to represent the Four Elements. Now, *Evening* and *Dawn*—or, perhaps more correctly, *Falling-asleep* and *Awakening*—on the tomb of Lorenzo are, like him, in a contemplative and melancholy mood (122). Lying half on their sides, their limbs are relaxed, even sagging; their outlines smoothly follow the convex curves of the sarcophagus lid. Their modelling is soft; both are carved from very deep blocks. *Night* and *Day*, or *Asleep* and *Awake*, on Giuliano's tomb, show very strong movements (114); their convex outlines are for-cibly opposed to the segmental curves of the sarcophagus; their blocks are comparatively shallow but are densely filled with forms. A similar contrast underlay the designs for the river-gods, as shown by Michelangelo's clay model and his working drawing.

These differences of form and mood have often been interpreted as symptoms of a stylistic change, and Giuliano's tomb has been con-sidered the later. In fact, only the architecture of this monument was executed after that of Lorenzo's, and one can observe some slight changes in its ornament which may be judged in this way. But these are insignificant. All the figures were demonstrably conceived at the same time, and their execution was begun irrespective of their places. (I have found evidence to prove that the *Day*, which has often been considered as the latest among the statues in the chapel, was actually begun in marble first.)[20] These figures were equal parts in a preconceived com-position, and this composition secured the matchless unity, both in content and in form, which distinguishes the work. All its parts speak the same language.

The three decades which began with the Battle Cartoon and end with the Medici Chapel were the period in which Michelangelo endeavoured to realize in his art the 'Truth of Beauty' after which he aspired—the phrase is found in one of his poems dating from the end of the period.[21] This beauty (121, 125) was entirely his own, but it was attained and formed under the animating guidance of classical antiquity and was rightly compared with it by Michelangelo's contemporaries. For a short

he Tomb of Lorenzo
dici. Florence, San
o.

moment, before a complete change occurred, Michelangelo's art—a
highly idealistic and individual art—is comprehensively based on the
purity of Platonic form.

The history of the work can be told briefly. Michelangelo's final
designs for the chapel, for its interior and exterior architecture and
its monuments, were ready by the spring of 1521. The building was
carried on rather slowly, and the dome was not finished until as late as
the end of 1523. Meanwhile Michelangelo twice went to Carrara to
order the marble for all three monuments. But owing to the desolate
finances of the Medici, following the death of Leo X in December 1521,
he was not allowed to start on the statues, and there followed a long
break in his own work. Only after the election of Cardinal Giulio
to the Papacy in November 1523 was he given complete freedom of
action.

There followed three years of most intense activity in the chapel,
from the beginning of 1524 to the beginning of 1527. The whole of the
marble architecture as it now exists was finished, and the six statues on
the tombs and also that of the Virgin for the altar-piece were begun in

123. *Night*. Florence, S
Lorenzo.

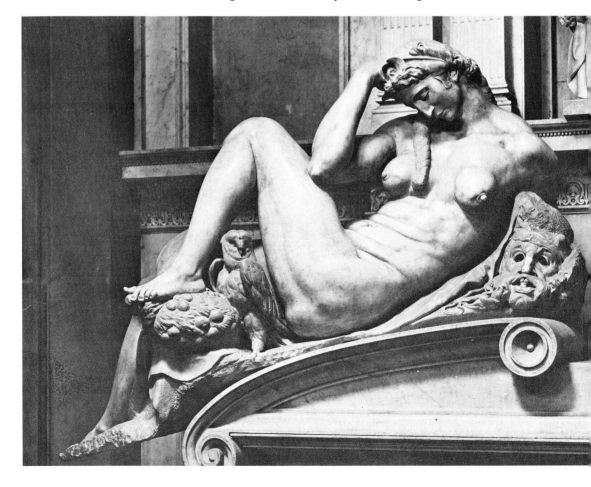

marble at this time (126). Then, again as a consequence of political events, work was discontinued for a second time, but now for more than three and a half years. Rome was sacked by the Emperor's troops; Florence, for the last time in her history, became a republic once more. Michelangelo, who had taken a leading part in this revolution, was not among its many victims. In the autumn of 1530 he was pardoned by the pope on condition that he would continue his work in the chapel, which had become the symbol of the Medicean destiny of Florence. Yet, in the four years from the fall of Florence to the pope's death in September 1534—a period which in its second half was twice interrupted by prolonged visits to Rome—Michelangelo did not begin any new figure, nor did he erect the monument on the entrance wall, although, as we have seen, this was to be the focus of his whole composition. He more or less finished the seven statues he had begun before 1527, and he made the models for four more which were to be executed by assistants: the statues of the patron saints, and the allegories to left and right of Giuliano. Late in the summer of 1534, at the age of fifty-nine, he left his work and his native town for ever.

Day. Florence, San
zo.

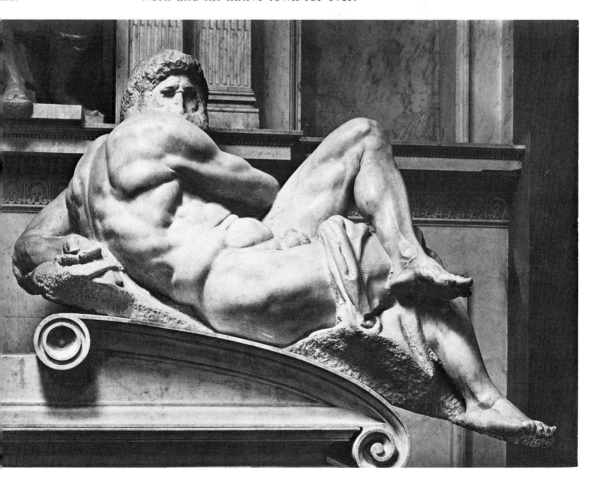

125. *Night* (detail). Flor‹
San Lorenzo.

The New Sacristy was not the only major work left in an unfinished state when Michelangelo moved from Florence in 1534. Another was the library of San Lorenzo—a monument hardly less significant than the chapel in the history of Cinquecento art.

The Medici owned a collection of manuscripts and printed books second to none in the age of the Renaissance. Lorenzo de' Medici conceived the idea of making this collection accessible to students and erecting a building to house it in his garden opposite the monastery of San Marco, where he had his 'free school' for sculptors. His death prevented him from realizing this idea. It was taken up with great energy by his nephew Clement VII, thirty years later.

At first the commission was given to the same builder who had worked under Michelangelo in the New Sacristy and was an old servant of the Medici, Stefano Lunetti. Michelangelo was asked only to contribute a design for the fabric. But in this case as in others the whole undertaking, including the furnishing of the building, very soon became

his exclusive responsibility. This happened in 1524, at the time of the most intensive work in the chapel. No wonder that neither work was completed within the terms fixed for them by the pope.

The library was to be built on the premises of the monastery of San Lorenzo. The problem of site was solved by Michelangelo, after two months of planning, in April 1524. I believe that it is possible to reconstruct this interesting process, and I should like to try to illustrate its three stages.

he Virgin and Child.
ce, San Lorenzo.

First, Michelangelo proposed two alternatives. Each of these would have denied any degree of artistic independence to the new building which was considered in both designs as serving purely practical purposes. The monastery of San Lorenzo (127) forms a large rectangle stretching out southwards and eastwards from the church (the sequence of buildings on the east side is not indicated in this plan). It contains two cloisters: a larger and a smaller one, between which there is a connecting east-to-west wing. It appears that two conditions were fundamental to the planning: first, that the library should have its access from the main cloister, which had a direct entrance from the piazza, the square in front of the church; and second, that it should be erected at first-floor level, for obvious reasons of lighting. We possess two large fragments of Michelangelo's plan of the whole complex in which he indicated his alternatives. These can be explained in the following way (128, 129).

(A) The library running north-to-south across the smaller cloister, with its entrance in the central bay of the south arcade of the main cloister; the building would pierce the connecting wing, traverse the second cloister, and pierce again the southernmost block of the monastery.

(B) Entrance in the central bay of the east arcade; the building running east-to-west and piercing the whole eastern block of the monastery, right down to Borgo San Lorenzo, which was—and still is—one of the city's main thoroughfares.

Pope Clement chose (A) and asked for details and an estimate; he was particularly anxious to know how much of the monks' quarters would be destroyed. This proved to be the stumbling-block on which the project fell; the loss would have been too great, not only on the first-floor level, but also on the ground floor, owing to the necessary substructures. Michelangelo was asked to work out his other project (B). Seeing the pope's interest in the latter, he transformed it into a very ambitious scheme: making it the north end of the eastern block, with a long façade on a now widened piazza and a short one on Borgo San Lorenzo. This would have solved the difficult problem of fenestration. But it was also an entirely new stage in the planning. Now the library was considered a monumental building and was to be used, in this particular project, to give a new shape to the piazza—a shape which would profoundly affect any future projects for the façade of San Lorenzo.

It was a costly project, involving the expropriation of a row of shops and dwellings as well as the building of a monumental exterior. Michelangelo withdrew it before submitting his detailed plans and estimates to the pope in order to avoid the certain conflict with the realization of his own project for the church façade. (The latter was promised him upon completion of the New Sacristy.)

Michelangelo's final project was no less ingenious and bold, but it was much less expensive: to erect the library as an additional storey along the whole west wing of the monastery, with a vestibule giving access to it from the upper arcade of the cloister (130, 131). This building, as originally intended by Michelangelo, would have been in harmony with Brunelleschi's church fabric, and its entirely homogeneous east wall would not have disturbed the peace of the cloister arcades either. For his original project was to build the vestibule as high as the

an of the Church and
ery of San Lorenzo,
e (after Paatz).

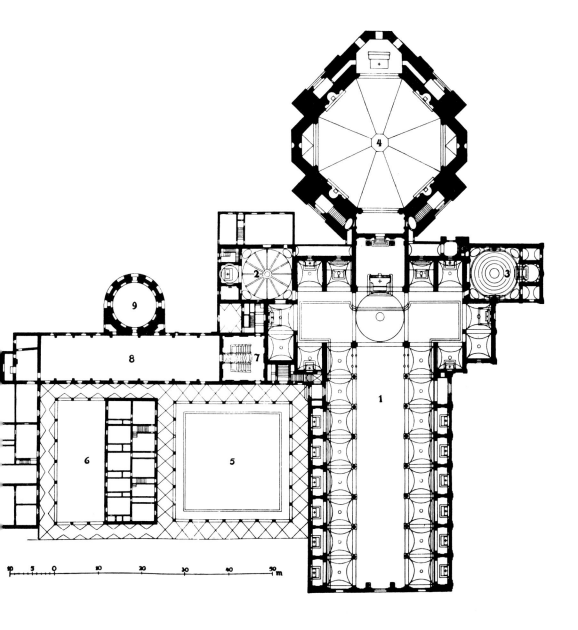

138

128 (*left*). Sketch-plan for the library of San Lorenzo. Florence, Casa Buonarroti.

129 (*right*). Sketch-plan for the library of San Lorenzo. Florence, Casa Buonarroti.

Aerial view of the
monastery of San Lorenzo,
Florence.

reading room, inside and out, and to continue the façade across both, without any alteration in design, except that the vestibule windows were to be blind. In the interior a dado, as high as the difference in level between the vestibule and the library, was to include both the entrance doors to the vestibule and the staircase up to the library; a richly composed main storey was to be set above it, with a low attic and a low-pitched, coved vault, with a circular skylight in the centre. The fifteen-bay reading room, or library proper, was finished by the end of 1525 (132). Subsequently the building of the vestibule began on the lines indicated; it reached the cornice of the main storey in about a year. Then, during the second stage of the work in 1533/4, after a long break caused by political events, the plan was changed at the pope's demand; the project for a vault with a skylight was ruled out and a second storey, with windows on two sides, was added instead of the attic, thus making the vestibule considerably higher than the library. The vestibule was finished only at the beginning of this century, according to Michelangelo's plans for the interior but with disastrous consequences for the façade.

Both Vasari and Condivi stress the anti-classical tendencies in Michelangelo's architecture. But these tendencies were not present from

the beginning. We saw that both the upper storey of the tomb of Julius
II in the project of 1516, and the final design for the San Lorenzo
façade of the following year, are purely classical in their details, and
are, in this respect, not unlike Bramante's late works. The same applies
to the *pietra serena* architecture of the Sagrestia Nuova, designed in the
spring of 1521, for we could derive all its constituent forms from one
ancient monument, the Pantheon; whereas the marble architecture of
the tombs and particularly that of the lateral bays appear to be to a
great extent free from such conventions. But the library, conceived as a
whole in 1524, is Michelangelo's first real attempt at a new system of
architecture. In it, contrasts are transformed by over-emphasis into
conflicts, in the whole as well as in details. In the whole (133, 134),
notice how the vertical emphasis and rich plasticity of the vestibule
contrasts with the calm, uninterrupted sequence of equal bays, with
walls in very low relief, in the reading room.[22] In details, one notices
especially the 'buried' shafts of double columns, or the voluted double
consoles of marked plasticity which, however, do not serve as supports.
The inspiration of this system is no longer the work of Brunelleschi and
his followers. Structurally it has certain affinities with the Gothic

131. Exterior view of the
library of San Lorenzo,
Florence (after Portoghe

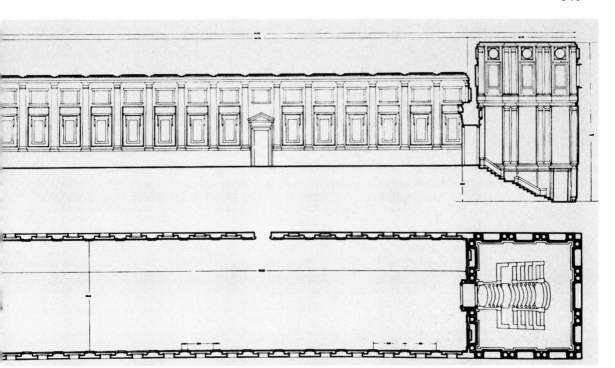

Section and plan of the
ing-Room and
bule of library of San
nzo, Florence (after
vo).

Reading-room of the
y of San Lorenzo,
nce.

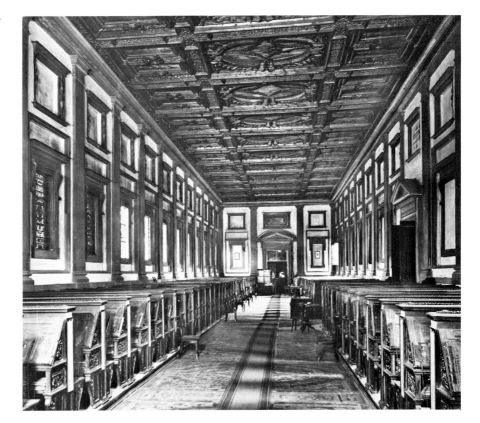

Trecento in that the wall consists of a firm skeleton (or structural frame) with rubble-filling. You see this clearly from the outside (131), where the windows are set in rectangular recesses, framing a second layer behind the frame. Inside, the vertical parts of the frame are reinforced by pilasters, the recesses are separately framed, and above them there are smaller recesses, also framed. The result is a subtle system of parallel planes, separated one from another by *pietra serena* parts; from the practical viewpoint this system was to be perfected later in the exterior composition of the Palazzo dei Conservatori. It meant a great reduction in the weight of the walls, and this was important in a structure in which the static problem was extremely difficult to solve; the walls of the reading room actually rest on massive piers connected by arches built into the monastery walls. It should also be noted that one does not see the continuous socle of the pilasters in the interior: the library desks, or benches—they are both—reach the same height as this socle and are pushed close enough to it to function visually as if they *were* the socle.

134. The Vestibule of the library of San Lorenzo, Florence.

The 'Gothic' which we find in the vestibule is an inverted one. Here the skeleton, the frame, the structural parts, recede while the intercolumnar parts, the bays, the fillings, break forward. So deceptive is this contrast, that in descriptions the latter are usually called mighty wall-piers which overpower the columns. I think they are built of rubble, and that their projection was intended to emphasize the elasticity of the double columns which, we should remember, were originally to carry a vault. An old photograph shows an unfinished section of the upper storey (in accordance with the changed plan of 1533): here, wall-piers, built of solid brick, can be seen above the columns, and double pilasters, centred on the columns, were to be set

Tabernacle in the vestibule of the Library, San Lorenzo, Florence.

eft). Door of the
ng-Room of the
v, San Lorenzo,
ce.

*tudy for a wall-tomb.
*ce, Casa Buonarroti.

against them; the sections between them are rubble-filled and some of
them were to be pierced by windows.

Almost all ornament is banned from this system, nor is there room in
it for statues. Their places have been taken by purely architectural
motives, but these have gained a life of their own as intense as any
figures could have. You see it in the movements of the frame in the

tabernacles of the vestibule, which are a new version of the lateral tabernacles of the chapel (135, 114). The door, when seen from the reading room (136), is a very complex design, the result of one structure penetrating, or passing through, another in two directions; an aedicule, consisting of free-standing columns carrying an architrave and a segmental pediment, is pierced by a framed door; but between the door's frame and its triangular pediment the aedicule breaks forward from behind, a length of its architrave appearing as a seemingly isolated form. One understands this play of forces only by looking at the side elevations of the structure.

The same applies to the famous staircase (which cannot be photographed adequately, but see 134). It is, in principle, a free-standing structure: Michelangelo's much cherished idea of a free-standing monument in the centre of a square room has been revived on a larger scale. Not all its forms correspond precisely to his intentions. Those who fitted it together from the existing parts, about 1560, did not quite succeed in reconstructing his original project, in spite of the help given to them by the aged master from memory and *per distantiam*; but its system has not been changed. The downward movement of the middle flight starts from the bridge which connects the free-standing structure with the library door; the upward movement of the two side-flights is broken and diverted at the landing. This contrast of directions, accompanied by changing rhythms, well illustrates the identity of purpose between sculpture and architecture which Michelangelo tried to establish at this stage of his development.

I conclude with a design for a wall-tomb of exactly the same date, 1526 (137). If we go by the length of the sarcophagus, lightly sketched in black chalk, it was to be a very large monument; and yet, as the plan shows, it was to receive only one statue, in the tabernacle in the centre. In this design all the motives of the vestibule reappear in new combinations—even the voluted consoles, here placed high up, seemingly supporting the second entablature. And we find some additional motives, for instance the 'soft' parts of the façade seem to break through the first entablature. There is movement everywhere: vertically and horizontally, from depth and into depth; and the interplay of parallel planes could hardly be more complicated.

The Last Thirty Years

In the autumn of 1536, twenty-four years after the completion of the Sistine Ceiling, Michelangelo was again working in the papal chapel. The execution of the *Last Judgement* took five years. This fresco, too, was unveiled on All Saints' Day, 1541.

During the period of nearly thirty years which separates these two events, the general public had seen scarcely any new work from Michelangelo's hand. The only exception was the statue of the Saviour holding the Instruments of the Passion, erected in the church of Santa Maria sopra Minerva, at Christmas 1521 (138). Ten years later, Michelangelo was forced to undertake another work, an *Apollo* (140), as a present for Baccio Valori who, after the siege of Florence, and on behalf of Clement VII, established a reign of terror in the defeated city. This work was known to very few people, and was left unfinished. Valori even wanted Michelangelo's help in rebuilding his house which had been partially demolished by the order of the Republic—the traditional, symbolic punishment imposed on traitors in Florence. He was replaced after a few months, and Michelangelo's unfinished present was seized by the Medici; it is now in the Bargello. A third work, immediately preceding the *Apollo*, the painting of *Leda* (142), left Michelangelo's studio to go directly to France; it was later destroyed.[23]

Part of the surface work on the Minerva *Christ* had been done by a young assistant, and there were rumours circulating in Rome when it was set up that this man was responsible for its whole execution (which was not true). The fame of this admirable figure is of a later date. It represents the first appearance of a new ideal in Michelangelo's art which we have already met in later works, such as the statue of Giuliano de' Medici, or the *Victory* in the Palazzo Vecchio (121, 99). In the *Apollo* this ideal appears fully realized: the twist is continuous, the forms lead into depth or emerge from depth; the block is much deeper than it is wide.

Our knowledge of the period between 1524 and 1526, when the statues in the Medici Chapel were begun, and 1534 when the *Last Judgement* was designed, can be amplified by the study of a group of drawings of a particular kind. They are a novelty in Michelangelo's work and also in Italian art; the only recorded precedent was the lost

148

138. The Saviour with the
Instruments of the Passion.
Rome, S. Maria sopra
Minerva.

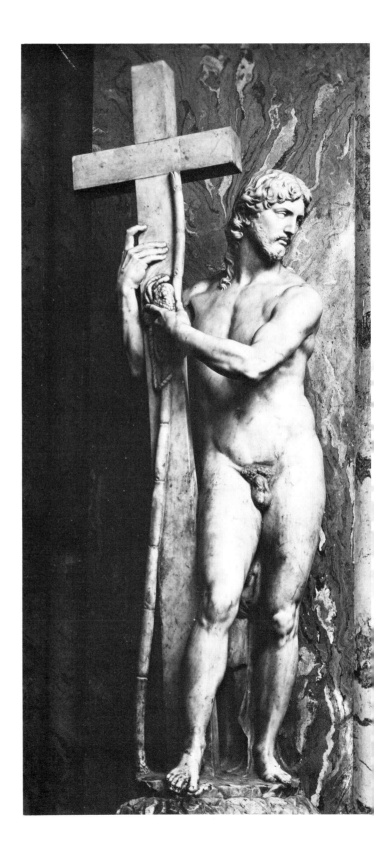

139 (*opposite*). The Saviour
(detail). Rome, S. Maria
sopra Minerva.

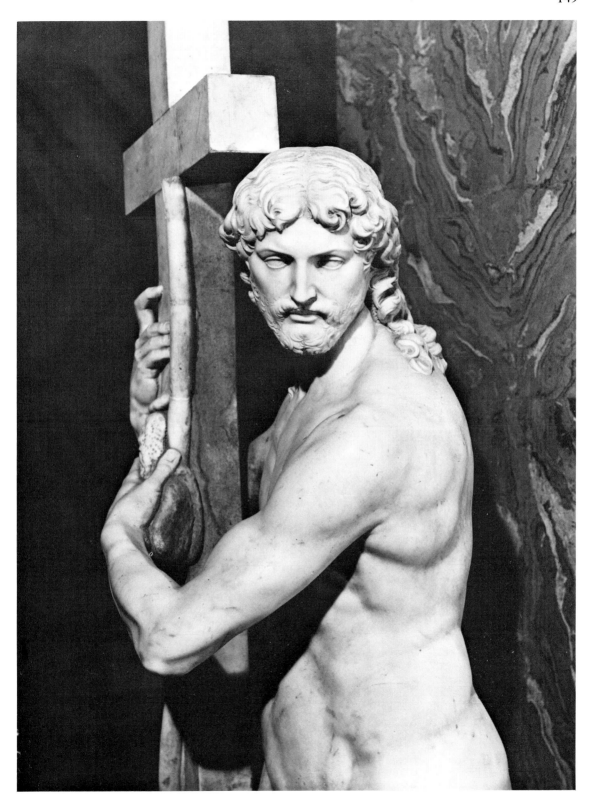

far left). Apollo.
ence, Bargello.

left). Apollo. Florence,
ello.

Cornelis Bos, engraving
*rsed) after
*elangelo's *Leda*. London,
*sh Museum.

drawing of *Neptune and the Sea-Gods* which Leonardo made as a present for his friend, the poet Antonio Segni. Michelangelo's drawings were made for a similar purpose and were brought to the finish of an engraving. His friends who owned them ensured well-deserved publicity for them: they were studied by other artists and were reproduced in all sorts of material and techniques of all kinds. Their historical significance, therefore, is great.

The complete list of these drawings is surprisingly long. Most of them are well-known, but it is perhaps useful in our context to examine some in detail. The series begins with three modest sheets, made by Michelangelo for a younger friend, the Florentine businessman Gherardo Perini. This we learn from Vasari, who greatly admired them and called them *teste divine*; they date from about 1526. The three female heads (143) are studies which may be regarded as by-products of Michelangelo's work on the *Times of Day*, unless we should see in them the three ages of woman. The half-length composition reproduced in 144 probably represents Venus, Vulcan, and Cupid. Mannerism has a predilection for classical regularity of feature combined with an elaborate, and often fantastic, coiffure, and these heads of Michelangelo were

repeated by minor artists in all possible and impossible contexts; Bacchiacca practically specialized in them. The third drawing (145), called the *Lost Soul*, is obviously a study in the physiognomy of fear or panic; in its expressiveness it resembles the tragic mask under the left arm of the *Night*. It was equally popular; Cellini included it in the relief on the pedestal of his *Perseus*.

The *Archers*, of 1530, at Windsor (146), is probably based on a literary source that has yet to be found, but the content seems clear: in general terms one could say that 'blind and passionate desire will not reach the true target'. From the point of view of form, the impression we gain is that of a relief, and reliefs of the later Cinquecento are, I believe, based on drawings like this. The *Allegory of Duke Cosimo's Government at Pisa* by Pierino da Vinci, of about 1550, may illustrate this (147). You do not find here the continuous recession of Renaissance reliefs: as in the drawing, the contrast between the majority of very flat forms and a few projecting ones is essential for the effect, and with both the distribution of the higher relief has been determined by compositional considerations only. This refusal to attempt any illusion of reality is most characteristic of Mannerism.

143 (*left*). *Teste divine.* Florence, Uffizi.

144 (*right*). *Venus, Vulcan and Cupid.* Florence, Uffizi.

Two more drawings of the type of the *Archers*, both probably of 1533, the *Children's Bacchanal* and the so-called *Dream of Michelangelo*, are allegories again based on unknown texts. The youth in the *Dream* (148) is representative of the Human Mind, and he is surrounded by dream-visions of Deadly Sins; in the *Bacchanal* (149) the hero is drunk, like Noah in the last story on the Ceiling, and the *putti* represent functions of life at its lowest level. The composition is rather

The Lost Soul. Florence,

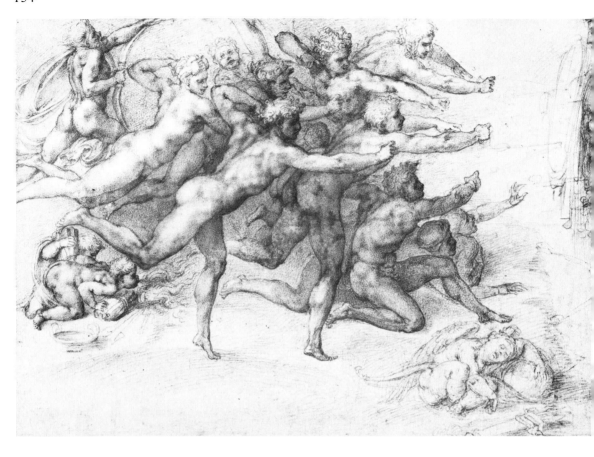

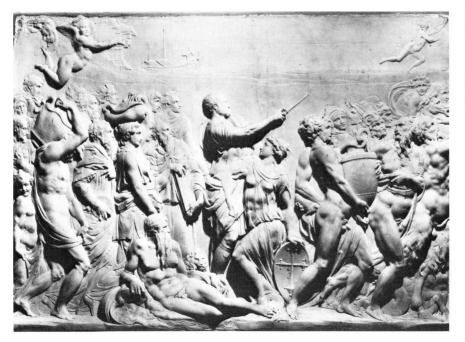

146. *The Archers*. Winds
Royal Library.

147. Pierino da Vinci,
*Allegory of Duke Cosimo
Government at Pisa*. Vati
Museum.

remarkable. The stage is set in a cave, and the rocky ground rises in
tiers, upon which the five groups are disposed on two diagonals inter-
secting in the centre. The figures in the central group are on the largest
scale and are also, together with the hero, the most plastic: a perspective
of content, if I may use the expression—at any rate a Mannerist com-
position *par excellence*. This drawing is also a good example of the

delicacy of technique introduced by Michelangelo, and reserved for this class of drawing: they are stippled in a laborious process. Vasari remarked, on the *chiaroscuro* thus produced, that 'with the lightness of breath you could not have achieved greater unity'. In the *Resurrected Christ* (150) the method is adapted to a single, isolated figure. This large drawing belongs to a long series of variations on a theme. It is a remarkable invention; the Divine Soul who by His own will has torn apart all earthly bonds ascends to His true home. And it is an ideal example of what Mannerism called a *figura serpentinata*, which can be defined as 'the greatest possible movement of the whole of the body without locomotion': the axis is completely fixed in the left leg and the right arm, while the right leg finds its countermovement in the left arm. Everything is in balance and the drapery only echoes the swing of the whole figure.[24]

Finally, let us turn to two versions of the *Fall of Phaethon*, both from 1533 (151, 152). The small version is very close to the poetical mood of Ovid's *Metamorphoses*; the hero is a helpless victim, and the scene with the transformation of Phaethon's sisters into poplars is, as a kind of landscape, unparalleled in Michelangelo's work. The composition follows the uninterrupted curve of a capital S. The large sheet supersedes

149. *The Children's Bacchanal*. Windsor, Ro[yal] Library.

The Resurrected Christ.
or, Royal Library.

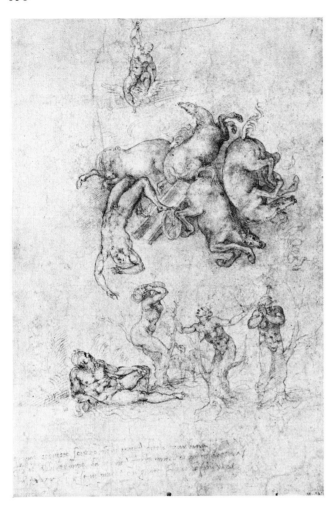

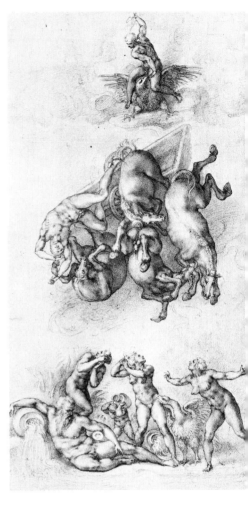

this first attempt. In it, each of the three groups became more intensely dramatic, accentuated by the sharp caesura which has detached the lowest. A detail (153) may clarify the special method employed in all these drawings. In some places one can see the first very fine spidery outlines. Then follows the main shading in parallel strokes, thirdly the laborious stippling process, and lastly the reinforcing of the contours. The work on such a sheet must have required several weeks, and from the fact that the sculptor of large marble statues should have submitted himself to such an exacting process at the age of fifty-eight, and also done so repeatedly in later years, we may conclude that these drawings meant a great deal to him as an artist.

The two versions of the *Phaethon*, and the *Children's Bacchanal*, were among the drawings which Michelangelo presented to his friend Tommaso de' Cavalieri, a young Roman noble. After an absence of sixteen years, the artist returned to Rome in August 1532, and for ten happy months he worked there on the reduced version of the tomb of

151. *The Fall of Phaeth*
London, British Museu

152. *The Fall of Phaeth*
Windsor, Royal Library

Julius II. It was at that time that he became acquainted with Cavalieri and it is known that this newly-formed friendship was one of the main motives for his change of residence. In 1533 Michelangelo decided to settle in Rome for good. This decision changed his life; it also decisively established Rome as Italy's artistic centre.

However, Michelangelo was not allowed to continue his work on the monument. Clement VII once more intervened; he asked, and eventually persuaded, him to accept a new commission.

Our earliest document about the *Last Judgement* is a letter, written by a diplomatic agent in February 1534; it reports the news that the pope has succeeded in overcoming Michelangelo's resistance and that the artist will soon start on a fresco to be painted above the altar in the Sistine Chapel. Looking at the scheme of the original decoration of the altar-wall in the chapel (154) and thinking of the works which it comprised, one cannot help calling this commission barbarous, for it meant at least a partial destruction of the two Quattrocento series, the histories and the series of the popes; eventually, under Michelangelo's hand, it meant the destruction of the altar-piece and of the two lunettes as well. The demand for the work was apparently stronger than any aesthetic consideration. These were the years immediately following the Sack of Rome and its political consequences, when there began a ser-

Detail of fig. 152.

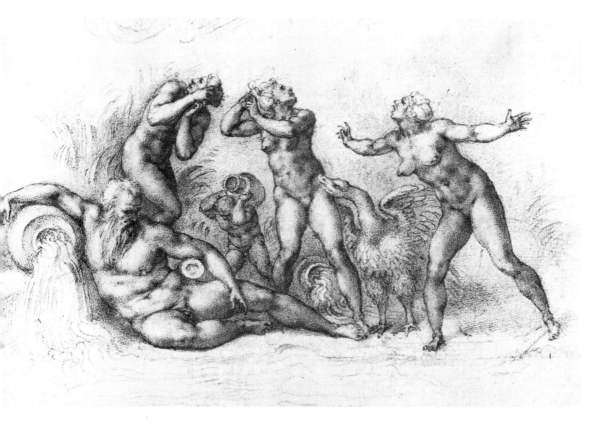

154. Reconstruction of the end-wall of the Sistine Chapel, *c.* 1530.

ious movement towards reforming the Church from within. In ordering this work, Clement VII was the exponent of a mood more or less general in Italy.

As in the case of the Ceiling, Michelangelo's first drawings for the fresco conform to the original commission (155). According to this sketch the main group was obviously intended to fill the space between either the centres or the outer frames of the two windows (to be walled-up), the figure of Christ thus taking the place of its Quattrocento predecessor; the groups of the Elect and the Damned would probably have formed columns reaching down to, or perhaps below, the first cornice of the chapel. This is an essentially static composition, not

Compositional study
e *Last Judgement*. Bay-
Musée Bonnat.

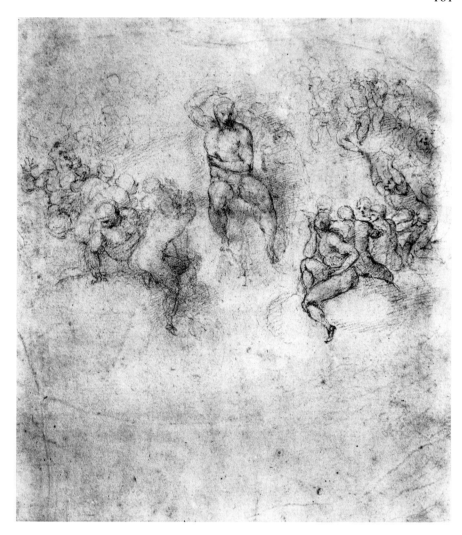

unlike that of Fra Bartolomeo for Santa Maria Nuova, of 1499, with
the characteristic difference that Michelangelo's semi-circle of figures is
convex.

The next drawing, a sketch for the whole composition (156), clearly
keeps to the same limits; but it converts the static scheme into a
dynamic one. The artist tried to save the altar-piece by drawing the
mighty S-curve of his groups round its frame; it is the scheme of his first
version of the *Fall of Phaethon* repeated on a gigantic scale. Height and
width remain unaltered; in other words, only the *Finding of Moses*, the
Nativity of Christ and the figures of the Saviour, and Saints Peter and
Paul, were to be sacrificed. Then the *peripeteia* followed. To be sure,
this first scheme was not homogeneous iconographically, nor could it be
made homogeneous in form. The result was an extensive new plan, the
design on which the execution was based.

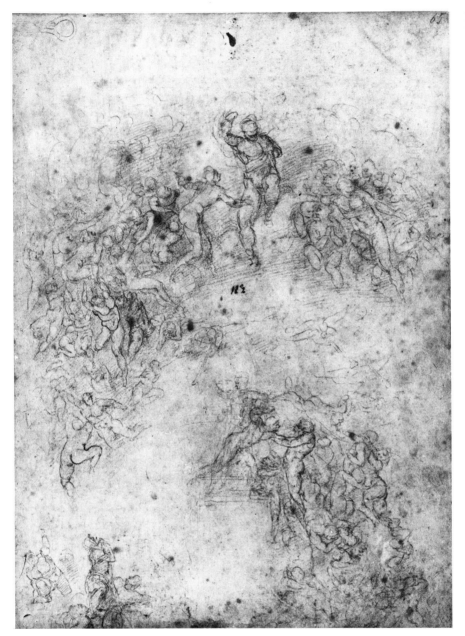

156. Compositional stud
for the *Last Judgement*.
Florence, Casa Buonarr

And so, the fundamental fact concerning the genesis of the *Last Judgement* is that Michelangelo once more outran his commission. Instead of painting a picture on the wall above the altar, he replaced the whole decoration of the altar-wall of the chapel (157). All that remained of this wall was a dado to right and left of the altar and behind it, and this was to be covered with a decorative tapestry. The rest, right up to the vault, was destroyed, including the windows, the three cornices, and the pilasters. Nor is the new painting an illusionist extension of the

157 (*right*). *The Last Judgement*. Vatican, Sis Chapel.

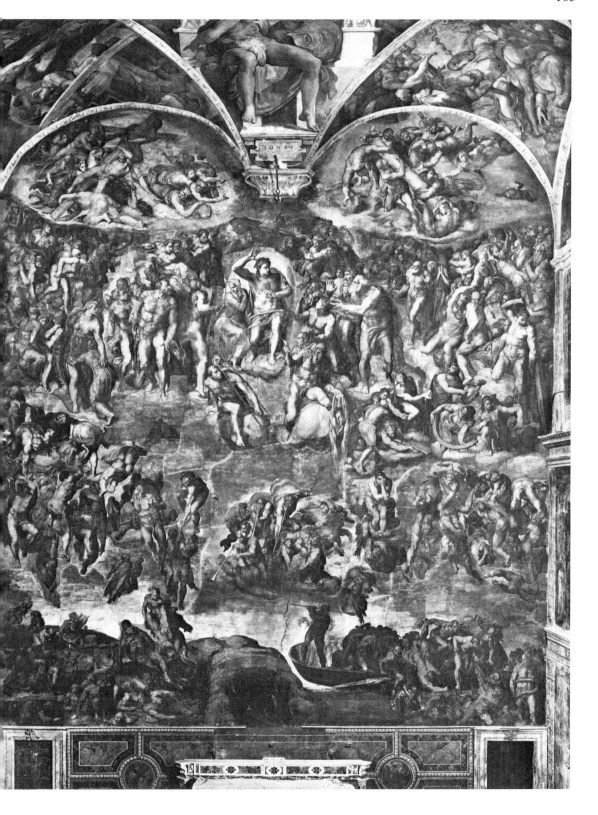

chapel space: it opens up the view of a second reality behind it and independent of it. We face this reality as something objective, as something opposed to us, as a world that is governed by its own rules. There is no consistent perspective, vertically or horizontally; the scale of the figures increases higher up and the viewpoint shifts from group to group. And there is no frame whatsoever: the fresco simply cuts through the side-walls of the chapel and the vault. It is a façade formed of plastic figures.

Nevertheless, in working out his composition the artist found ways to take into account the suppressed structure of the altar-wall and to bring his fresco into some kind of visual harmony with the rest of the chapel. The horizon in the fresco corresponds to the first cornice; the break between the higher registers corresponds to the second cornice; and the lunettes contain separate groups, each being a satellite to the slow elliptical movement that governs the whole. And instead of two arched windows there appears, on the corresponding level, an opening in the centre: it is the bright yellow mandorla behind Christ and His Mother, interrupting the dark blue ground, a new centre for the whole tripartite decoration. The strangest of all these veiled correspondences is that the Mouth of Hell has taken the place of the former altar-piece. Now, this fact could be taken as an epitome of the deep pessimism which prevails in Michelangelo's whole interpretation of the subject. Much has been said about this pessimism in the four centuries since the unveiling of the fresco. I should like to draw your attention to some deviations which we find in the *Last Judgement* from the subject's traditional iconography.

Christ rises from His throne of clouds (158). His face is turned towards the Damned below, and His right arm is raised in a gesture of damnation, punishment, or annihilation. This gesture is familiar from the *Phaethon* drawings, and like Jupiter there, this figure resembles the Apollo type, the male ideal of Mannerism. The Virgin, a figure on a considerably smaller scale, is crouching under Christ's uplifted arm, as though in fear of the consequences of that gesture. According to tradition her place was that of an intercessor on the right side of her Son, opposite Saint John the Baptist who, as the other intercessor, was always placed on Christ's left. Michelangelo kept to this tradition in his first designs. In the fresco, as executed, Saint John has been given the rôle of a protagonist on our left, and opposite him is Saint Peter. (Since Vasari's first edition Saint John has wrongly been called Adam, although Condivi immediately corrected Vasari's error.) The prominent place thus given to Saint Peter is explained by the position of the fresco in the chapel of the popes, and also by the fact that this image was to replace one previously in the same register, beginning the series of the early popes. (He is also accompanied by the *Apostolus Segregatus*, Saint Paul, the other Founder of the Church.) But far from being interces-

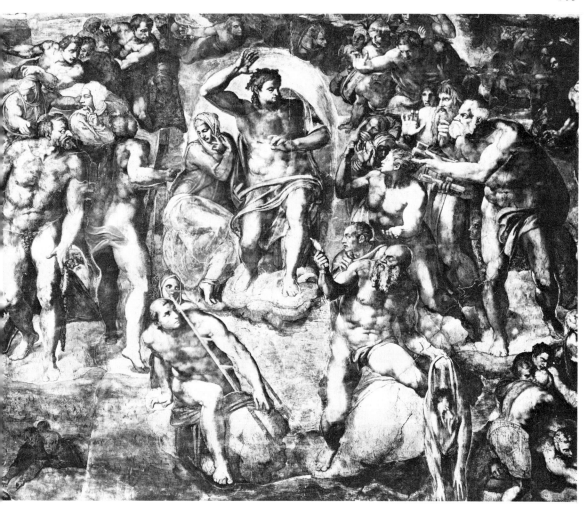

The Last Judgement
). Vatican, Sistine
el.

sors, the two saints, the Baptist and Saint Peter, seem to expect, and to demand, the utmost severity. The places accorded to Saints Lawrence and Bartholomew, immediately at Christ's feet, may be explained by referring to the history of the chapel: Saint Lawrence's was the first Church feast which was celebrated in the newly-built chapel in 1483, and Lawrence also was a patron saint of the Medici, and so of Clement VII, who commissioned the work. Moreover, the coronation of Sixtus IV, the builder of the chapel, took place on Saint Bartholomew's Day, and ever since the chapel was built this feast has been its most important day of commemoration. One may wonder why Michelangelo painted his self-portrait on the excoriated skin of this saint. (The fact, though demonstrably known to contemporaries, was later forgotten and was rediscovered only in this century.) Perhaps it is not far wrong to see in this portrait an act of religious self-humiliation, similar to that which often occurred in the choice of names in Early Christian times.

The prominence given to the representation of the Deadly Sins (first among them, as in Giotto's series in the Arena Chapel, being Despair) is doubtless a sign of the great religious excitement of the years after 1530. But it is possible that in this, too, Michelangelo had to comply with the demand of his patron. We gather from Vasari that, in fulfilment of a vow and in order to commemorate his own deliverance from the Sack of Rome, Clement VII wanted such a group executed, composed of gigantic bronze figures, on the tower of the Castel Sant'Angelo.

In the lowest zone of the fresco the Resurrection of the Flesh has been rendered, according to the vision of Ezekiel, as well as a description of Hell, mainly based on Dante: Condivi calls the principal motive here 'Caronte colla sua navicella' and refers to the *Divine Comedy* as its source. Reading this, one cannot help being reminded of another famous *Navicella*, Giotto's gigantic mosaic in the narthex, opposite the façade, of Old Saint Peter's. Giotto's work represented the lifeboat of the Church. Here his composition was repeated with a negative interpretation. This was done in the same mood in which the place above the altar-*mensa* was given to Satan's cave. The repetition of certain gestures and configurations from the mosaic makes, it would seem to me, this connection certain. As I have said already, discussion of Michelangelo's interpretation of the *Last Judgement* began as soon as the fresco became known—and it has not finished yet. Such discussions very often disregard the stylistic character of the work. But this is just the point from which historical criticism should begin, even if it is mainly concerned with the content of the work. The *Last Judgement* represents a new stage in the development of Michelangelo's art and clearly indicates the beginning of his late style.

High Renaissance artists intended to establish a harmony which was to include all the parts, without depriving them of their independence. By contrast, ever since about 1510, when he planned the second half of his Ceiling, Michelangelo had striven to subordinate the parts to a few governing principles (or even to one) which were to be the life-spring of the whole. This tendency becomes clear when we study the genesis of his designs for the monuments of the four Medici. Now, in this composition of the *Last Judgement*, containing several hundreds of figures, a maximum of subordination has been achieved. The figures are, with a few exceptions, not separated from each other. They are enclosed in groups which, in themselves, are self-contained only in so far as each of them is given a particular programme to represent. The governing principle is a slow movement from left to right—in a circle, or ellipse. It includes all the groups of the two main horizontal sections, and it makes the remaining groups, in the lowest and in the topmost register, its base and its satellites. At the same time the spectator becomes aware of the fact that this coherent movement is a most effective expression of

the common destiny of Mankind, which is the real content of the work.

This unity has been enhanced by the choice of a particular colour scheme. One often reads that the colours of the fresco are harsh and crude. That is an incorrect statement, superficial in the literal sense of the word. Certainly, the fresco has suffered much in the course of more than four centuries. On the orders of later popes many of the nudes were partly overpainted, and some of these additional draperies are indeed of rather harsh colour. Dust, smoke, and a wax-varnish put on top of them, have darkened the surface of the fresco, more especially in its lower regions. But the original colour-scheme can still be recaptured in many important places. It is a harmony in clear, deep blue, painted in the finest lapis lazuli, and richly modulated, subdued rose—both unreal and impressive to the highest degree.

We have found examples of a dynamic way of representing events in some of Michelangelo's finished drawings which preceded his *Last Judgement*; but the style of the figures in the fresco is very different. Instead of elongated proportions, and rich combinations of twisting and bending movements, most of the figures have a Herculean build and keep, in their movements, to the limits of an imaginary rectangular block. They are compact masses, or solids, mostly turning one of their broader sides towards the surface, that is to say appearing more or less frontalized. One has the feeling that now, as movement prevails in the whole composition, and as all the groups are subjected to this movement, every single figure could be reduced to a simple sculptural existence. At any rate, we meet this orthogonal, or lapidary, style in all Michelangelo's late works. In the *Last Judgement* one can follow the process that led to its full realization. In the uppermost sections, in the two lunettes which were painted first, traces of the previous style can be found (159), as well as many heads of great beauty. In the groups of the Resurrected below, the new figure style appears definitely established (160). The reason for this is that although Michelangelo had worked out the *modello*, the design of the whole, probably during the spring and summer of 1534, the different sections of the full-size cartoon were drawn successively, each preceding the respective phase of execution, conforming to the main horizontal registers. As I have said already, the painting of the fresco began in the autumn of 1536 and lasted five years. Michelangelo was sixty-six when his work was unveiled on 1 November 1541.

Since the commission to paint the *Last Judgement* had been forced on him by Clement VII, Michelangelo, after the pope's death in the autumn of 1534, made a desperate attempt to take up his work on the tomb and to fulfil his obligations towards the heirs of Julius II. It was a desperate attempt, for the new pope—Paul III Farnese, who had known him since the time they had spent together in the house of Lorenzo de' Medici about 1490—wanted his services for himself. First

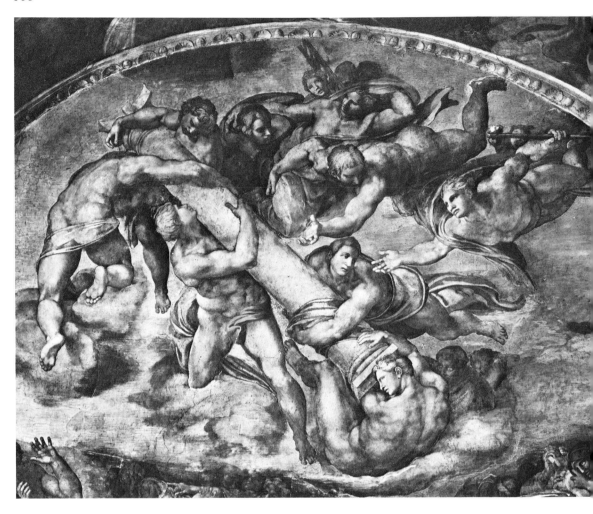

of all, he insisted that his predecessor's commission should be carried out. Then, at the end of 1541, after the unveiling of the fresco, Michelangelo again hoped that he would be allowed to save the peace of his soul by completing the tomb, but he was disappointed once more. We learn, again from a diplomat's letter, that already in November of that year—that is to say when not all the scaffolding had been dismantled in the Sistine Chapel—the pope decided to give Michelangelo another commission for monumental paintings; and soon afterwards the heirs of Julius II were persuaded to submit to the reigning pope's will. The artist's reaction was a mixture of revolt and despair. The phrases he used at the time of this last crisis in the history of the monument are moving: 'I cannot live, still less can I paint', he writes, and 'One can only paint with one's brain, not with one's hand; he who has not his brain at his command, abuses himself if he tries', and finally, 'I cannot deny anything to the pope—I shall paint with discontent, and my work will earn discontent.'[25]

159. *Angels with Symbol* *the Passion* (detail of fig.

160 (*right*). *The Elect* (d of fig. 157).

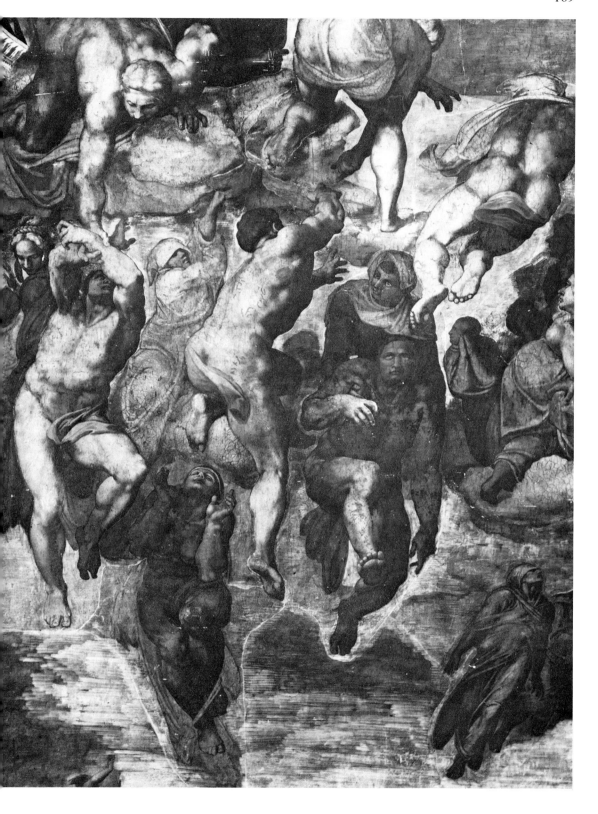

The Cappella Paolina (161), next door to the Sistine Chapel, was built for Paul III by Antonio da Sangallo the Younger during the years which Michelangelo spent on the scaffolding in front of his gigantic fresco. It consists of a not very large vaulted nave and a small chancel. The wide central recesses of the two side-walls contain in their lunettes large windows (the left-hand one is now blind). Michelangelo's task was to cover each of the spaces below the windows with a single fresco. They are nearly square spaces, 6·0 by 6·3 metres. The frescoes in the narrow lateral bays of the side-walls and the whole decoration of the vault were painted by younger artists long after Michelangelo's death. His two paintings represent the *Conversion of Saul* (on the left) and the *Martyrdom of Saint Peter* (on the right). The latter (163) is in much better condition and is the later of the two. Michelangelo started on its cartoon in 1546 and finished the fresco in 1550. These dates show that he was working on this painting after he had been finally relieved of the burden of the tomb, and so this part of the work was carried out under a benign star. In the earlier fresco (162), which covers the opposite wall, and is also of immense power, one cannot help observing some reflections of the troubles, the worries, and the pains of which Michelangelo's letters speak (particularly in the right-hand group of soldiers). In the 1930s both frescoes were cleaned and were freed from much overpainting; the reproductions show their present state.

The *Martyrdom of Saint Peter* is Michelangelo's last work in painting. One may ask whether it shows any new features which cannot be found in the *Last Judgement*. I think it does, both in its figure style and in its composition. In this fresco each of the figures is conceived as being in a rectangular block—one could almost say, *is* such a block, for, as a rule, the hollows and projections of the contours have been reduced to a minimum. And every figure is strictly frontalized, that is to say is turned with one of its broader sides towards the picture plane. What applies to the figures also applies to groups. Each group fills a square block to its very limits, and is placed in front of us so that the eye can easily grasp its measurements. The large central group placed on a kind of pedestal, the pious women in the foreground, the soldiers on the left, the group of disciples at the top right, all these are blocks of more or less the same shape, only on different scales (164). And, strangely enough, all these rectangular blocks seem to have been seized by the same movement—a movement which, unlike that in the *Last Judgement*, is not being enacted on the surface, but is revolving in space. This whole composition may be compared to a colossal millstone, seen somewhat from above, turning slowly clock-wise. Though less clearly, this is also perceptible in the fresco on the opposite wall where the movement is in the opposite direction—but is split by the wild jump of the abandoned animal; and this pattern of movement is repeated in the upper half. As the groups in the martyrdom scene are

161 (*right*). The Paulin Chapel (view from the Vatican.

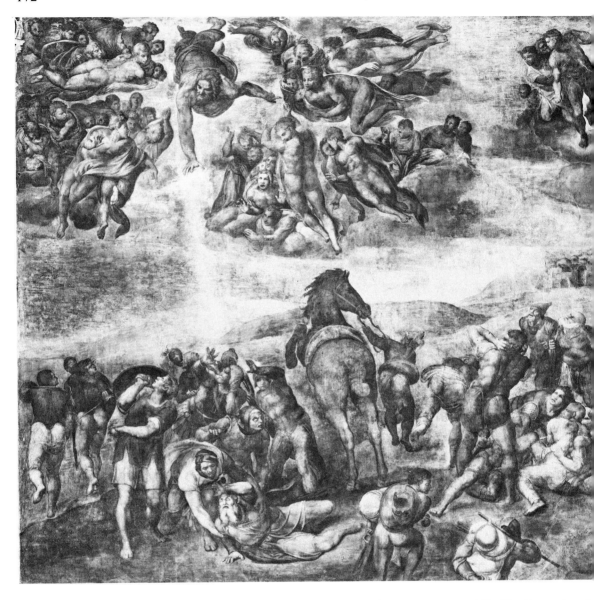

cut by the frame on three sides one has the feeling that the movement extends beyond the limits of the picture space. Such movements, rendered on the side-walls of a chapel, may be regarded as symbols of the force that draws, or drives, the worshipper towards the spiritual centre of the interior, the altar. This new device of Michelangelo's was at once taken up by younger artists and became the general principle of Mannerist and Baroque chapel-decoration. Tintoretto, for instance, already used it very consciously in the 1550s.

The extreme degree of subordination of all parts, under one principle which governs the whole, is also manifest in the way in which the subject has been treated. There are no 'supers' in this drama—a drama

162. *The Conversion of* Vatican, Pauline Chape

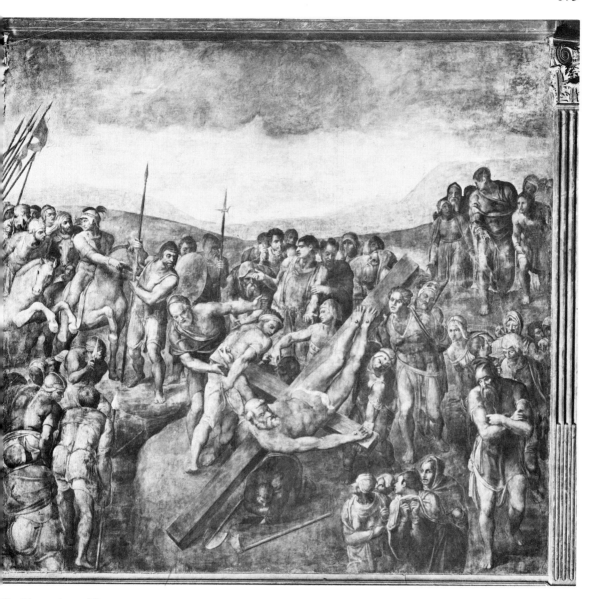

he Martyrdom of Saint
Vatican, Pauline
l.

which has been interpreted by the artist as a reiteration of the death of Our Lord. All the persons and groups appear, in their different ways, to be directly related to the event. Their multitude represents all types of religious behaviour, ranging from blind indifference and enmity to conversion and ardent confession. In characterizing these different habits and states of the soul, Michelangelo reached an extreme degree of expressiveness. This quality of his work is perhaps more accessible to us today than it was for centuries, for until quite lately these late paintings of Michelangelo were scarcely studied (and harsh judgements on them still occur at times). The anonymous convert on the right in the *Martyrdom* (165) may be regarded as an ideal self-portrait.

164. Detail of fig. 163.

During the last twenty years of his life Michelangelo's greatest efforts were dedicated to architecture. There seems to be an inner logic in the fact that immediately after the conception of a work of this character, Michelangelo should have devised his plans for Saint Peter's (166, 168), and for the Area Capitolina (167). The moulding of solid masses and the shaping of space became his ultimate tasks. He did not accept any more commissions for painting or sculpture, but he did not altogether lose his interest in the figurative arts. He readily and constantly helped certain younger artists by providing them with designs for all sorts of

Detail of fig. 163.

religious painting. Although some of the results of this collaboration appear to us to be indifferent, or even feeble, they were accepted by contemporaries as genuine products of Michelangelo's genius. For the historian they are documents of no little importance. I have chosen two examples, one from the 1530s, one from the late 1550s.

The first of these concerns the same Sebastiano Veneziano with whom Michelangelo had collaborated extensively in the years following the completion of the Sistine Ceiling. Sebastiano's painting is a small altar-piece (169), given by the Viceroy of Sicily to the Emperor's minis-

166. Etienne Dupérac aft
Michelangelo, ground-pla
of Saint Peter's.

167. Etienne Dupérac a
Michelangelo, the Area
Capitolina.

ter Francisco de los Cobos, and still in the latter's chapel at Ubeda in Andalucia (it has been cut on all sides). In his negotiations with the donor, Sebastiano had offered to paint either a Virgin and Child with Saint John, or a *Pietà* 'like that in Saint Peter's'. The latter subject was chosen and, indeed, this picture, too, is a true *Imago Pietatis*, with the Virgin holding the *sudarium* and the nails, and expressing the feelings of the worshipper. The sculptor of the famous group in Saint Peter's contributed a large, carefully finished drawing for the figure of Christ (170). Since there is another sheet by Michelangelo containing sketches for this figure and for the Virgin's right arm, we may assume that he also made a design for the group as a whole. This was done, in all probability, in 1534, the year in which he prepared his *modello* for the *Last Judgement*, and the study clearly shows the figure style of the fresco. The head is drawn unnaturally small to avoid exceeding the limit of the imaginary block; the torso is turned to the front as far as possible, and displays a continuous surface without contrasts or gaps. This is Michelangelo's new sculptural style, as fully realized here by graphic

169. Sebastiano del Pio
The Pietà. Ubeda.

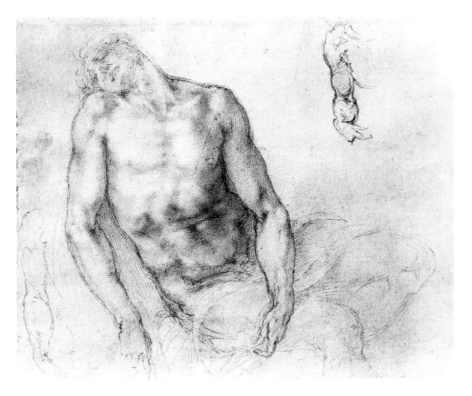

170. Study for the Ube
Pietà. Paris, Louvre.

Modello for *Christ driv-
ing Moneychangers from
Temple*. London, British
Museum.

Sketch for *Christ driving
Moneychangers from the
Temple*. London, British
Museum.

means as it is by colour and tone in the fresco. In comparison with this
drawing, Sebastiano's figure appears stiff. At the time of the Viterbo
Pietà (77) it was the natural freshness of his Venetian colour that
hindered him from taking full advantage of the plasticity of his
prototype; here, it seems to have been his tendency towards the
abstract, the geometrically regular that prevented him from seeing the
full meaning of this new sculptural style.

My second example is Michelangelo's last extensive figure composition (171). With this *modello* is reproduced one of the preparatory sketches (172) of which a number has survived, and we should take note of the difference in scale: the sketch is just under 17 cm wide, the *modello* 37 cm. Both are strikingly reminiscent of the *Battle of the Centaurs*, done nearly seventy years earlier. In the sketch, the forms are angular and the figures are heavy; in the *modello*, the figures are twisted, turned, and bent in such a way that only a centripetal force—the force epitomized in the pose and gesture of the central figure—seems to hold them together. It is a design that could have been executed on any scale, even as a large fresco. Actually, the *modello* was made for a small painting by Marcello Venusti, a young painter much favoured by Michelangelo (173). Venusti kept its scale, only cladding the figures and adding some accessories. We do not know the source of his remarkable architectural background, but it is unlikely that Venusti himself invented it. It is difficult to understand the popularity of products such as this, but it is an historical fact that they were sources of inspiration for whole generations of artists in Rome and elsewhere, and provided a common language for the later phase of Mannerism.

In conclusion let us look at Michelangelo's last works of sculpture. None of them was commissioned. In his old age Michelangelo was content to have some blocks of marble ready in his studio and work on them from time to time to keep his mind and body sound. He retired from the world completely and became almost a legend: a saintly old man, 'quel santo vecchio' as he was called by Vasari who had seen the studio. He wanted the *Pietà*, now in the Cathedral of Florence, to be placed on his tomb, and he gave his own features to the burdened disciple, Nicodemus (174). He worked at the group from time to time in the years between 1545 and 1555, without ever finishing it. Eventually, in a moment of despair, he tried to destroy it with his hammer. But the fragments were reverently collected by his servant, and a young pupil undertook the task of piecing them together and completing the group. This pupil, Tiberio Calcagni, died soon after starting his work, and since then the group has not been touched. Calcagni's share in it is not extensive; he was probably responsible for much of the surface modelling of the figure of Mary Magdalene and, perhaps, for part of the polishing of the figure of Christ; the two other figures he certainly did not change at all. The victims of the master's despair were both arms of Christ and the fingers of the Virgin's left hand. These parts were satisfactorily put together again by Calcagni. But the left leg of the figure of Christ is missing. This is not due to the attempted dismemberment; it was Michelangelo himself who, for some reason or other, perhaps because of a defect in the stone, was forced to piece on a separate bit of marble for this limb. Indeed, I am inclined to think that this act, which he had committed in order to save his work, was the very reason for his

ft). Marcello Venusti,
driving the
lenders from the
e. London, National
y.

174. *The Pietà*. Florenc
Cathedral.

175 (*right*). *The Palestr
Pietà*. Florence, Accade

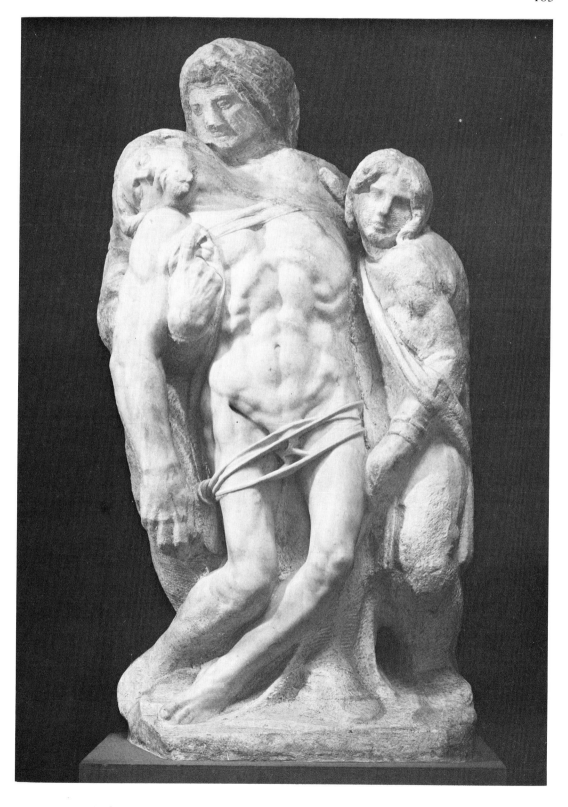

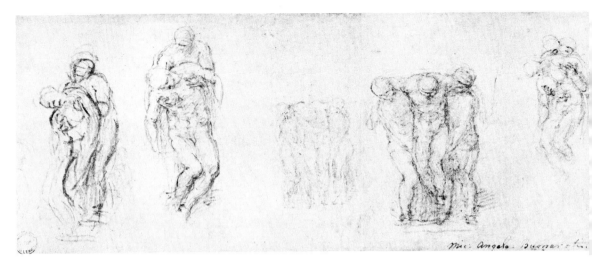

despair and for giving up the sculpture. We are told by many sources that the method of piecing-on in sculpture was generally despised in the sixteenth century as not worthy of a true artist; it was certainly a major crime in the eyes of the man who had an almost metaphysical conception of the significance of the unviolated block. And yet, though incomplete and partly gone over by a later hand, this group appears as a perfect embodiment of the principles which we have observed in the contemporary *Martyrdom of Saint Peter.*

The second *Pietà*, formerly at Palestrina and now in the Accademia in Florence, though not a fragment, is also unfinished (175). It is mentioned in no contemporary document or record, and the tradition which ascribes it to Michelangelo is late. Nor has it been generally accepted. In considering its attribution I think we should take into account the fact that the block used for this group of three figures—each on a different scale but all three over life-size—that the block was part of the architrave of some Late Roman building. It is nearly three times as wide as it is deep, and this circumstance was accepted by the artist, finding expression in a particular style of relief, invented, it seems, for this one work. Its principle is that the nearer the forms are to the front, the more flattened they become. (In a way it is a reverse of the High Renaissance relief.) With the exception of the head of the Virgin, all the principal forms are in one plane, and this is the original front plane of the block; recession is evident only in the bottom part. It appears that Michelangelo, in a sheet of undoubted authenticity (176), was experimenting with a group of the *Deposition* which would conform to these principles; and there exist studies of detail, some unpublished, which are very near to the evocative realism of the group. All of these drawings point to the end of the sixth decade of the century, and there are at least two designs by Michelangelo dating from this period, but only known in copies by pupils, which show proportions such as these—the

176. Studies for the *Pietà* Oxford, Ashmolean Museum.

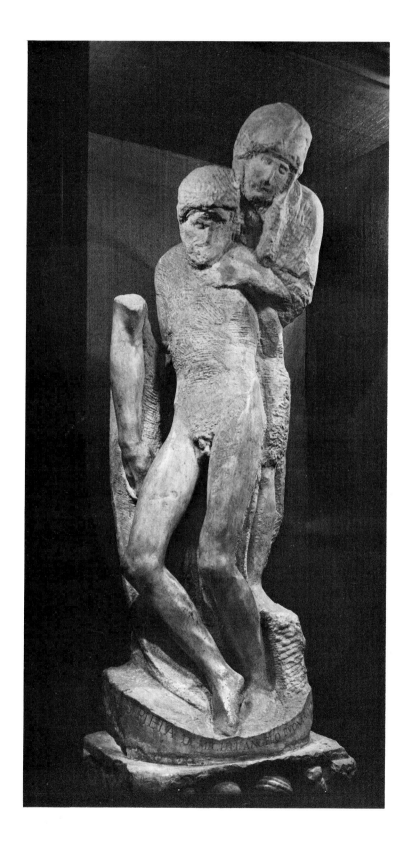

The Rondanini Pietà.
n, Castello Sforzesco.

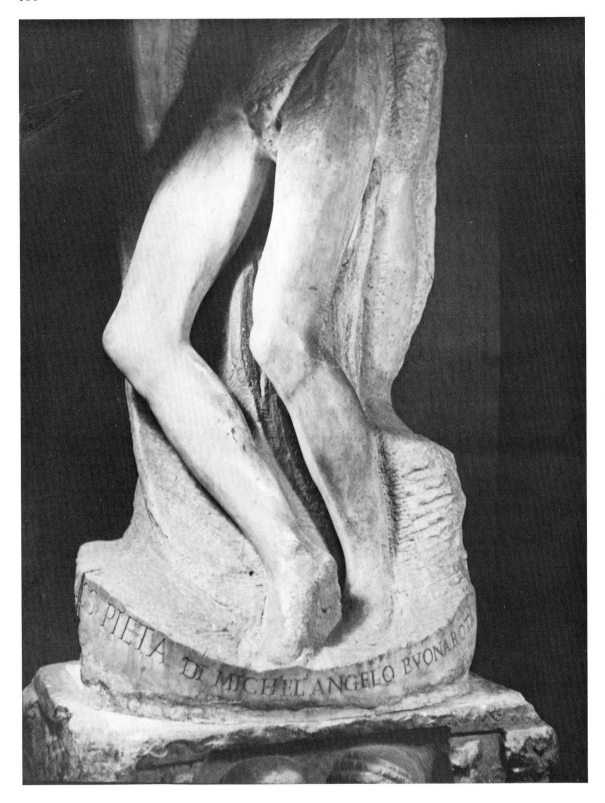

(*left*). Detail of fig. 177.

. Detail of fig. 177.

other embarrassing feature of this remarkable group.[26] To my knowledge, the origin of the block used for it has not been identified by the archaeologists; it would, perhaps, help in finding where the group was actually carved.

The other sketches on the Oxford sheet (176) have usually been connected with a third late *Pietà*, the so-called *Pietà Rondanini*, now in the Castello Sforzesco at Milan (177–179). This group appears to be a palimpsest of several successive designs. Vasari states that Michelangelo had begun working on it *before* he started on the group of four figures now in the Cathedral; and Daniele da Volterra, who stayed with the

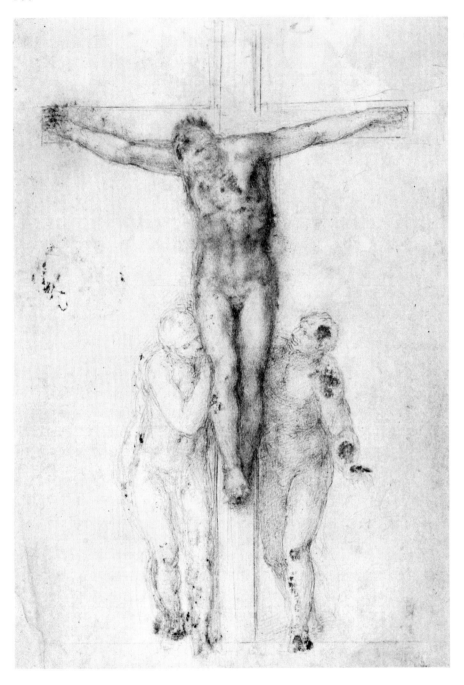

180. *The Crucifixion*. London, British Museum.

master during his last illness, says that Michelangelo worked on this group as late as six days before his death. From the beginning this was undoubtedly a group of only two figures: the dead Saviour supported by His Mother, as shown in the sketches at Oxford. All that remains of the first version is that magnificently shaped right fore-arm of Christ, and parts of the figure of the Mother, which here again must have been

181 (*right*). *The Crucifixion* London, British Museum.

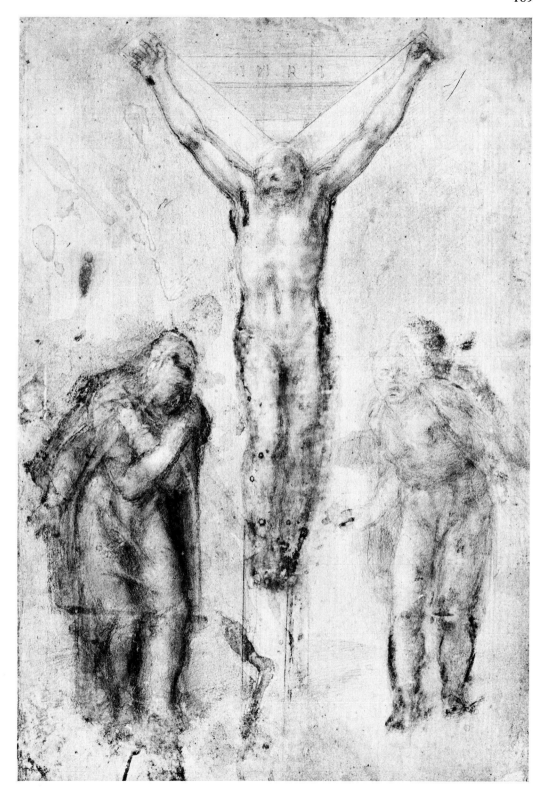

rendered on a much smaller scale. The two legs, on a smaller scale than the arm and too far removed from it, must be fragments of a second version. Then the upper half of this version (together with some remnants of the first) were sacrificed to the third. This version itself shows two stages. First, the head of the Virgin was turned to the left—the Mother, overwhelmed by her grief, turns her face to seek help in Heaven. (There is a *pentimento* also in Christ's head.) Then in the last stage the two heads are frontalized, Christ's head and arms partly merging into the Virgin's body; so the two figures have become one, they are inseparable from each other—a unique conception in Michelangelo's work and in sixteenth-century art.

Two of the late sculptures of Michelangelo are fragmentary, and all three have been left unfinished. But we possess a series of finished drawings dating from the same years (180, 181); they help us to understand what Michelangelo's intentions were in his very last works. The Platonist who had painted the tragedy of the imprisoned soul on the Ceiling, the religious pessimist who had shown the destiny of Mankind on the altar-wall of the papal chapel, became a confessor of the redemption wrought by Divine Love.

Notes

1 Condivi to Michelangelo, undated; see J. A. Symonds, *The Life of Michelangelo Buonarroti* (London, 1893), ii. 406, and K. Frey, *Sammlung Ausgewählter Briefe an Michelagniolo Buonarroti* (Berlin, 1899), 350, who dated it after 1556.

2 As evidence that the Medici Garden was not a sixteenth-century myth as some scholars have recently claimed, Wilde cited a letter of Ser Amadeo of October 1494 which calls Michelangelo 'ischultore dal giardino . . .' (K. Frey, *Michelagniolo Buonarroti, Quellen und Forschungen* . . . (Berlin, 1907), i. 120.

3 See *Vite d'Artisti di Giovanni Battista Gelli* in *Archivio Storico Italiano*, Series 5, xvii (1896), 41, 55, 59.

4 This remark predates, of course, M. Lisner's rediscovery of the S. Spirito Crucifix which, although he never saw the original, Wilde was inclined to accept.

5 See J. Wilde, 'Eine Studie Michelangelos nach der Antike', *Mitteilungen des kunsthistorischen Institutes in Florenz*, iv (1932–4), 41.

6 Piero Rosselli to Michelangelo, 10 May 1506; see P. Barocchi and R. Ristori, *Il Carteggio di Michelangelo* (Florence, 1965), i. 16.

7 *Ricordo* of 10 May 1508; see L. Ciulich and P. Barocchi, *I Ricordi di Michelangelo* (Florence, 1970), 1–2.

8 Michelangelo to Giovan Francesco Fattuci, December 1523; see P. Barocchi and R. Ristori, *Il Carteggio di Michelangelo*, iii (Florence, 1973), 8.

9 F. Hartt, '"Lignum Vitae in Medio Paradisi"; The Stanza d'Eliodoro and the Sistine Ceiling', *The Art Bulletin*, xxxii (1950), 115, 181 ff., and ibid. xxxiii (1951), 262 ff.

10 This book is expected to appear shortly.

11 H. Hettner, *Italienische Studien zur Geschichte der Renaissance* (Brunswick, 1879).

12 See Marsilio Ficino, *Opera Omnia* (Basle, 1553), 1326, and P. O. Kristeller, *Il pensiero filosofico di Marsilio Ficino* (Florence, 1953), 286.

13 For a fuller account, see Wilde's lecture, 'The Decoration of the Sistine Ceiling', in *Proceedings of the British Academy*, xciv (1958), 61–81.

14 See Michelangiolo Buonarroti, *Rime*, ed. Girardi (Bari, 1960), 4.

15 Michelangelo to his father Lodovico, early October 1512; see P. Barocchi and R. Ristori, *Il Carteggio di Michelangelo*, i (Florence, 1965), 137.

16 See E. Wind, 'Sante Pagnini and Michelangelo. A study of the succession of Savonarola', in *Gazette des Beaux-Arts*, VIe Pér., xxvi (1944), 211 ff.

17 Michelangelo to Varchi, 1547; see *Trattati d'Arte del Cinquecento: fra Manierismo e Controriforma*, ed. P. Barocchi, i (Bari, 1960), 82.

18 For a more elaborate analysis by the author, see Wilde's Charlton lecture, *Michelangelo's 'Victory'* (Oxford, 1954).

19 For the view that the New Sacristy was conceived only in 1519, see Wilde's 'Michelangelo's Designs for the Medici Tombs' in *The Journal of the Warburg & Courtauld Institutes*, xviii (1959), 54 ff.; and for documentary confirmation, G. Corti, 'Una ricordanza di G. B. Figiovanni', in *Paragone*, clxxv (1964), 24 ff.

20 See *Michelangelo's 'Victory'*, p. 15, note 3, where Wilde points out that Michelangelo carved the *Day* from a block already to hand in his Florentine workshop.

21 See Michelangiolo Buonarroti, *Rime*, ed. Girardi (Bari, 1960), 21.

22 The break in Michelangelo's articulation of the right-hand wall of the reading room is, of course, of the nineteenth century, made by the door built to give access to the rotunda-shaped additional reading room to the west.

23 For further remarks of the author's about the *Leda*, see his 'The Genesis of Michelangelo's Leda', in *Fritz Saxl, Memorial Essays* (London, 1957), 270 ff.

24 At this point in his lecture, Wilde recommended to his students the beautiful passage devoted to the *Resurrection* drawings by Kenneth Clark (see *The Nude* (London, 1956), 297 ff.).

25 See the letters to Luigi del Riccio and to an unidentified cleric, both of October 1542, in G. Milanesi, *Le Lettere di Michelangelo Buonarroti* (Florence, 1875), 488 ff.

26 It seems likely that the autograph studies of details to which Wilde here alluded were drawings until recently in the Gathorne-Hardy Collection; and that one of the pupil's copies was another drawing in the same collection (for one of the autograph studies, see L. Dussler, *Die Zeichnungen des Michelangelo* (Berlin, 1959), pl. 122 and for the copy, ibid., pl. 269).